IMAGES
of America

ORANGETOWN

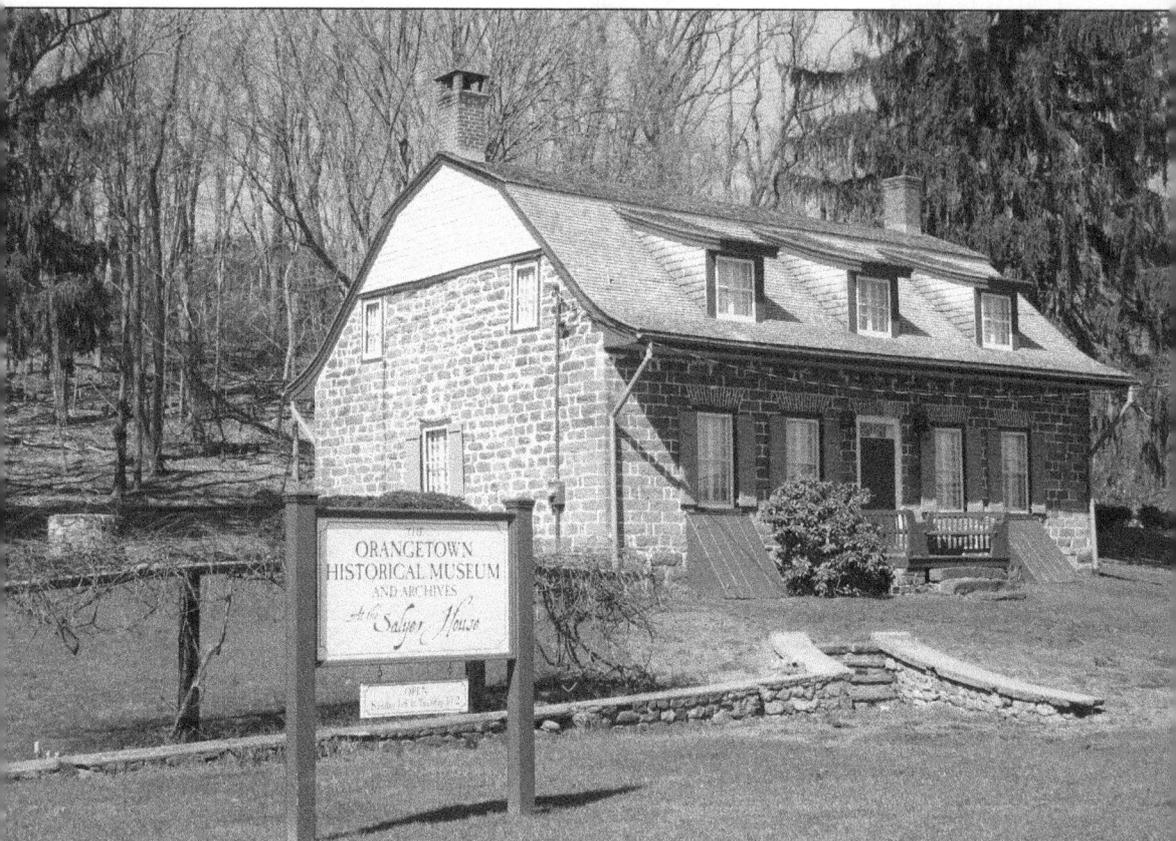

The Orangetown Historical Museum & Archives was founded in 1992 to acquire, archive, and exhibit objects that reflect the history of Orangetown. Located in the 18th-century Michael Salyer House in Pearl River and the Issac DePew House in Orangeburg, the museum also actively documents, researches, promotes, and publicizes Orangetown's heritage for each of its 10 historic communities and the people who reside in them. (Courtesy Orangetown Historical Museum & Archives.)

ON THE COVER: Seven young visitors enjoy a warm summer afternoon on the Hudson River at Fort Comfort Beach in Piermont c. 1903. They, like thousands of others in the early 20th century, traveled to Fort Comfort by boat and train for fresh air, relaxation, swimming, boating, amusements, and fine accommodations. It was, in its day, a most elegant destination for a week with the family, or a weekend getaway with friends. (Courtesy Springsteen Collection, Orangetown Historical Museum & Archives.)

IMAGES
of America

ORANGETOWN

The Orangetown Historical
Museum & Archives

ARCADIA
PUBLISHING

Published by Arcadia Publishing
Charleston, South Carolina

Library of Congress Control Number: 2011928025

For all general information, please contact Arcadia Publishing:
Telephone 843-853-2070
Fax 843-853-0044
E-mail sales@arcadiapublishing.com
For customer service and orders:
Toll-Free 1-888-313-2665

Visit us on the Internet at www.arcadiapublishing.com

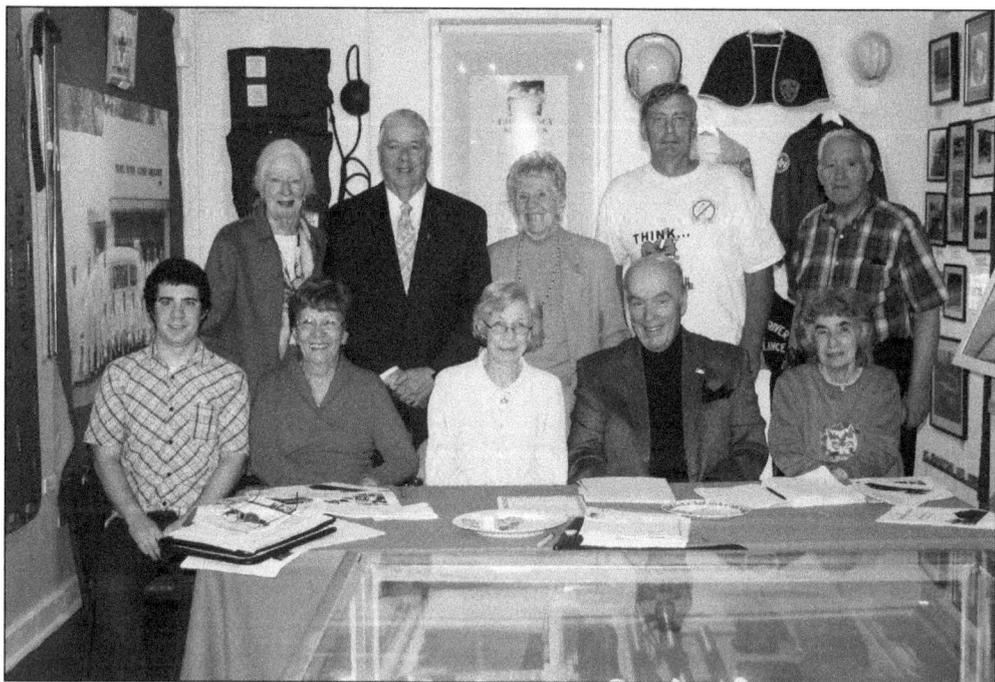

The Friends of the Orangetown Museum Board govern, support, and supervise the duties of the museum, and are responsible for fundraising activities, applying for grants, and generating ongoing support within the community. The board members are, from left to right, (first row) Joseph Barbieri, Luise Weischowsky, Catherine Dodge, Jeffrey Keahon, and Ellen McCarty; (second row) Marie Manning, Robert Simon, Rosemarie Fornario, Kimbal Parker, and Robert Knight. Not pictured are Anne Pinzow, Laura Davie, and Joe Leiper. (Courtesy OHMA.)

CONTENTS

Acknowledgments 6

Introduction 7

1. Tappan 9

2. Palisades and Snedens Landing 23

3. Piermont 35

4. Sparkill 49

5. Nyack 59

6. Pearl River 69

7. Orangeburg 83

8. Blauvelt 95

9. Grand View 105

10. South Nyack 117

ACKNOWLEDGMENTS

The idea for this book happened several years ago when I was asked where the town hall of Pearl River was located. It occurred to me that folks moving into Orangetown needed to know how the Town of Orangetown is organized and why there is no town hall in Pearl River. I was encouraged by many people in Orangetown to write a book that would provide both newcomers and Orangetown natives with some of the high points of each of Orangetown's 10 communities and show why our town is "Rich in History." This is that book.

I am indebted to Brian Jennings, Nyack Library; Carol Weiss, Nyack historian; Jill Gross, Tappan Library; Laura Grunwerg, Blauvelt Library; Jim Cassetta, Pearl River Library; Grace Mitchell, Piermont Library; Sr. Maureen Murphy of the Dominican Convent in Orangeburg; Joanne Potanovic, Historical Society of Rockland County (HSRC); Marilyn Schauder and Chris Gremski, members of the Tappantown Historical Society (THS); Alice Gerard, and the Palisades Library. My thanks also go to Barbara DeGraw and the staff of Bergen County Camera. At the same time, I thank Jim Becker, Catherine M. Dodge, Phil DeLorenzo, Geraldine Leote, Larry Kigler, Tom Hackett, Ellen Cherecwich, Scott Webber, Ruth and Howard Brawner, George Potanovic, and Robert Knight for the use of their postcards, slides, photographs, and collections.

There were many people who provided invaluable facts, insights, and personal observations of their lives in Orangetown. Without them, the details of everyday life here would very well be lost to history. For that I thank Theodore Cooperman, John "Jack" Geist, Harold Jones, Betty Knower, Jean Pardo, Allan Seebach, Myra Starr, and Charlene Stern. I also thank Karen Serafin and Jim Davies of the Orangetown Assessor's Office. Support from the Friends of the Orangetown Museum and the Town of Orangetown was also essential and appreciated. My thanks as well to Orangetown Supervisor Paul Whalen and all the members of the Orangetown Town Board.

Lastly, I thank Elizabeth Skrabonja and Joseph Barbieri of the Orangetown Historical Museum & Archives (OHMA). And Paul Clark who researched, wrote, and edited this history of Orangetown with me. Thanks to you all.

—Mary R. Cardenas
Town of Orangetown Historian

INTRODUCTION

In the early development of the counties of New York State, Orange County was a large area on the west shore of the Hudson River. Orangetown was a small community of 24 square miles, located in the county's southernmost tip, some 13 miles upriver from New York City. It was in the hamlet of Tappantown (now Tappan) that a county seat was established and remained there until the courthouse burned down on October 13, 1773. Later, a new courthouse would be constructed in New City (Clarkstown), which became the new (and present), county seat.

Tappantown figured significantly in the Revolutionary War. It was here that the Orangetown Resolutions were signed by a group of Orangetown citizens protesting taxes and the blockade of Boston Harbor. The resolutions were signed on July 4, 1774, two years before the Declaration of Independence. Tappantown was also the place where Maj. John André, a co-conspirator with Benedict Arnold, was brought before a court of inquiry in the Dutch Reformed Church, found guilty, and sentenced to be hanged on October 2, 1780. During his trial, Major André was held prisoner in what is today the '76 House. In May 1783, the Washington-Carleton Papers were signed in a formal agreement ending the Revolutionary War. The signing took place in Tappantown at the DeWint House. A 17-gun salute to the new nation, the United States, was fired by the British warship *Perseverance* just offshore near Snedens Landing.

Orangetown today consists of the six hamlets, or unincorporated communities, of Blauvelt, Orangeburg, Palisades/Snedens Landing, Pearl River (including a part of Nanuet), Sparkill, and Tappan, plus the four incorporated river villages of Piermont, Grand View, South Nyack, and Nyack. By New York State's definition, a hamlet is a small community, mostly agricultural or suburban, that is part of a larger town—in this case Orangetown—that provides municipal services such as police and public works. A village, on the other hand, has its own municipal building, and provides many public works and services to the community on its own.

For years, Orangetown remained an agricultural-based area, although new industries and services produced shoes, pianos, sewing machines, wagons, shipbuilding, shipping, and tourism. In 1904, Dr. Ernest Lederle purchased the Turfler Farm in Pearl River and set up Lederle Antitoxin Laboratories, which produced diphtheria antitoxin, and later, tetanus antitoxin and typhoid vaccines. During World War I, it produced gas gangrene antitoxin, and during World War II, it maintained the largest blood plasma processing plant and produced penicillin. On September 25, 1942, Orangetown was suddenly thrust into the 20th century when Camp Shanks was built in parts of Orangeburg, Tappan, and Blauvelt. In all, it processed 1.3 million soldiers for service in Europe. Camp Shanks also processed 290,000 German and Italian POWs, who were repatriated after the war.

But perhaps the most profound change to life in Orangetown came about on December 12, 1955, with the opening of the Tappan Zee Bridge and New York State Thruway. It was "the beginning of the end," of the small community of Orangetown. Today, the number of farms in all of Rockland County has dwindled down to five, with one of them in Blauvelt.

In addition to the thousands of people who live and work in Orangetown, this vibrant town is also a bedroom community for thousands of residents who travel and return each day from jobs in New York City and elsewhere. In all, individuals and families appreciate the distinct charm, character, and lifestyle that each hamlet and village here has to offer.

Orangetown, We Hail!

A vision held within each heart
From which a righteous quest had its start
Freedom's plea with words defined
Orangetown Resolutions, July 4, 1774, were signed
The Declaration of Independence to follow its path
Man to be beyond oppression, domination and wrath
Major André, Benedict Arnold conspiracy and travail
Be it Truth and Justice ever to prevail
Washington-Carleton papers in 1783 signed and sealed
The heart and pulse of freedom in words revealed
And so declared a nation new to soar
A seventeen-gun salute at Snedens shore
Snedens Landing in memorial be
A beacon holding fast Freedom's decree
Rich lands for labor and toil
Bounty and abundance from land and soil
Enterprise, invention, production to serve need and desire
Each vision alight with Freedom's flame and fire
And with freedom's defense and call anew
Be there World War II
From Camp Shanks soldiers to foreign shores they be
Hold they dear the protected right to live Free
Change during years past and present to prevail
Orangetown, Rich in History, we with heart hail.

—Rose Marie Raccioppi
Poet Laureate
Orangetown, New York

One

TAPPAN

Almost a century old by the time the American Revolution began, the hamlet of Tappan holds a prominent place in the history of Orangetown and the nation. It was a well-known crossroads, and its connection to the Hudson River by way of the Sparkill made it an important inland port. Until 1773, Tappan was the county seat of Orange County, and on July 4, 1774, the Orangetown Resolutions were published to protest British taxation and the occupation of Boston Harbor.

The DeClark-DeWint House, the oldest house in Rockland, was built in 1700 and used by Washington three times as his headquarters, and it is where he met the British commander to finalize terms for the end of the Revolutionary War on May 4, 1783. In the Tappan Dutch Reformed Church, Maj. John André was tried and convicted in 1780 for conspiring with Benedict Arnold to commit treason and was confined in the Casparus Mabie House, today's '76 House. Here, he awaited execution by hanging, which was carried out on a nearby hill on October 2, 1780.

By the early 1800s, Tappan's role in regional trade subsided as steamships began favoring the deeper waters of Piermont and Nyack. By 1859, the Northern Railroad of New Jersey had connected Sparkill to Jersey City, and in 1870, the line was extended to Tappan but served primarily as passenger lines.

Over the course of the late 19th and early 20th centuries, Tappan evolved into a picturesque, mostly residential hamlet. The first post office was established in 1875. Small farms and companies were operating—one of which, the Cereo Company, made the nation's first commercially produced baby food. During World War II, Camp Shanks was built in part of Tappan, where soldiers trained before deployment to Europe on ground once occupied by Washington's troops. After the war, many soldiers returned to live in Shanks Village, which was replaced by tract housing in the 1950s and 1960s.

Today, Tappan's heritage is preserved in an 85-acre historic area. In 1993, a central section of this area was designated as a historic district and placed in the State and National Registers of Historic Places.

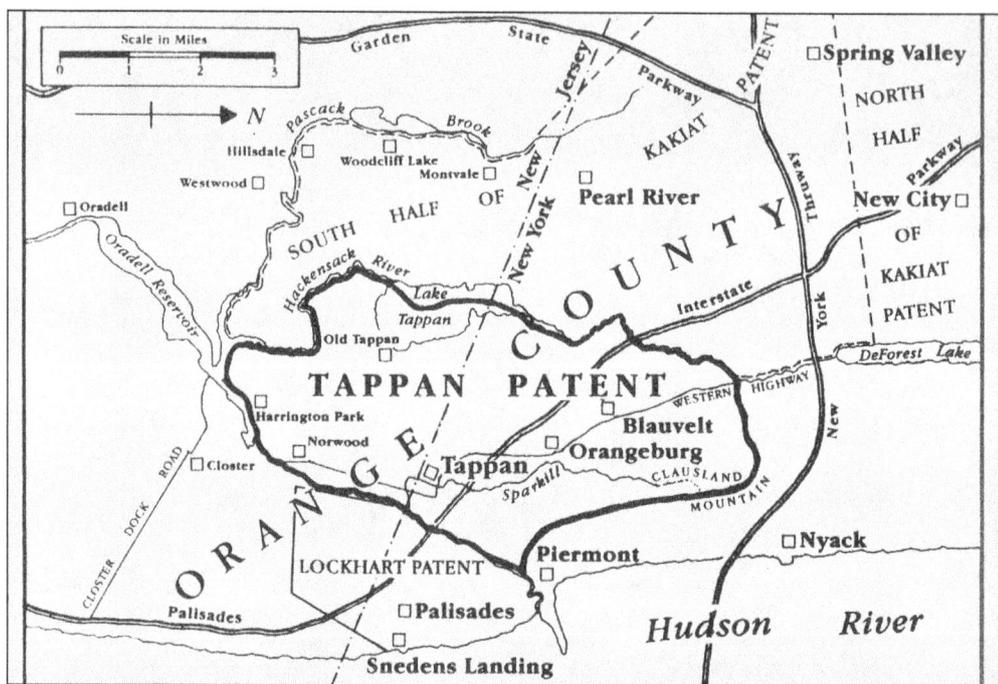

A patent was an official document, issued by the governor, verifying that Native Americans had been paid for the tracts of land they sold to European "patentees." The Tappan Patent was the confirmation of sale to 16 families, mostly Dutch, who purchased land from the Tappan Indians within this map's boundary. It was issued on March 26, 1686, and entailed roughly 16,000 acres of land. (Courtesy Tappantown Historical Society.)

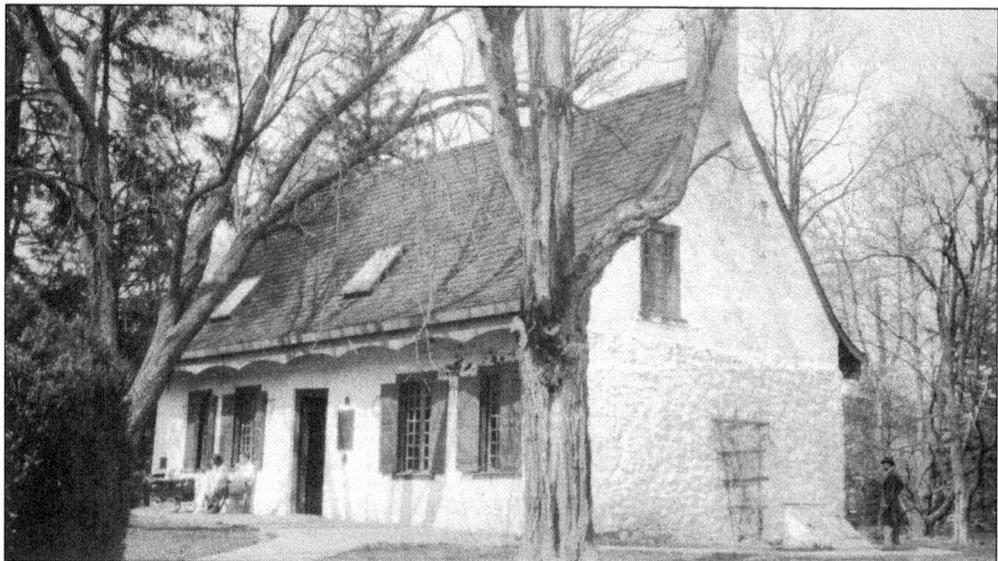

The DeWint House was built in 1700 and occupied three times by Washington as his wartime headquarters. On May 4, 1783, Washington met here with Sir Guy Carleton to finalize terms for the exchange of prisoners, evacuation of British-held posts in New York, and the return of American property, ending the war and establishing the new nation. In 1931, it was purchased by the New York State Free and Accepted Masons. (Courtesy Chris Gremski.)

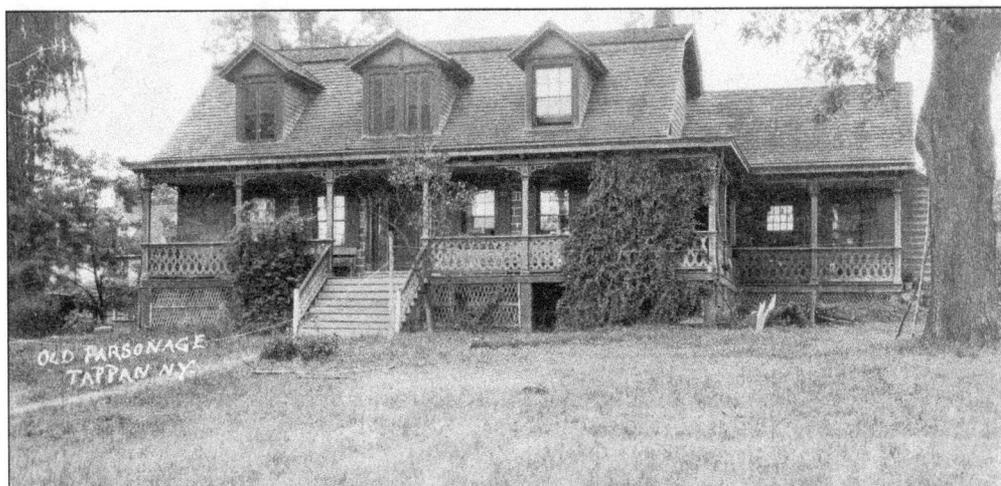

The Manse is the parsonage provided to the ministers of the Dutch Reformed Church (now the Tappan Reformed Church), which was founded in 1694. The Manse, built in 1729, has since been renovated several times. And except for a brief time during the Revolutionary War, this historic building has been continually occupied by ministers serving the church. The dormers were added to the Manse sometime after 1870.

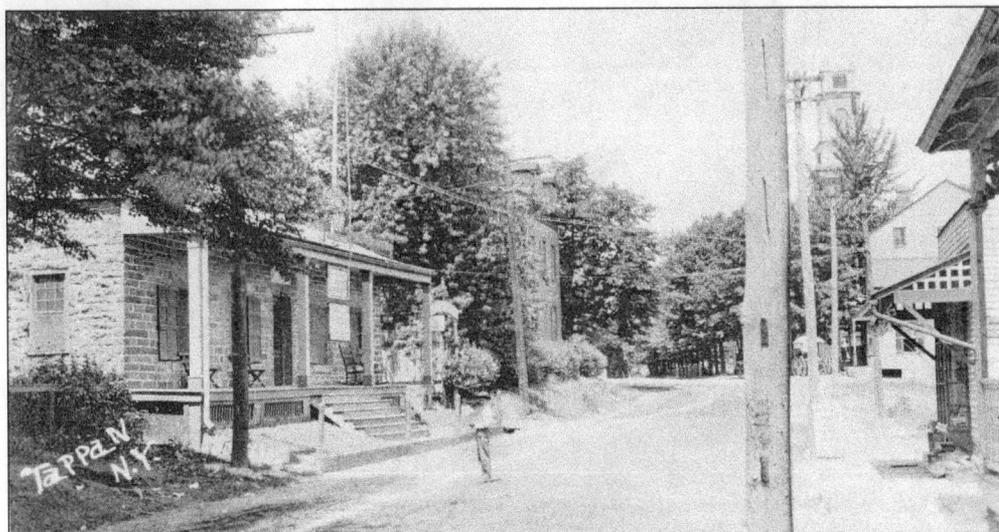

Tappan's 18th-century town center remains as distinctive today as it did in 1910. The Dutch Reformed Church is still prominent, and the Casparus Mabie House, built in 1753 and rebuilt after 1897, is today's '76 House. It was in the church built here in 1716 that Maj. John André was tried and convicted of treason. And, it was in the Mabie House that he awaited execution by hanging on a nearby hill in 1780. (Courtesy HSRC.)

11

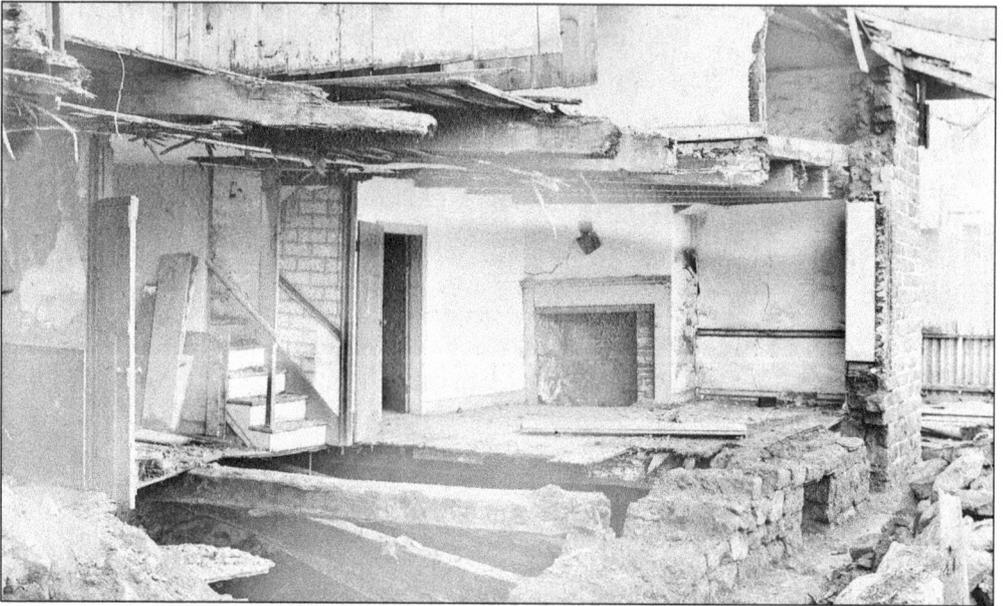

The front of the Casparus Mabie House collapsed and fell onto Main Street in November, 1897 after years of neglect by the house's owner, a Doctor Stephens. It is said that Major André stood before this fireplace as the verdict of his trial for conspiracy to commit treason was read to him. Stephens soon had the house boarded up so that treasure seekers would not steal any "souvenirs" from this famous space. (Courtesy HSRC.)

A year or so later, the damaged Mabie House was bought by Mary Anne and Charles Pike, who carefully repaired and restored it to its original state. It has since become the '76 House, a historic and long-established restaurant. During World War II, comedians and singers—including Jack Benny, Dinah Shore, and Frank Sinatra—entertained soldiers at nearby Camp Shanks, and they would stop in the '76 House afterwards for dinner. (Courtesy HSRC.)

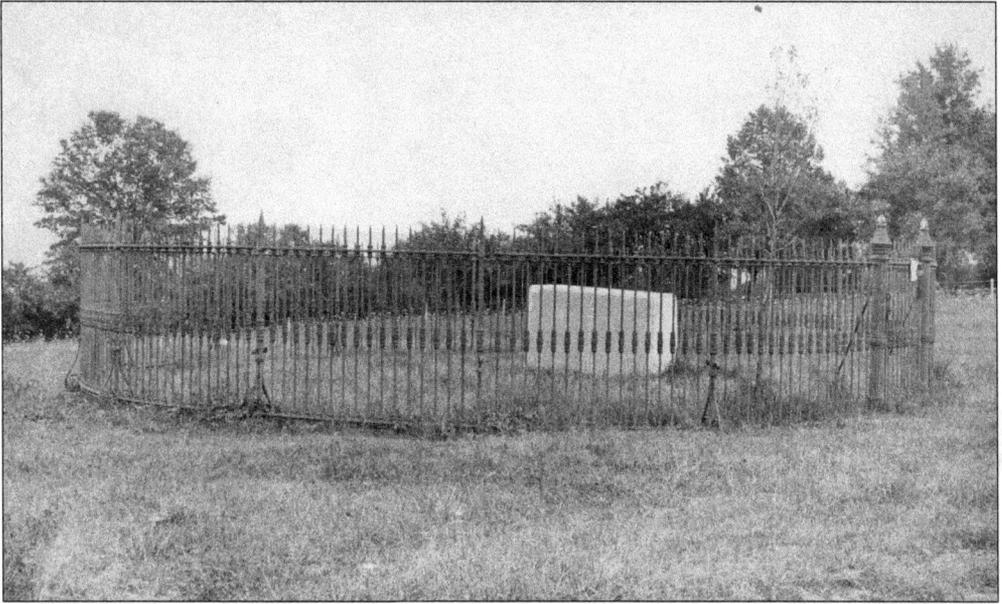

Erected on October 2, 1879, this monument marked the site where Maj. John André was hanged. The inscription was written by Arthur Penhryn Stanley, dean of Westminster Abbey. The monument was twice defaced and blown off its base, as pictured here. The monument was placed here by two men, an American and an Englishman, who shared a common history and the hope that this endeavor would produce good British-American relations. (Courtesy HSRC.)

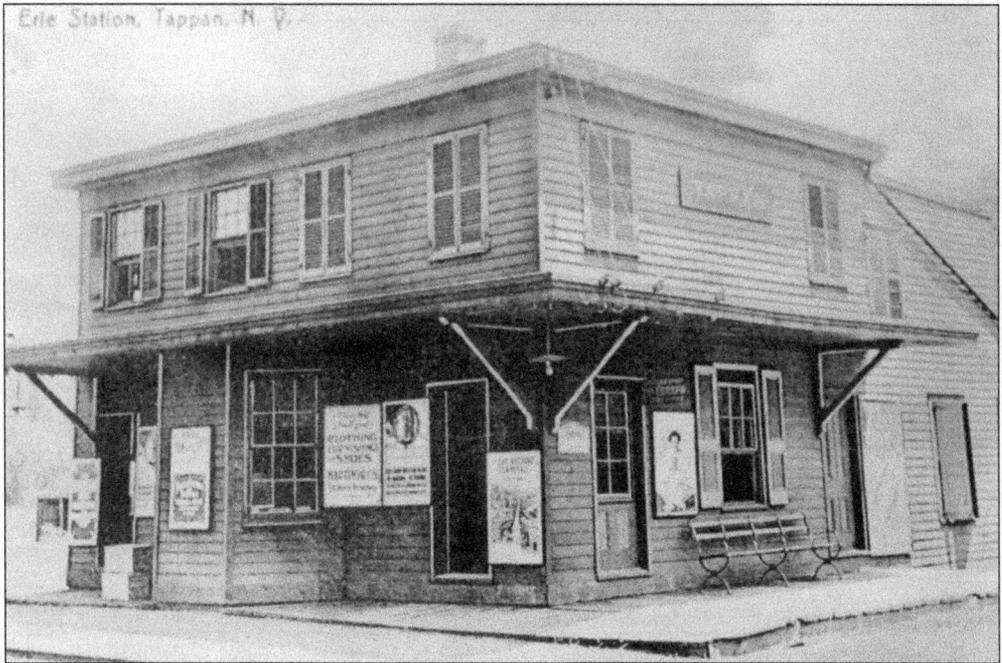

The Erie ran through Tappan beginning in 1851. The Erie station was built in 1859 on the northeast corner of Oak Tree Road near Lawrence Street, across from the Oak Tree Inn. This was both a commuter and a freight line. Commuter service ended in 1966 but freight continued. The tracks were taken up to become part of the Rails-to-Trails Conservancy. (Courtesy Chris Gremski.)

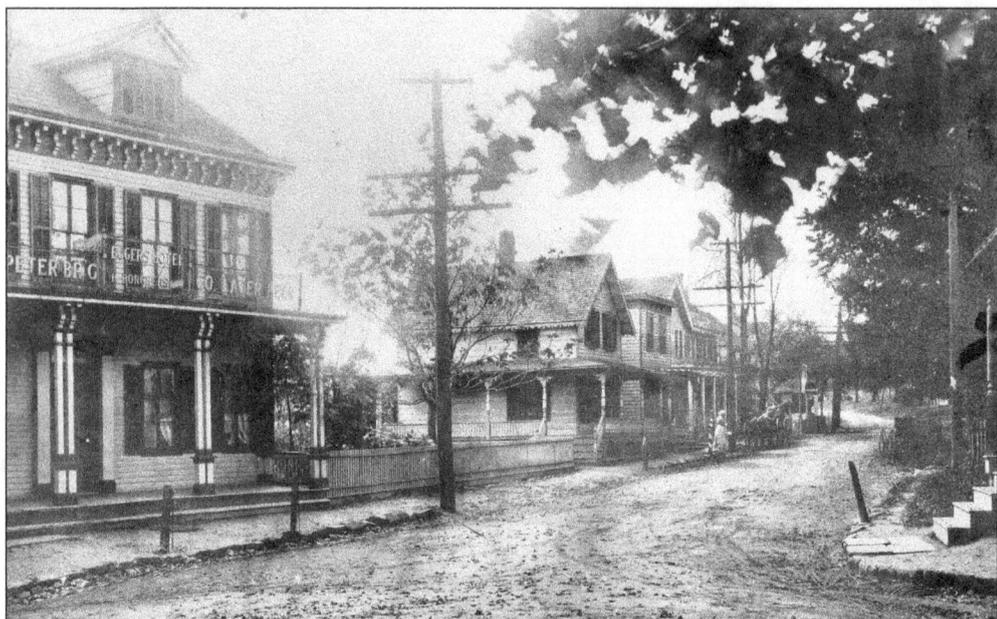

Eggers Hotel was well suited for its location at the end of Main Street and Tappan Road. It was originally designed and built as a private residence, which later became Van Wart's jewelry store. In 1882, Henry Eggers bought the building and converted it into a hotel. It is thought to be a stagecoach stop because there was a candle lantern outside. If the candle was lit, there were rooms available. (Courtesy OHMA.)

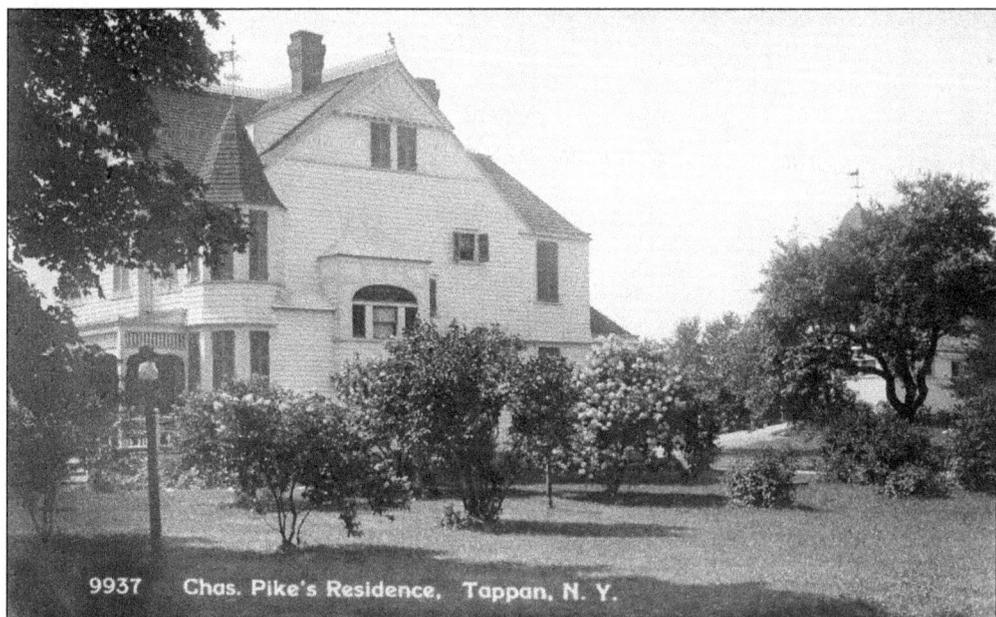

9937 Chas. Pike's Residence, Tappan, N. Y.

Built about 1893, this was the home of Mary Anne and Charles Pike. Eventually, it became the rectory for Our Lady of the Sacred Heart. The barn was converted into a Catholic church, but with the growing number of Catholic families, a multipurpose hall within the school served as the new church and was dedicated on September 28, 1957. The rectory was razed on July 25, 2005, for additional parking. (Courtesy Chris Gremski.)

14

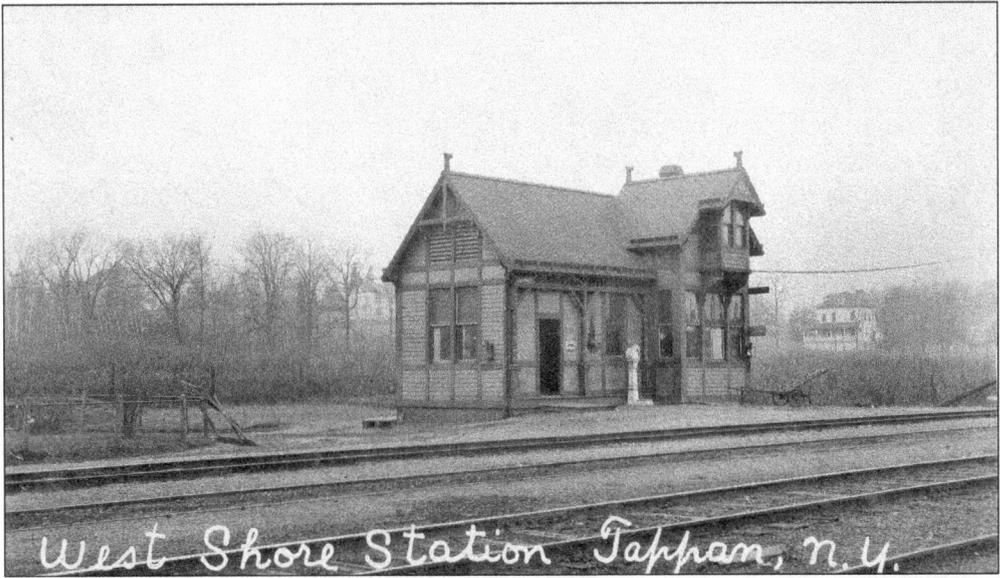

West Shore Station Tappan, n.y.

The West Shore Railroad line ran from Weehawken, New Jersey, to Tappan and some trains went on to Albany. The Tappan station on this line was built in 1883 and razed about 1964 to make way for the First National Bank of Spring Valley. During World War II, the West Shore brought soldiers to Camp Shanks for training before being shipped to Europe. Commuter service ended on December 15, 1959. (Courtesy Robert Knight.)

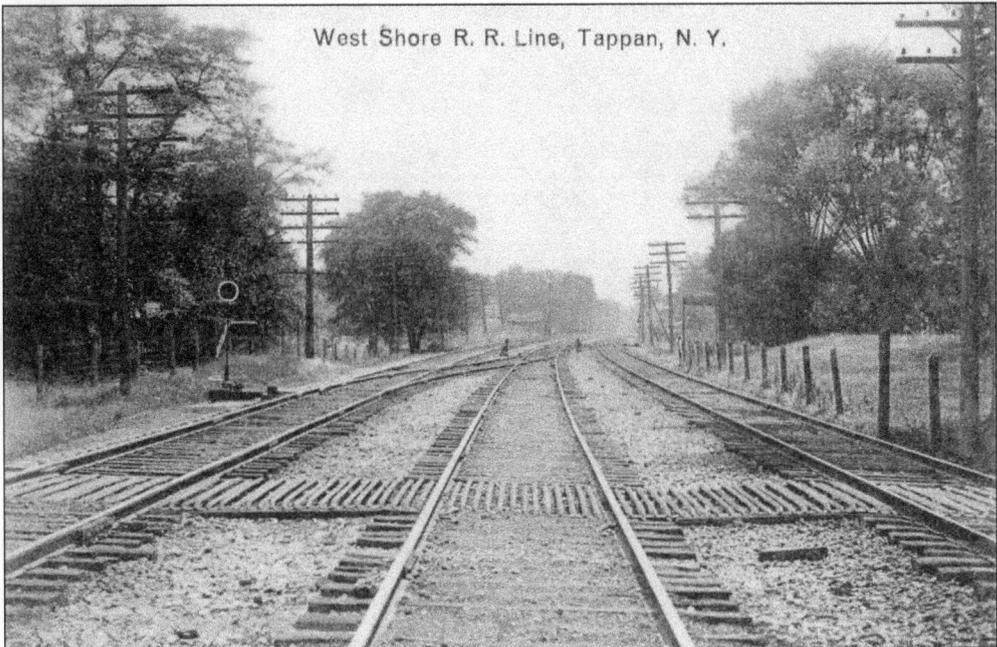

West Shore R. R. Line, Tappan, N. Y.

This shows the West Shore tracks parallel to Grand Avenue, facing south, heading into Northvale, New Jersey. After passenger service was discontinued in 1959, two sets of these tracks were removed. Freight service still continues through Orangetown on this line. The West Shore rail line came through Tappan in 1878. It was built by the Pennsylvania Railroad and leased to the New York Central, stretching from Weehawken to Buffalo, New York. (Courtesy Chris Gremski.)

15

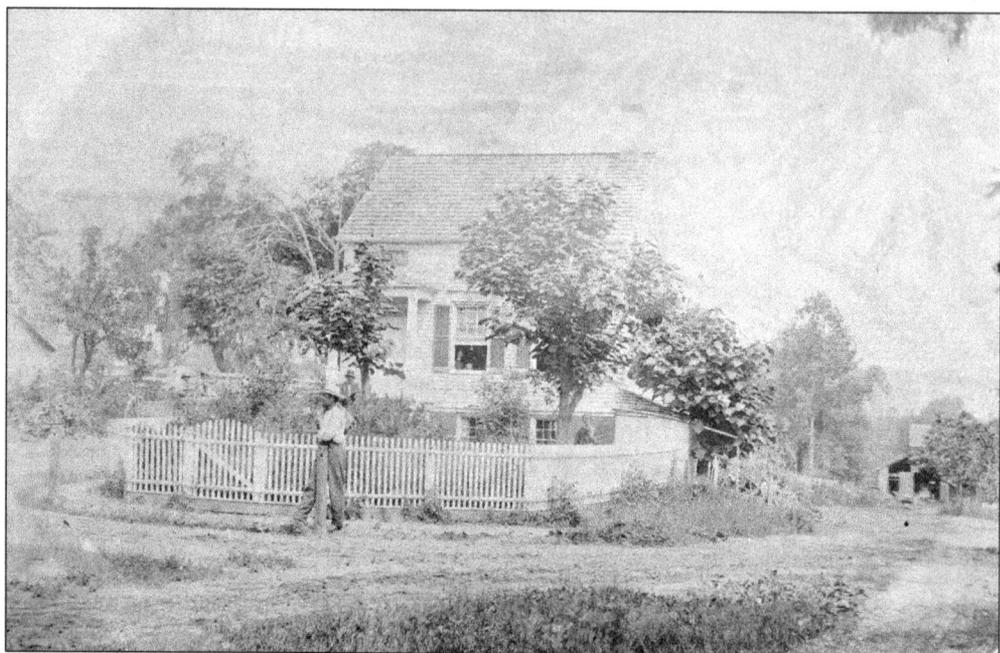

Facing the center of Tappan at the intersection of Kings Highway and Greenbush Road, the Haring-Smith House was built about 1835. This three-bay Greek Revival house became a small factory in 1900 when a later owner, Macey Demming, made the nation's first commercially produced baby food. The formula was a type of pablum (cereal) made of wheat gruel flour. Another product made was inorganic food for mothers, infants, and growing children. (Courtesy OHMA.)

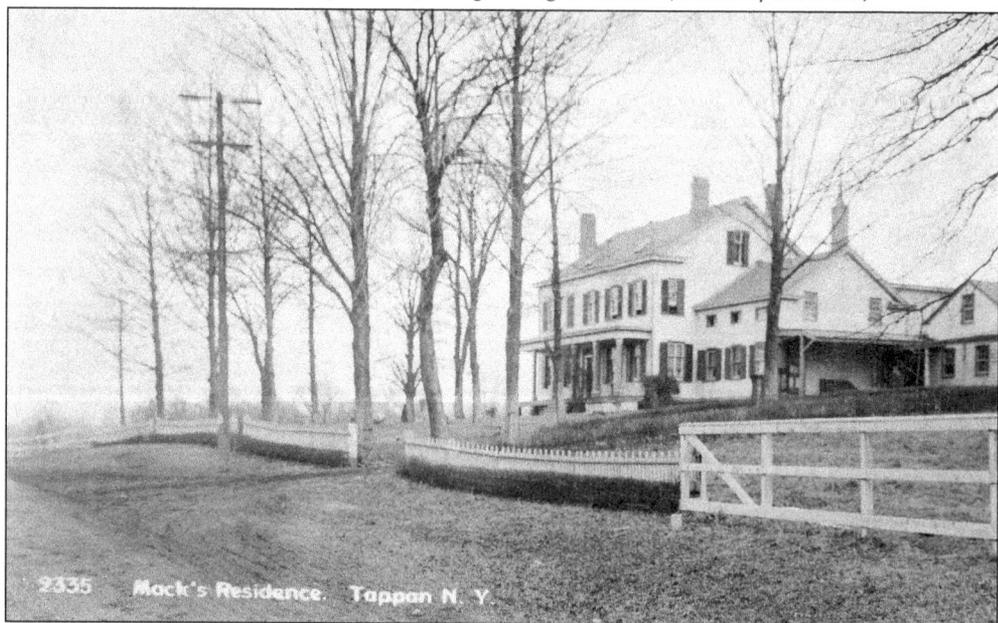

Built in 1845, this farmhouse was part of a 100-acre farm bought by the McGillicuddy family, or "the Macks," as they were called. They came to Tappan in the early 20th century and settled in this house with their three sons and 19 grandchildren. The house is located on Old Tappan Road but has been greatly changed with modern renovations. (Courtesy Marilyn Schauder.)

In the late 19th century, there were a number of benevolent organizations that provided help for the various needs of society. In 1905, Emma Whittemore started an organization called Door of Hope, which took in unwed mothers and working city girls who needed care and rest. Here, they were taught homemaking, sewing, and other skills. Located on Christine Lane, the home was taken over by the Salvation Army in 1913. (Courtesy OHMA.)

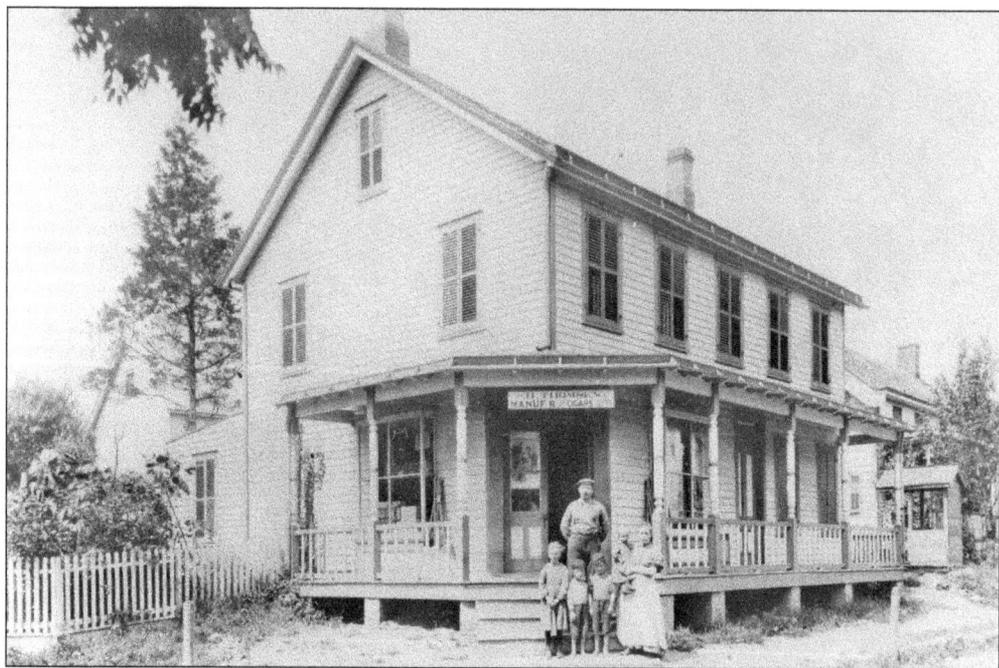

The Thomsen family of Tappan, pictured c. 1900, is standing in front of a house located on the corner of Old Tappan Road and Main Street, across from today's Tappan Library. The sign above Mr. Thomsen reads, "H. Thomsen Manufr of Cigars." Members of this family were carpenters who built a number of houses in Tappan. The store, as of 1985, is the Tack Box, which sells equestrian equipment. (Courtesy OHMA.)

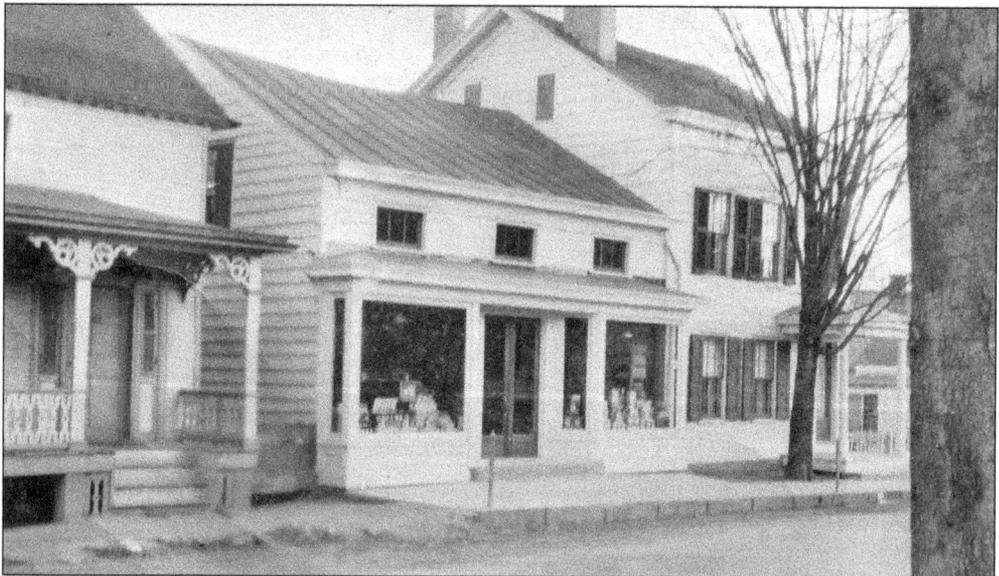

The two buildings on the left, pictured c. 1920, are today separated by a driveway. The building in the middle is now a wine shop. The other is the Tappan Library, which was once DeVoe's grocery store, a teashop, and Moritz Funeral Parlor. The first Tappan library began on the second story of a garage used by Moritz for his hearses, and old gun cases from Camp Shanks were used for bookcases. (Courtesy Chris Gremski.)

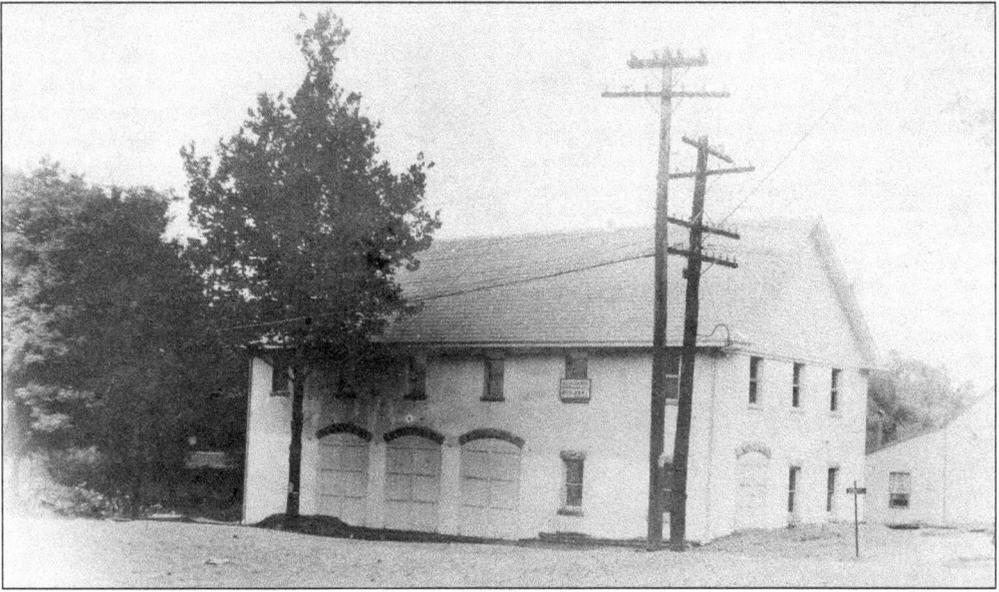

Until the Tappan Firehouse was built in 1911, fires in Tappan were fought by bucket brigades or by the John Paulding Engine Company in Sparkill. The Volunteer Fire Association of Tappan was incorporated in 1907. This 1910 postcard shows the Tappan Firehouse with a sign underneath the upper window, which says, "L.C. Adams Contractor and Builder, Pearl River, N.Y." The street sign has an arrow pointing to Sparkill and Nyack. (Courtesy Robert Knight.)

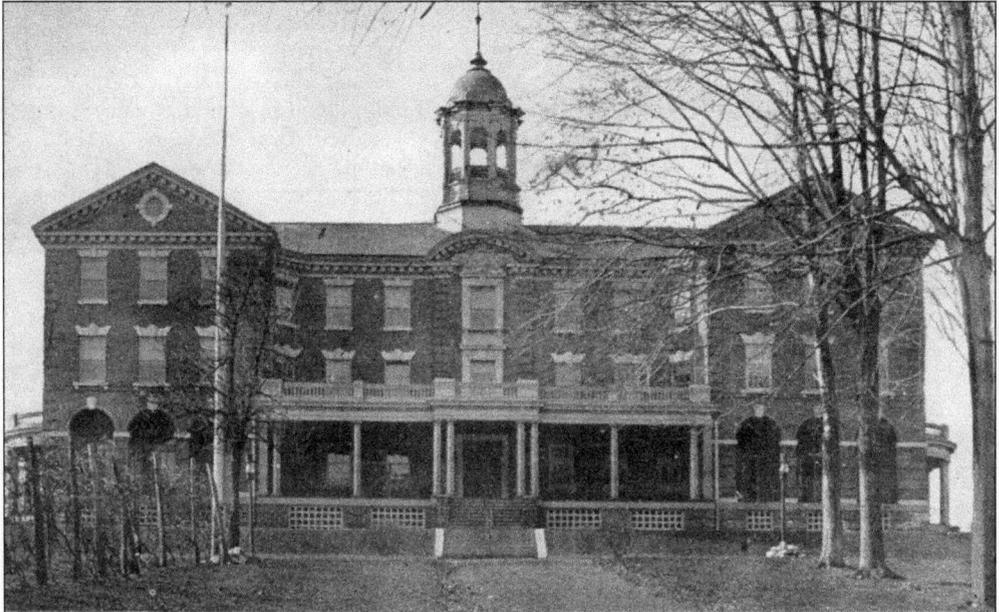

MASONIC HOME, TAPPAN, N. Y.

Completed in 1909, this structure was the second Masonic Home, which was built across from the first German Masonic Home along Western Highway. It was closed in 1981 because of the dwindling number of occupants and stricter building codes for this type of service. It was then leased that same year to Dominican College for a temporary dormitory. Elderly occupants were transferred to another Mason-owned facility in New Rochelle. (Courtesy Chris Gremski.)

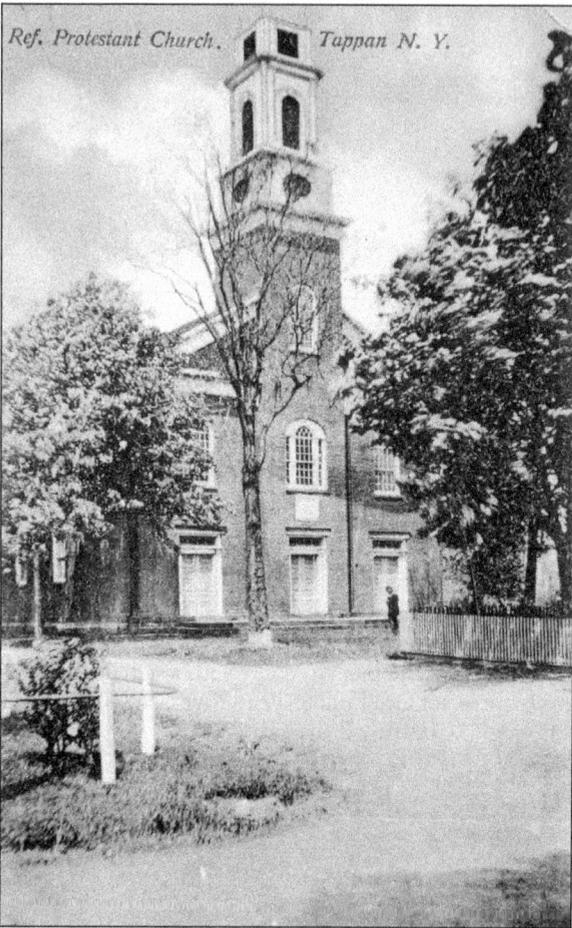

The Tappan Reformed Church, pictured here c. 1910, was the fourth church on this site, built in 1835. The first church was probably a small log structure. With the congregation growing, a second church was built here in 1716. It was in this church that a court of inquiry found Maj. John André guilty of treason. A third was built in 1788, and congregants came from northern New Jersey as well as New York. (Courtesy Chris Gremski.)

Main Street in Tappan, pictured below in 1914, shows unpaved Main and Washington Streets. The firehouse is on the left and the house beyond was a travel agency in the 1970s and is now a barbershop. There are two cars parked on the street, with obviously no parking issues. The steps on the right lead to the 1835 brick building once known as the Bartow House, now a real estate agency. (Courtesy OHMA.)

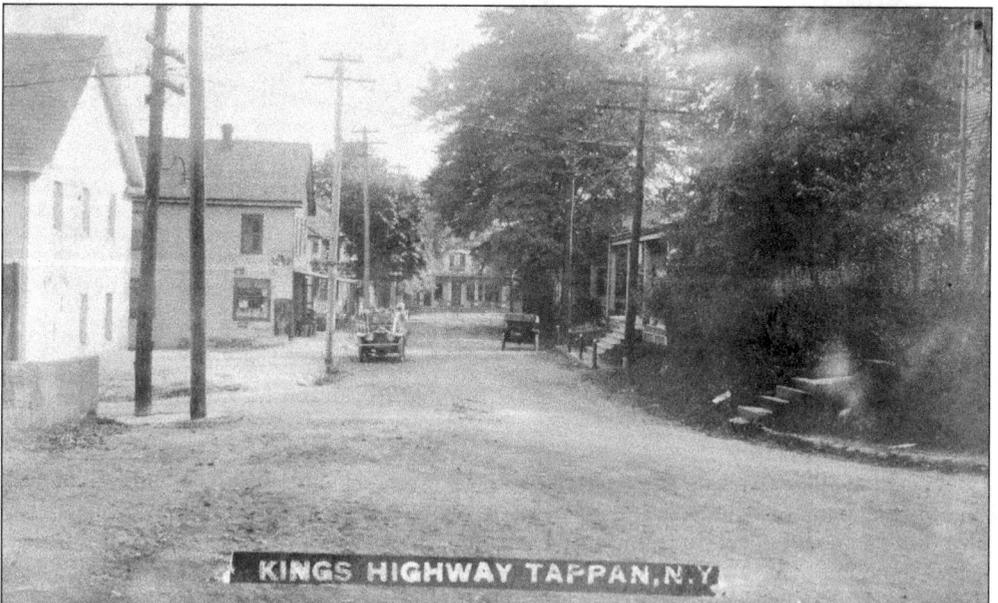

This house, now known as Il Portico restaurant, was originally a private home, and later became Van Wart's jewelry store. In 1882, Henry Eggers bought it and turned it into Eggers Hotel. Horses bringing travelers here were quartered in a barn across the street. In the 1960s, the hotel became the Oak Tree Inn. In 2005, Paul Melone, who owned the barn, sold it to the Tappan Library. (Courtesy Chris Gremski.)

Looking east on Oak Tree Road, an elm tree stands in the middle of the bridge over the Sparkill. It was known as the tar barrel tree after flaming barrels of tar were hoisted in it as a signal during the Revolution. The tree was cut down after 1952. The house on the left, pictured c. 1830, is the Campbell House, whose smaller section was probably built in the 18th century. (Courtesy James Becker.)

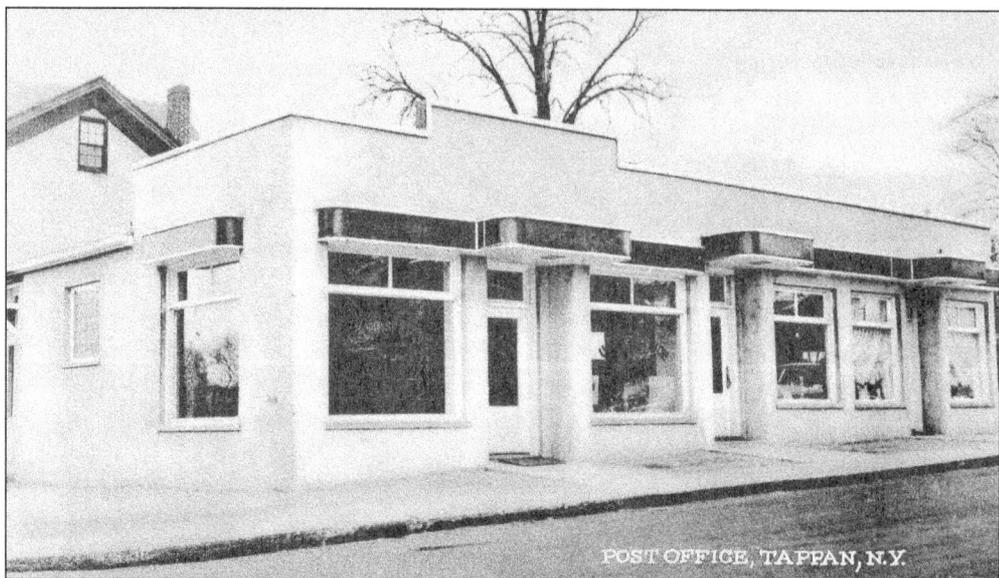

The first Tappan Post Office was in a building near the Tappan Library. In 1910, it moved to a small building near the West Shore Railroad tracks, then into the rail station. It relocated twice after 1936, and in 1948, it was moved to a new building on Brandt Avenue and Old Tappan Road. The building was updated in 1955, and in 1990, the post office moved into the left portion of the building. (Courtesy Marilyn Schauder.)

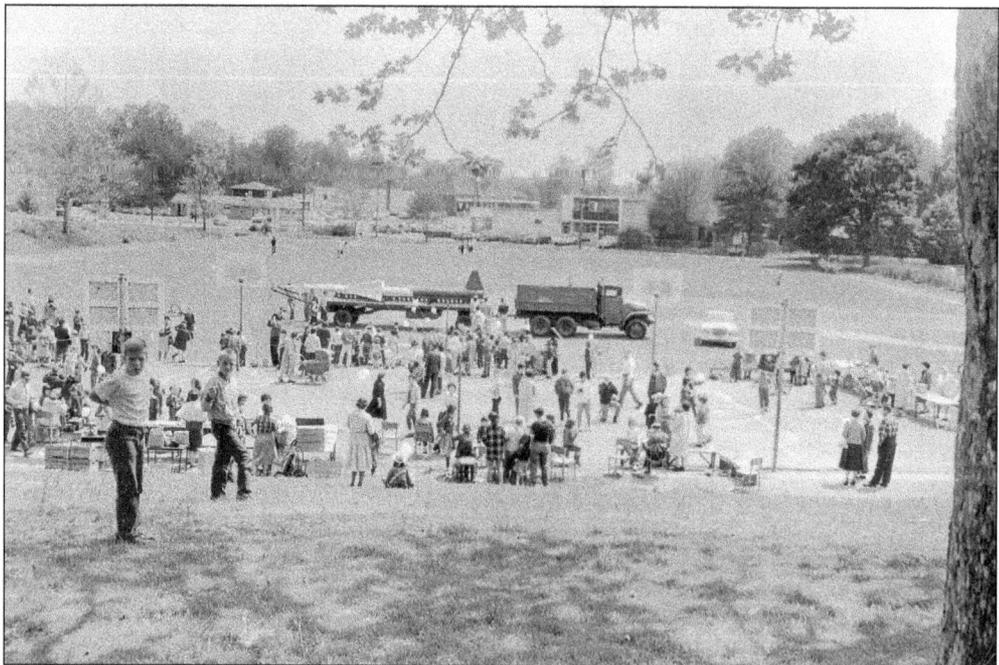

During the Cold War, Nike Ajax missile sites were placed in strategic areas in the United States, including Orangetown. The Ajax missile served as a last line of defense in the event that the Air Force interceptor fighter jets would be unable to destroy attacking Soviet bombers over the New York area. Pictured c. 1960, a Nike missile is on display in the playground of the old Tappan Grammar School. (Courtesy Marilyn Schauder.)

Two

Palisades and Snedens Landing

Palisades and Snedens Landing were part of land purchased by George Lockhart, a patent issued on June 27, 1687. The land was soon sold to William Merritt, who probably constructed Cheer Hall, and in 1737, Henry Ludlow built a home nearby called the Big House, the oldest remaining house here today.

By 1745, Robert Sneden and his wife, Mary (known as Mollie), were living near the ferry landing on the west shore of the Hudson. There, Sneden worked with Mollie's brother, Jan Dobbs. Dobbs began running the river ferry, called Dobbs Ferry, in Westchester, in 1729. After Robert's death in the early 1750s, Mollie took over ferry operations. This area was interchangeably called Snedens Landing, Dobbs Ferry, and Rockland. It is thought that Mollie ferried Martha Washington, her son, and others to Westchester in December 1775. After the British surrendered, the first salute to the American nation was fired off Snedens Landing on May 7, 1783.

During the early 1800s, population grew and businesses included fishing, quarrying, and shipbuilding. The first schoolhouse was built on Closter Road in 1825. The arrival of steamboats and railroads in the 1840s and 1850s affected the local economy. To attract shipping, Lawrence Sneden built a 500-foot pier in 1850, but the railroad soon proved more efficient. With the establishment of the first post office in 1855, the hamlet's name was changed to Palisades.

The Erie Railroad connected New York to Tappan in the 1850s, as did the West Shore in the 1870s, and wealthy New Yorkers were drawn to Palisades for land to build summer and permanent homes. As the 1900s began, cars, telephones, and electricity improved life. The building of Route 9W in 1929 improved land travel.

In 1900, Mary Lawrence married well-known French-Italian sculptor François Tonetti, and in the 1920s, began renting houses she owned to actors, artists, writers, and musicians and turned Snedens Landing into an artists' enclave. Ferry service continued until 1946, when the 217-year-old Snedens-Dobbs Ferry ended. In 1967, Palisades developed its own historic district. The attraction of Snedens Landing continues to this day with the many well-known artists, actors, and other personalities who live here.

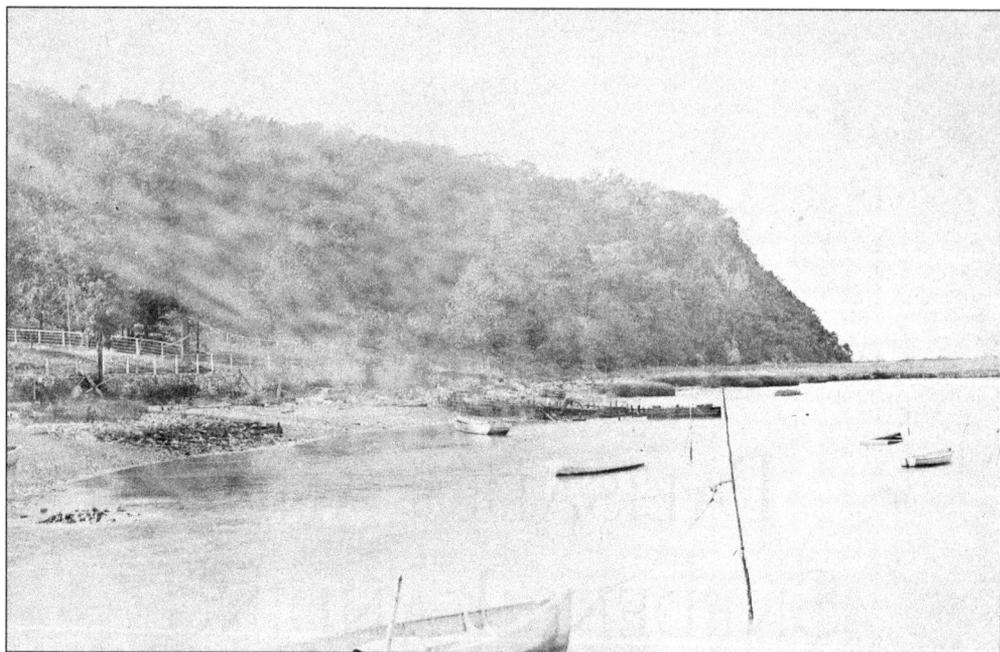

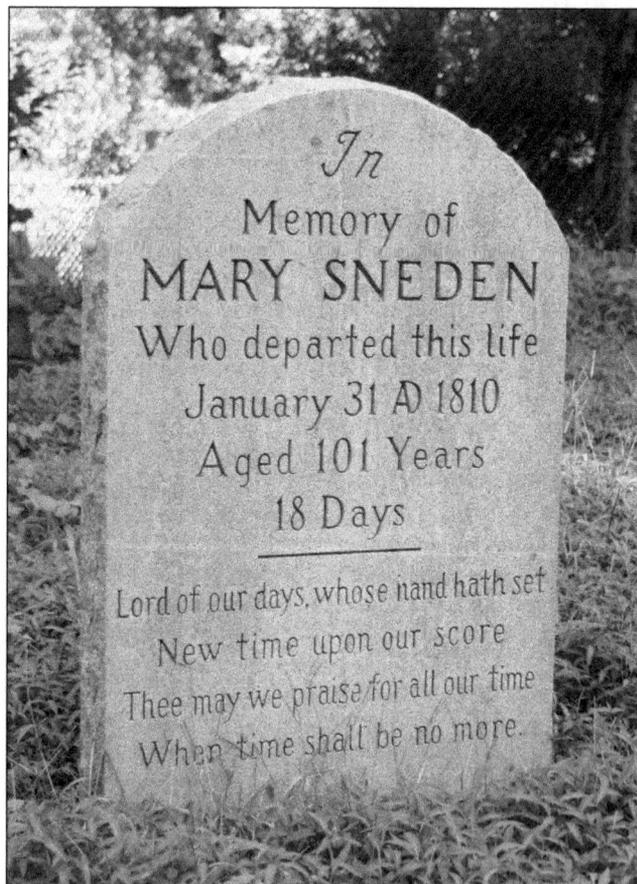

In
Memory of
MARY SNEDEN
Who departed this life
January 31 AD 1810
Aged 101 Years
18 Days

Lord of our days, whose hand hath set
New time upon our score
Thee may we praise for all our time
When time shall be no more.

Snedens Landing, pictured c. 1900, was one of two places where a gap in the Palisades allowed access to Orangetown's interior. In the 1850s, Capt. Larry Sneden built a 500-foot pier into the Hudson to enable the larger steamboats of the day to dock here. But use of his pier was discontinued after a bigger pier was built at the mouth of a larger gap in the Palisades at Piermont. (Courtesy OHMA.)

After 172 years of deterioration, Mollie Sneden's tombstone was carefully replaced in May 1982. The new tombstone bore the original 1810 inscription, "In Memory of Mary Sneden Who departed this life January 31 AD 1810 Aged 101 years 18 days Lord of our days whose hand hath set New time upon our score Thee may we praise for all our time When time shall be no more." (Courtesy Joseph Barbieri.)

Located near today's Route 9W, the Big House, so called because of its unusual length, was built in 1738 and had three sections: a large center and two smaller wings. It is possible that George Washington, Lafayette, and Von Steuben dined here as guests of Jonathan Lawrence after inspecting the construction of a nearby military blockhouse built nearby to safeguard Sneden's ferry and control communications between Westchester and New York. (Courtesy Alice Gerard.)

The sandstone used to construct this house was probably quarried at Snedens Landing, which was known for its light-colored stone. George Mann settled here in 1767 after purchasing 98 acres of land on which this house was constructed in 1784. The house is a one-and-a-half story design with a non-gambrel roof, and situated between the Presbyterian church and Route 9W, perpendicular to historic Washington Spring Road. (Courtesy Alice Gerard.)

Located near Washington Spring Road, this elegant sandstone house is still known today as the Capt. Larry Sneden House. Built sometime around 1820, the house was constructed from locally quarried stone and was constructed in the "old style" design (a non-gambrel roof) with sweeping eaves and two windows on either side of the door. Lawrence Sneden purchased this house in 1834 and lived in it until his death in 1870. (Courtesy Alice Gerard.)

With donated money from congregant Moses Taylor, the old Methodist Episcopal church was replaced in 1859. By 1926, it closed after its members joined the Presbyterian church. The building was purchased by an antiques dealer, Tippie O'Neil, in 1935 and became known as Yonderhill Antiques. After both Tippie and his associate John Garrison died, the antiques dealership continued briefly, then closed. In 2005, Weleda, a beauty spa, took over the building. (Courtesy Robert Knight.)

After Winthrop Gilman moved to Palisades in 1861, he and four other members of the Methodist Episcopal Church decided to found a Presbyterian church. Gilman had studied architecture and designed this Gothic Revival church building. The first service of the new church was conducted on January 3, 1864. Not long after, many other Methodists switched and became members of the new church, forcing the Methodist Church to close in 1926. (Courtesy Robert Knight.)

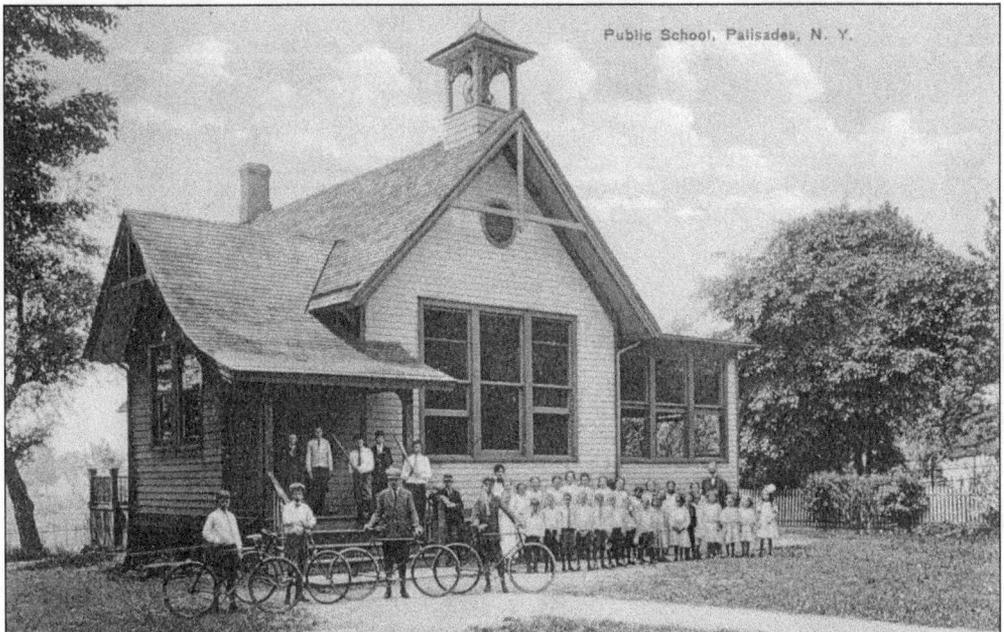

This two-room schoolhouse was built in 1867 where eight grades were taught. First through fourth grades were in one classroom, fifth through eighth in the second. It had a well and two outhouses. A new school was built across the street in 1936 and was closed in 1977. Students in Palisades were bused to other schools. The old school was eventually sold to the community of Palisades for $1. (Courtesy Robert Knight.)

27

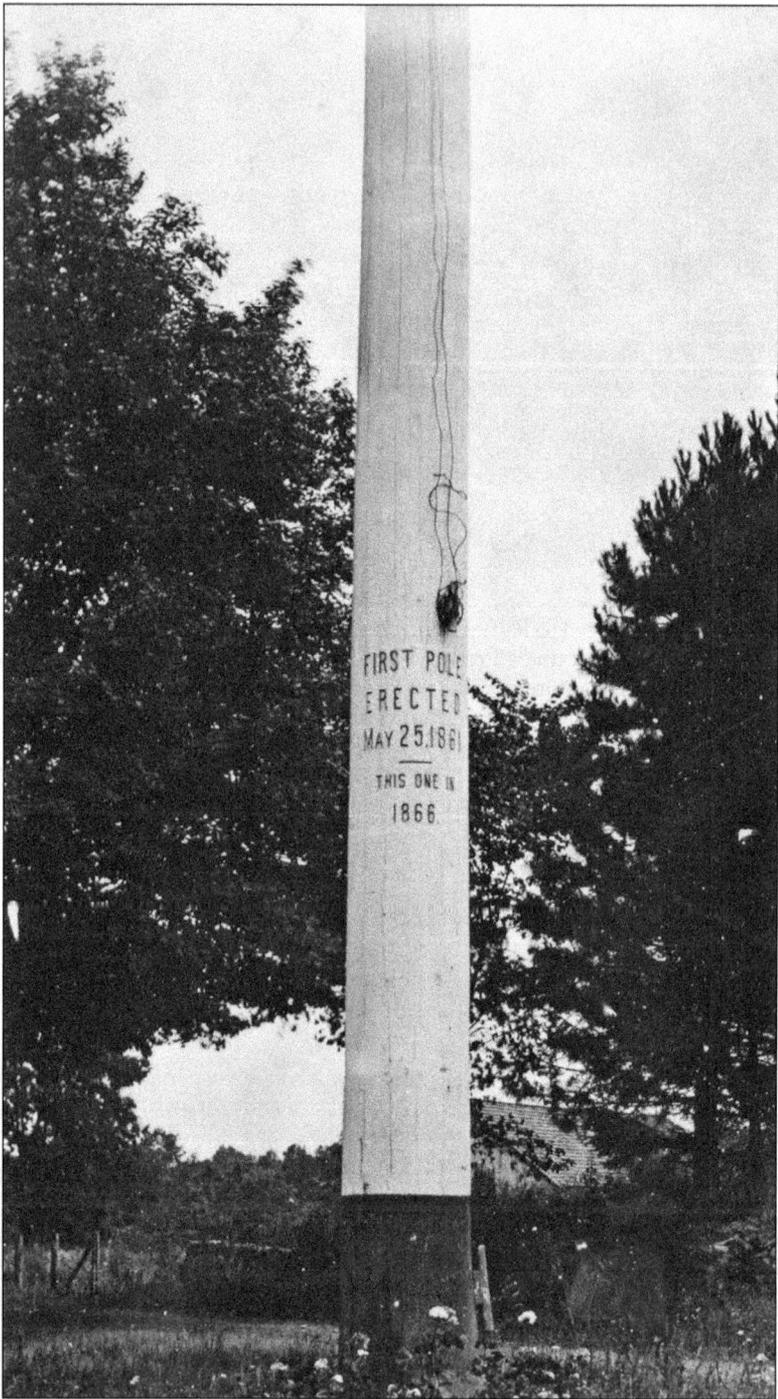

Herbert Lawrence donated the land on which the original Palisades flagpole was erected in 1861. It was known as the Liberty Pole to symbolize opposition to slavery. However, lightning destroyed it in 1866, and it was promptly replaced and cared for by a committee. Thinking the pole had rotted, the Town of Orangetown ordered the pole removed in 1930, but it was returned after residents prevailed with the town board. (Courtesy Alice Gerard.)

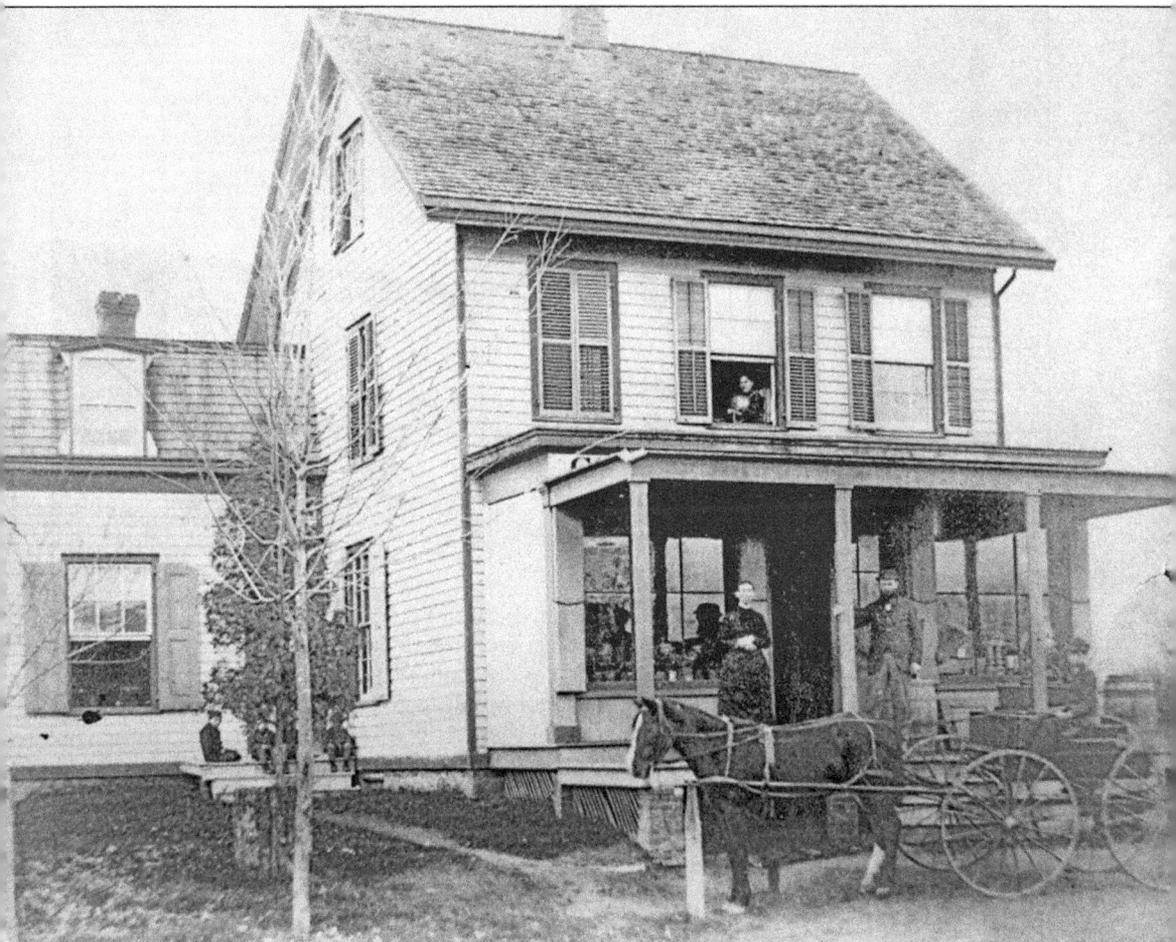

The James Post house was built in two parts, the first about 1850, and the second in the 1860s. The house was used as a grocery store, which delivered groceries and ice by horse and wagon. Later, a third section became the post office, and depending on which political party was in power every election, it would stay put or be literally moved across the road to Lawrence's grocery store. (Courtesy Alice Gerard.)

In Palisades, as in other communities at the time, groceries, baked goods, meat, ice, dry goods, and more were delivered daily to homes by horse and wagon. When a grocery store wagon would come through a neighborhood, it was customary for people to give the driver their lists of needed items, and the driver would then return with their groceries and other items later in the day. (Courtesy OHMA.)

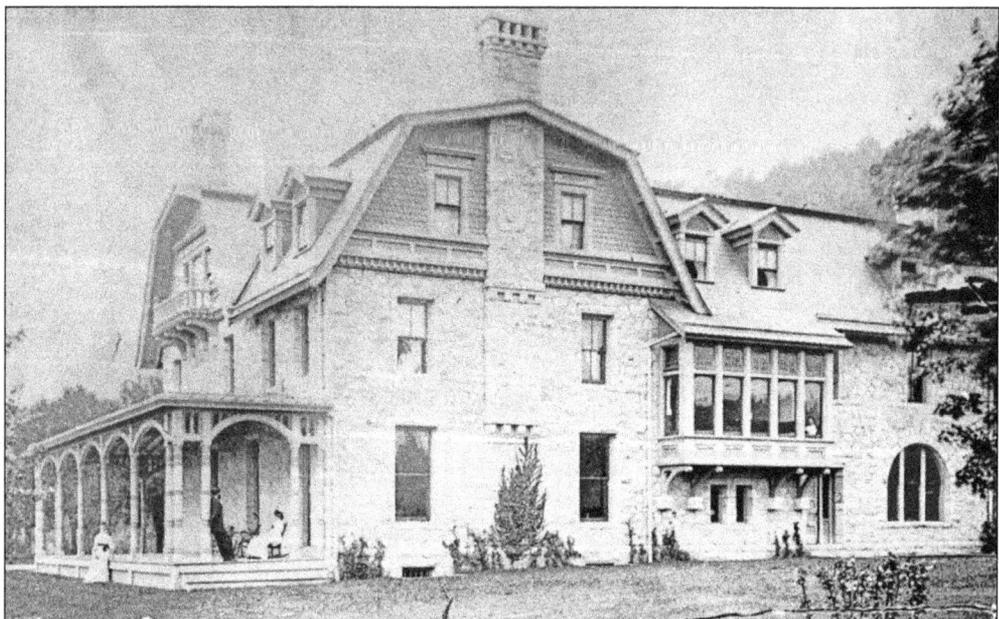

This large 23-room house was built in 1876 and was the former home of the wealthy H.E. Lawrence family from New York. It was built using stone cut from nearby quarries. The house appears to have been built in different sections, which vary in style. The exterior walls have a smooth finish, and in some areas, a rubble finish. The house remained in the Lawrence family until 1962. (Courtesy Alice Gerard.)

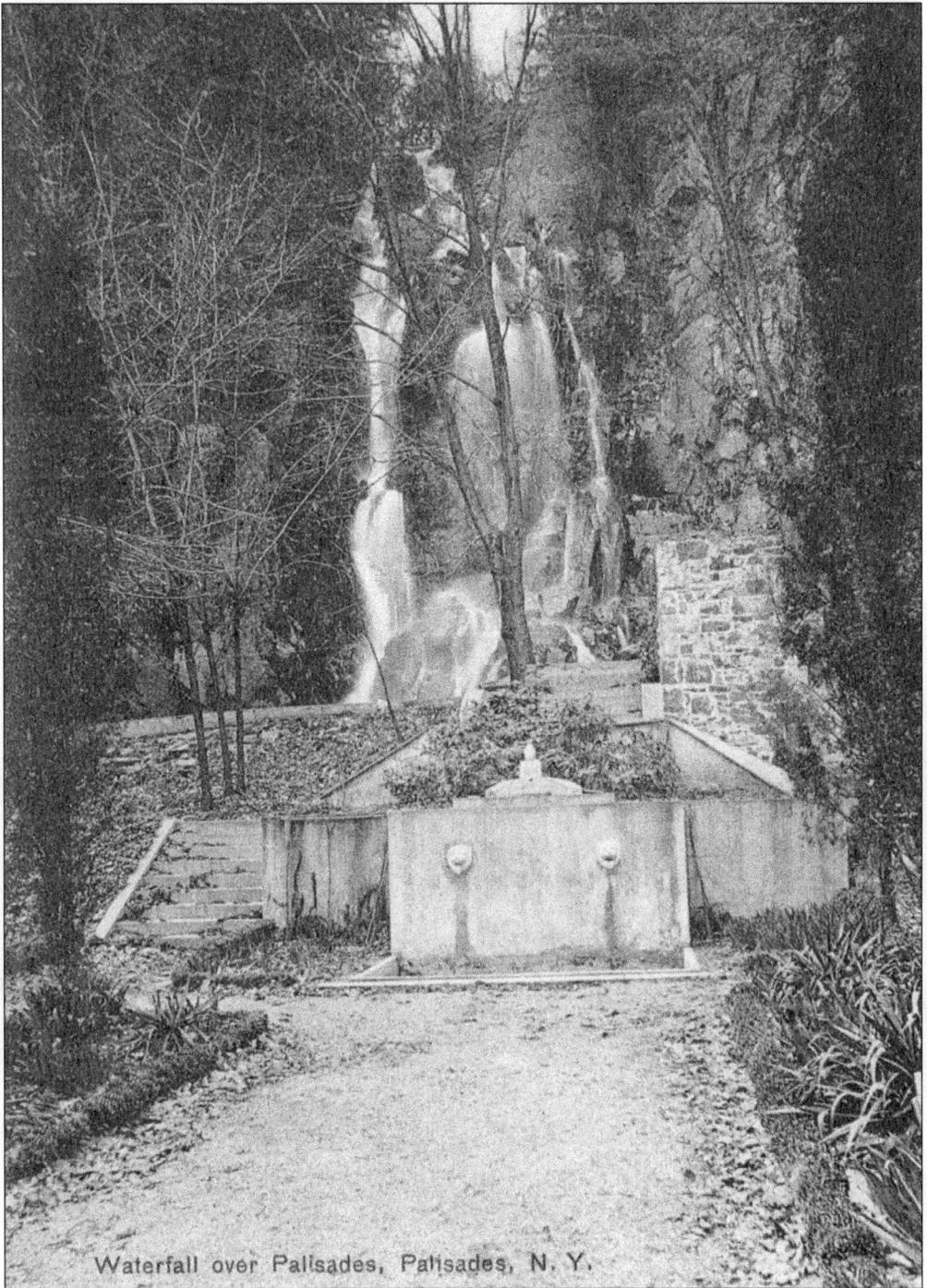

Waterfall over Palisades, Palisades, N. Y.

This waterfall is on property purchased by Lydia Lawrence, about 1884, to prevent the development of a proposed pier and picnic area. It was later enhanced by Mary Lawrence to prevent the possibility of a railroad coming through the neighborhood. Mary, who became Mrs. Tonetti, planted flowers and bushes, and with the help of friends, she designed a pergola. In later years, her pergola area was severely vandalized. (Courtesy Robert Knight.)

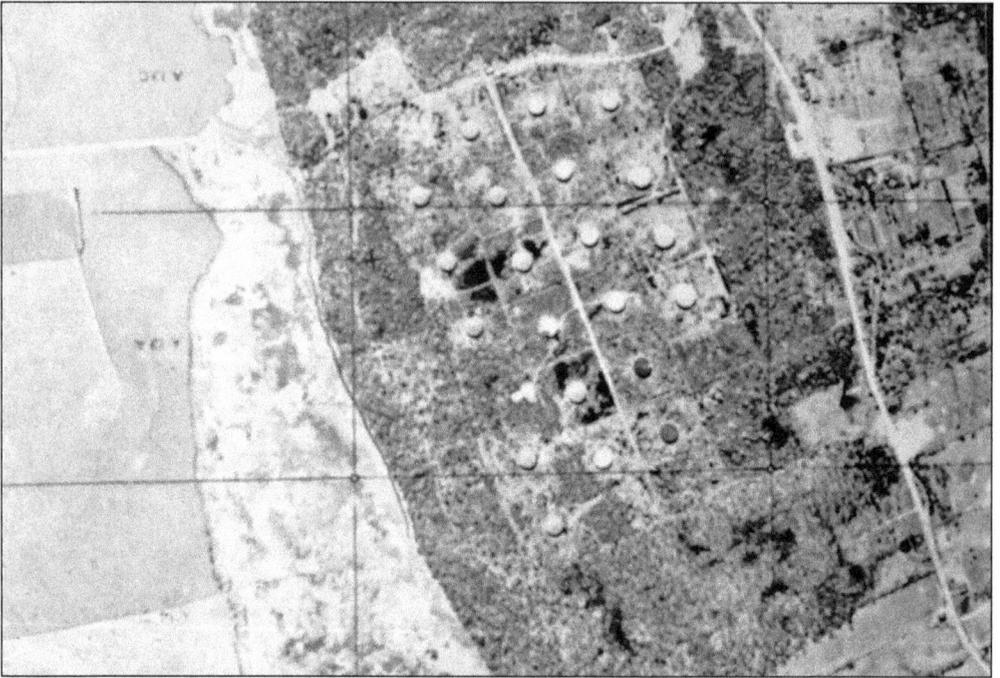

In the 1920s, Standard Oil Company built a tank farm on the cliffs between Route 9W and the Hudson. It was thought that oil brought in from barges could be stored there, then unloaded back onto the barges below the cliffs. It proved economically unfeasible and the tanks were removed in 1932. In winter, the craters left behind created ice skating rinks. The property is now part of Tallman Park. (Courtesy Nyack Library.)

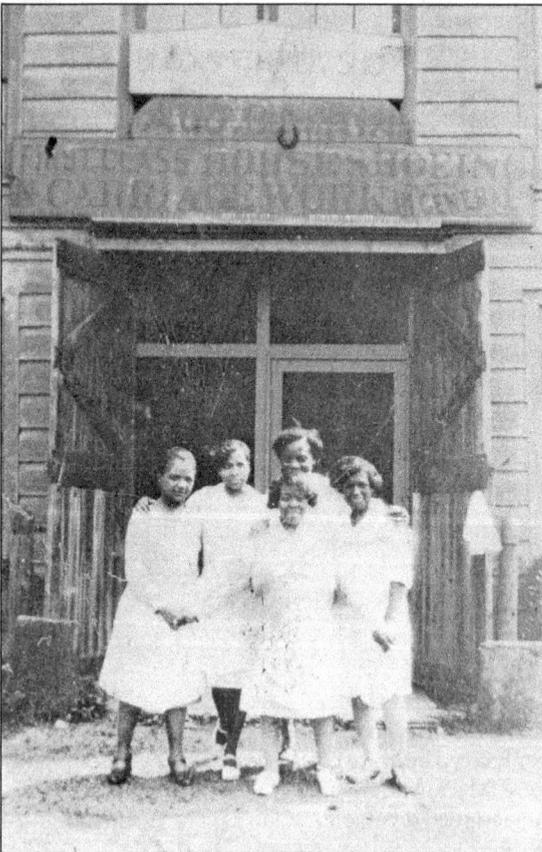

The former Waherberger's Blacksmith Shop was purchased by August Dumkin, another blacksmith. It was then sold in 1926 or 1927, with the lower floor rented as a tea room from 1928 to 1931. The wait staff here included Sadie Smith, Adele Dow Sisco, Frances Walker Pierson, Adelaide Spencer, and Lenora Sisco. Many notable personalities were served at the Blacksmith Tea Shop, including British Prime Minister Ramsay MacDonald, Helen Hayes, and Katherine Cornell. (Courtesy OHMA.)

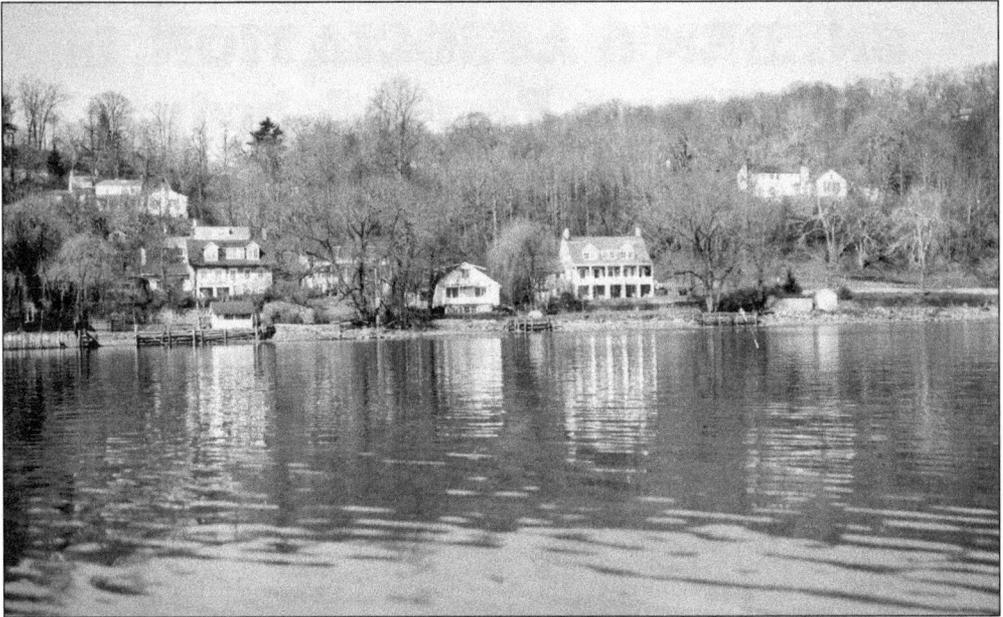

This photograph, taken in 1957 by Larry Sneden, provides a good view of the houses in Snedens Landing, including the Captain Larry Snedens House, the Bungalow (Conklin's boat building shed), and the William Sneden House near the shore. The narrow road winding up to Route 9W is known as Washington Spring Road, named after Washington's troops who were said to have drawn drinking water from a nearby spring. (Courtesy Alice Gerard.)

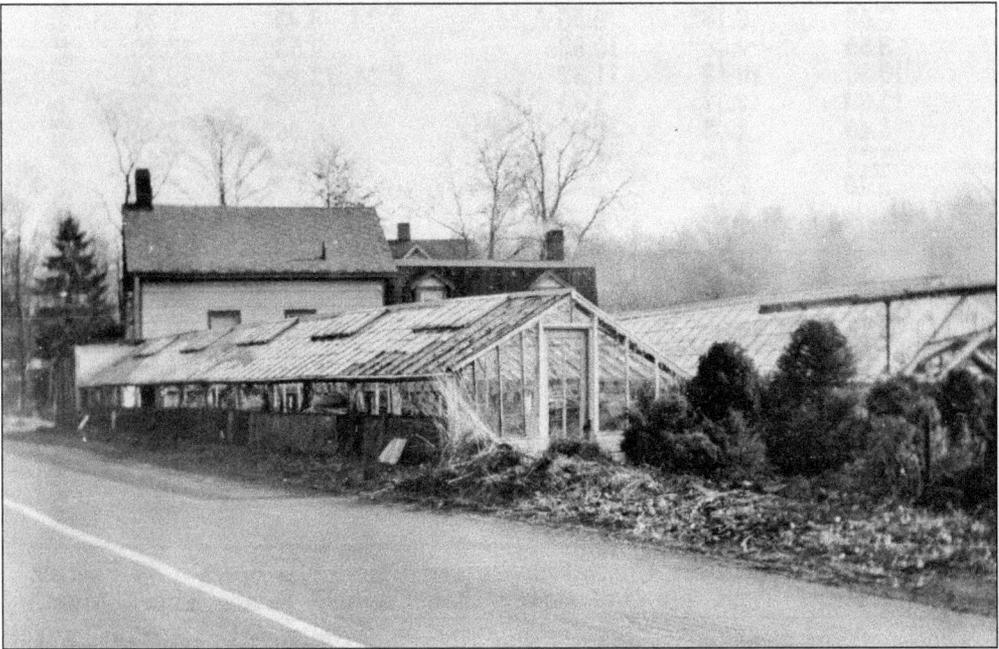

The Brown-Jordan Greenhouses were a large, successful wholesale plant and flower business that encompassed several acres on the south side of Oak Tree Road, across from the Palisades School. The greenhouses were closed in 1949, and the Jordan's residence was purchased by the Library Committee to enlarge the Palisades Library. (Courtesy Alice Gerard.)

SNEDEN'S ASSOCIATION, Inc.
Rail and Ferry Schedule
Effective May 2, 1932
DAYLIGHT SAVING TIME

MONDAY TO FRIDAY

To New York			From New York		
Leave Sneden's Landing	Leave Dobbs Ferry	Arrive Grand Central	Leave Grand Central	Arrive Dobbs Ferry	Leave Dobbs Ferry
7.50	8.13*	8.56 A.M.	A.M. 8.45	9.31	
8.55	9.18*	10.03	9.53	10.39	
10.20	10.43	11.32	P.M.		
		P. M.	3.55*	4.36	
3.50	4.14	5.02	5.05*	5.40	
5.10	5.29*	6.13	6.06*	6.43	
	or 5.40	6.27			
6.20	7.10	8.00			

SATURDAY

To New York			From New York		
Leave Sneden's Landing	Leave Dobbs Ferry	Arrive Grand Central	Leave Grand Central	Arrive Dobbs Ferry	Leave Dobbs Ferry
7.50	8.13*	8.56 A.M.	A.M. 8.45	9 31	
8.55	9.18*	10.02	9.53	10.39	
10.20	10.43	11.32	P.M. 12.19*	12.56	
12.30	12.57	1.48 P.M.	1.28*	2.07	
1.40	2.05	2.53	3.06*	3.45	
3.15	3.38	4.36	5.05*	5.44	
5.10	5.29*	6.13			
	or 5.40	6.27			

SUNDAY

To New York			From New York		
Leave Sneden's Landing	Leave Dobbs Ferry	Arrive Grand Central	Leave Grand Central	Arrive Dobbs Ferry	Leave Dobbs Ferry
9.15	10.03	10.50 A.M.	A.M. 8.45	9 31	
11.00	11.47	12.34	10.40	11.25	
12.30	12.57	1.49 P.M.	P.M. 12.17	1.02	
5.00	5.29*	6.13	4.36	5.21	
	or 5.40	6.25	5.38	6.21	
6.00	6.25*	7.05			

*Express.

Boat leaves immediately after arrival of train.

N.B.—New York Central clocks and time-tables operate on Eastern Standard Time, one hour slower than Daylight Saving Time. [OVER]

Commuting from Palisades and Snedens Landing to New York City and back every day was made more efficient by coordinated schedules like these. The schedule was issued to enable passengers from the Rockland shore to connect with the New York Central Railroad in Westchester. Travelers could leave Snedens Landing by ferry at 7:50 a.m., and board the train in Dobbs Ferry to arrive at Grand Central by 8:56 a.m. (Courtesy Alice Gerard.)

Three

PIERMONT

Piermont was known first as Tappan Landing, a sparsely populated place where a navigable tidal creek called the Sparkill linked the Hudson to Orangetown's interior. Its forested land, hills, and shoreline were included in the Van Purmerent Patent of 1671 and the Tappan Patent of 1686.

After the American Revolution, the area became more prosperous, and in 1824, a 500-foot pier was built by Judge Cornelius Blauvelt to accommodate steamboats. Tappan Landing was chosen in 1832 as the southern terminus of the Erie Railroad which, when completed, would link the landing to Lake Erie. Eleazar Lord, the railroad's first president and a leading property owner, built a new 4,000-foot, railroad-ready pier in 1838, and renamed the town Piermont. Less than three years after this lucrative rail service began in 1851, the railroad decided to relocate the terminus to Jersey City. By the 1860s, this transfer point to and from New York was all but closed.

The village of Piermont was incorporated in 1850. And in the years that followed, its relaxed and accessible river setting began attracting notice. In the 1870s, the Nyack and Northern, a passenger rail line connected Piermont to New York City and sparked a profitable tourist business. In the late 19th century and into the 20th, the Fort Comfort Inn and Fort Comfort Resort greeted thousands of visitors with accommodations, dining and family activities, and attractions like the Mine Hole, a historic mine of mysterious origins and legend.

During World War II, Piermont was the point of embarkation for Europe-bound troops from Camp Shanks. But for most of the 20th century, it was a paper factory town. In 1902, the Piermont Paper Factory began, then merged with the Robert Gair Company in 1920 to become a leading maker of paperboard containers, and the largest employer here since the Erie Railroad. After 1956, Gair merged and was sold to other companies and closed for good in 1984.

Today, the emblematic pier that has continually defined the life, history, and fortunes of Piermont is today a favorite place for walkers, fishermen, and visitors from Orangetown and the entire region.

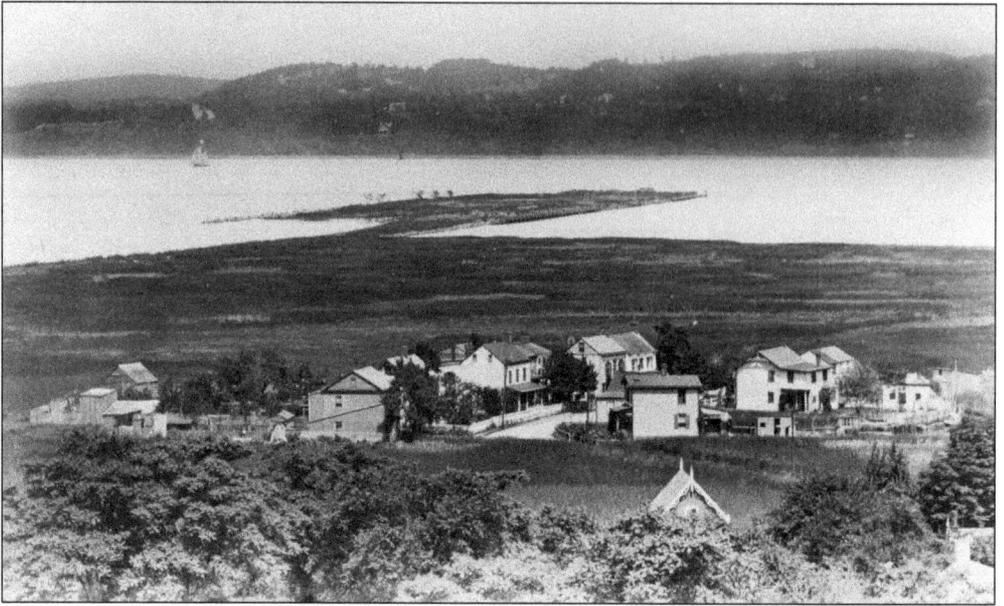

Down along the marshes, the small community of Bogertown, c. 1900, was established in the early 1800s and named for the Bogerts, one of the earliest Dutch families that settled here. For a time, Bogertown was separated from Paradise Avenue by the Bogertown Bridge and a gated fence that closed off the road. Paradise Avenue was extended here in 1824 to reach the 500-foot pier built by Judge Cornelius I. Blauvelt. (Courtesy Nyack Library.)

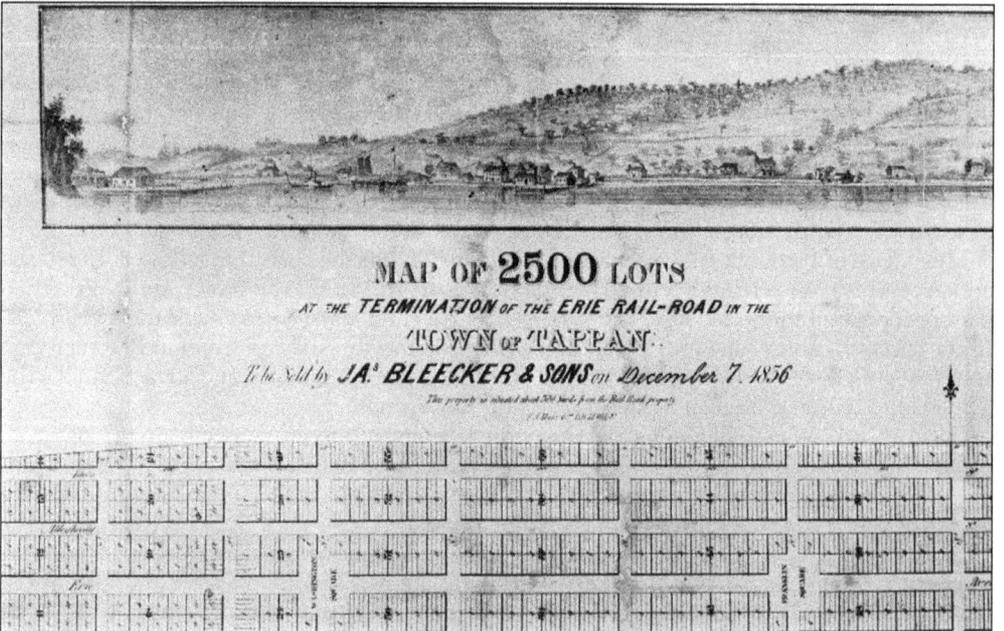

MAP OF **2500** LOTS

AT THE *TERMINATION* OF THE *ERIE RAIL-ROAD* IN THE

TOWN OF TAPPAN

As the Erie Railroad was being built, this 1839 map proposed sale of 2,500 lots after the rail line would be finished. At the time, Erie's eastern terminus in Piermont was destined to become a major business and transportation center. But three years after the line to Lake Erie was completed in 1851, the railroad decided to move the terminus to Jersey City, and none of this development was realized. (Courtesy Nyack Library.)

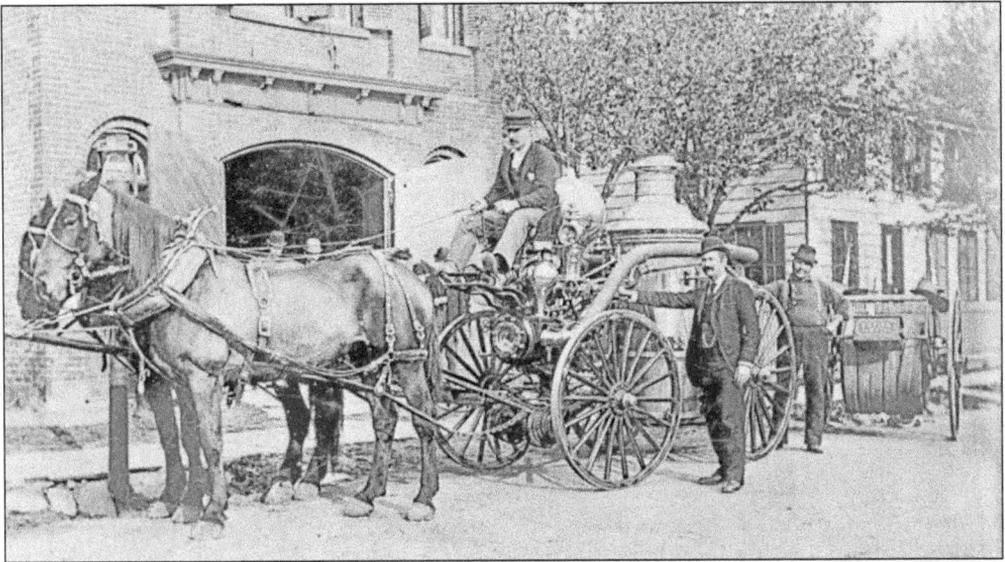

Empire Hose Company No. 1 was officially organized two years after Piermont was incorporated in 1850. As the village grew and expanded uphill, it became increasingly difficult to get water from the Hudson uphill to fight fires. Starting in 1854, reservoirs were built in strategic locations. To draw water from these reservoirs, Empire used equipment like this new two-horse pumper and hose cart, introduced into service in 1895. (Courtesy Nyack Library.)

Eleazar Lord—entrepreneur, three-time president of the Erie Railroad, and landowner—renamed the Tappan Landing Piermont after both the 4,000-foot pier he built in 1838 and the mountainous terrain that overlooked it. He constructed this stone villa in the mid-1800s and lived here until his death in 1871. It was sold and demolished in the early 1890s, and a larger stone castle was built in its place, and it remains there today. (Courtesy Charlene Stern.)

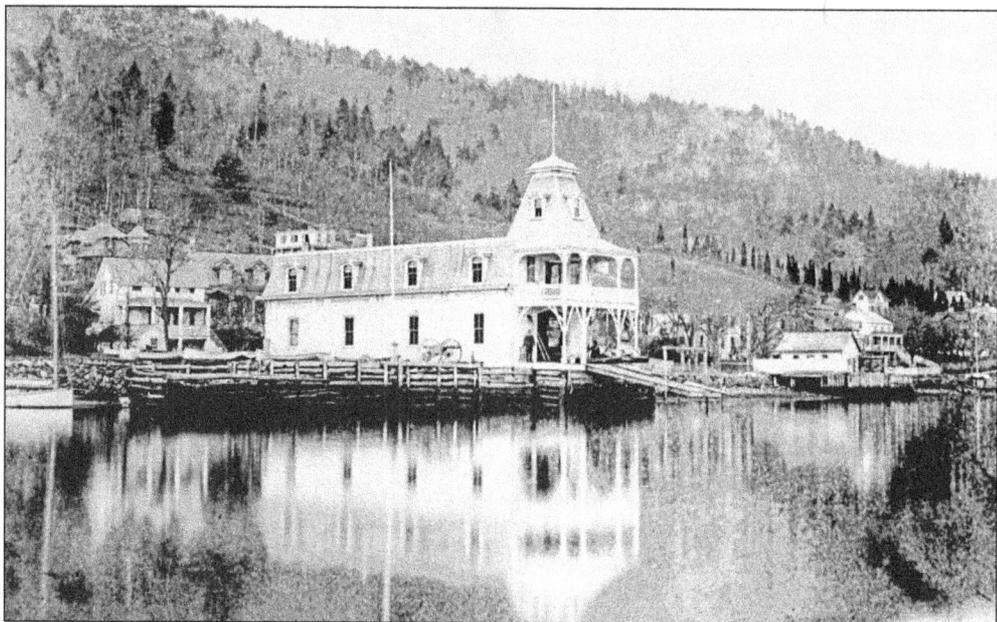

In the late 1800s, competitive rowing became a popular sport in America and in Piermont. The Piermont Rowing Association was organized in 1878. Its elegant, two-story boathouse, pictured c. 1890, was built in 1880 and used for training, storing boats, and social functions. By the 1920s, the popularity of rowing had faded, and the boathouse was transferred to the Knights of Columbus. In 1999, a new recreational Piermont Rowing Club was formed. (Courtesy the Brawners.)

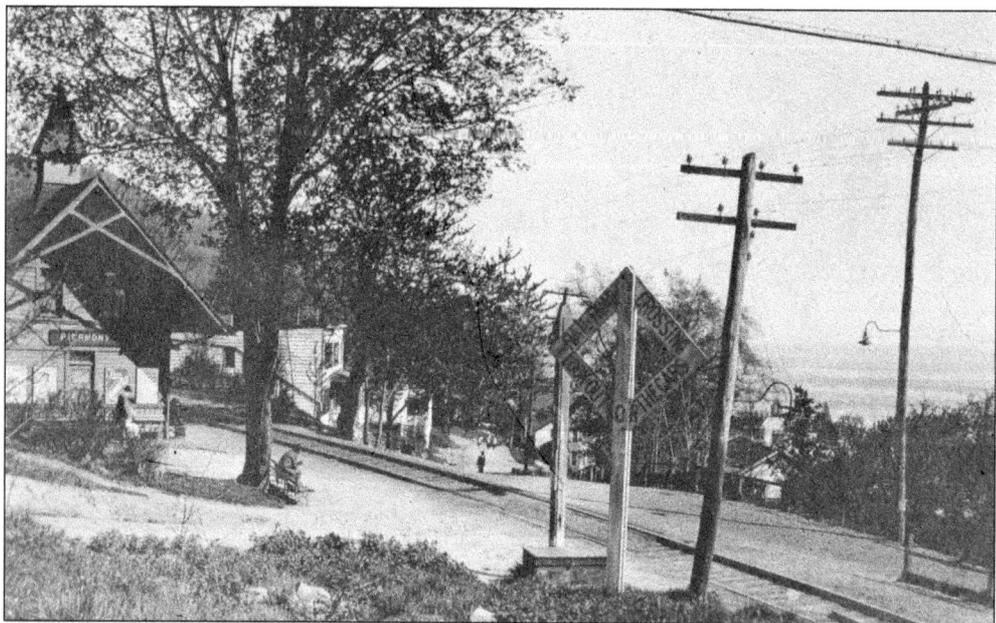

Built in 1873 by the Nyack and Northern Railroad, the scenic Ash Street station had a waiting room, telegraph operator's desk, and stationmaster's office. After passenger service ended in the 1960s, title to the station was given to Belle Kelly who was stationmaster, ticket agent, and telegrapher for more than 50 years. Piermont took ownership in 2004, and in 2008, it was placed in the National Register of Historic Places. (Courtesy Nyack Library.)

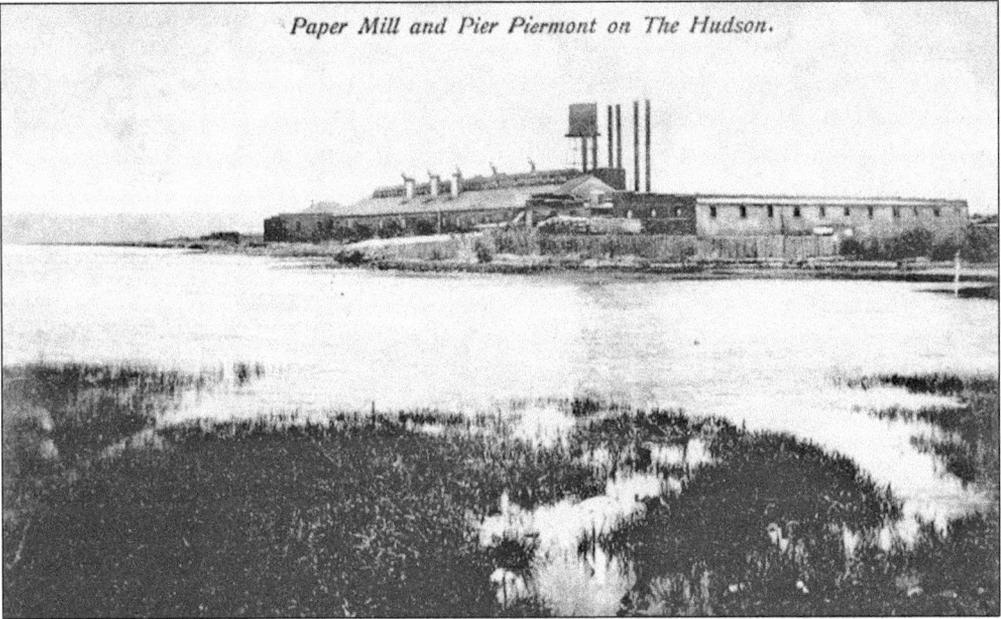

Paper Mill and Pier Piermont on The Hudson.

Piermont's trademark industry in the 20th century was paper. In 1902, on the same property where the Erie Railroad's repair yards, buildings and other facilities stood, the Piermont Paper Factory established a sprawling complex of brick-factory buildings at the foot of the pier to manufacture commercial-grade paper. Today, a large flywheel, part of the original machinery that generated power for the factory, is the centerpiece of Flywheel Park. (Courtesy Phil DeLorenzo.)

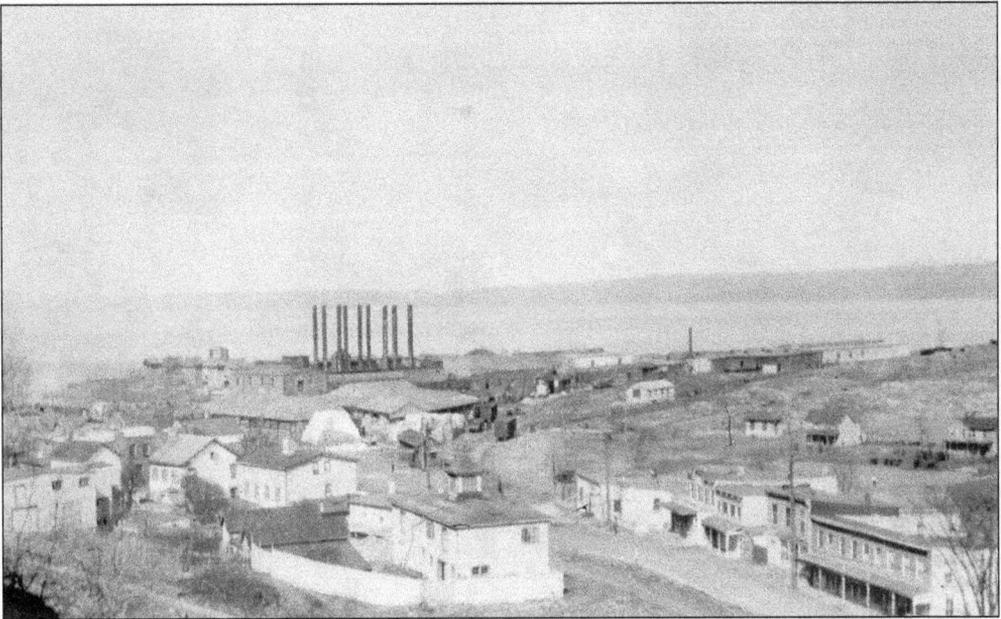

In 1920, Piermont Paper merged with the Robert Gair Company of Brooklyn to become a leading maker of folded paperboard containers for detergent, breakfast cereal, eggs, and other products. Gair became the largest employer since the days of the Erie Railroad. Between 1956 and 1984, the factory changed hands three times, and closed permanently in 1984. It was sold in the 1990s for development as a business and condominium complex. (Courtesy the Brawners.)

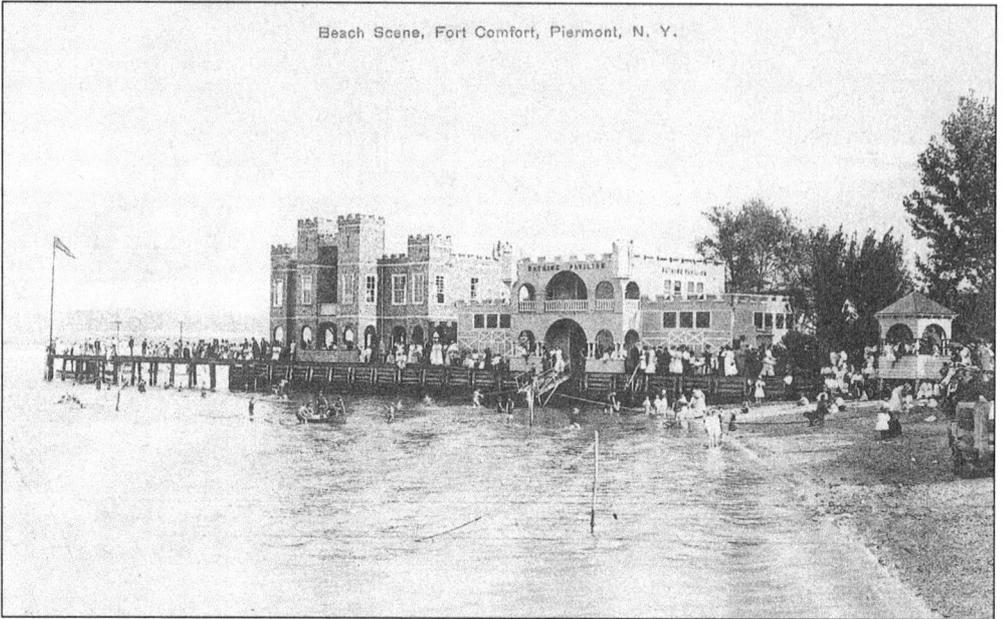

Beach Scene, Fort Comfort, Piermont, N. Y.

Fort Comfort Beach was a popular day-trip and vacation destination for people from New York and the region. The clean sand and clear, shallow water made it an ideal place for families with young children. The bath house and bathing pavilion were illuminated by electric lights for swimming past sunset, and booths were available for changing and showering. Swimming suits could be rented for a modest fee. (Courtesy Robert Knight.)

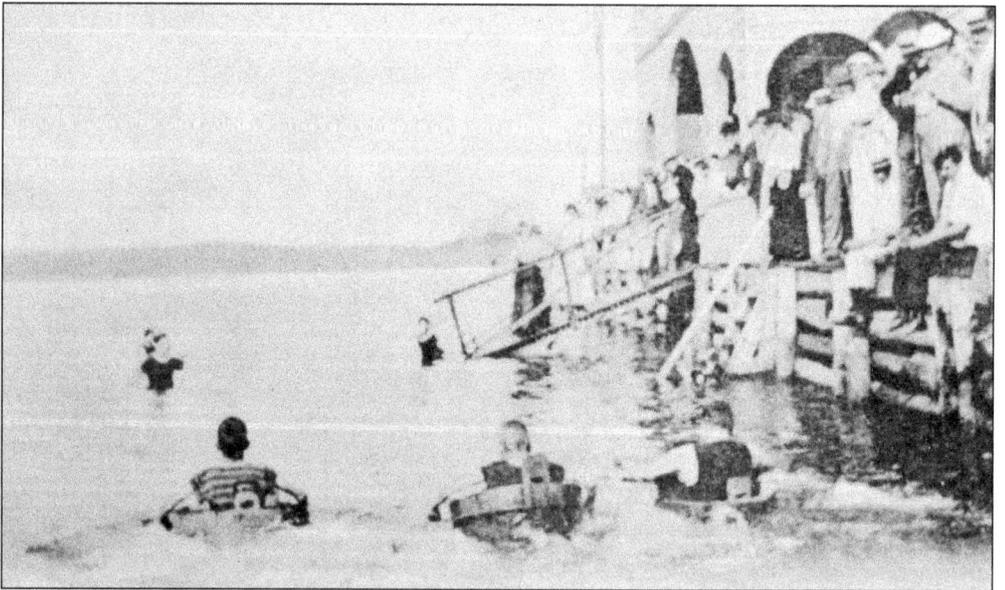

The accessibility of the railroad and ships from New York to Piermont helped build a profitable tourist business in the early 20th century. Fort Comfort Inn and Fort Comfort Park provided thousands of visitors year-round with accommodations, dining, and family entertainment. The park included a merry-go-round, bowling alley, dance hall, boating, and popular summer activities along the bathhouse and bathing pavilion like tub racing, pictured c. 1908. (Courtesy Phil DeLorenzo.)

40

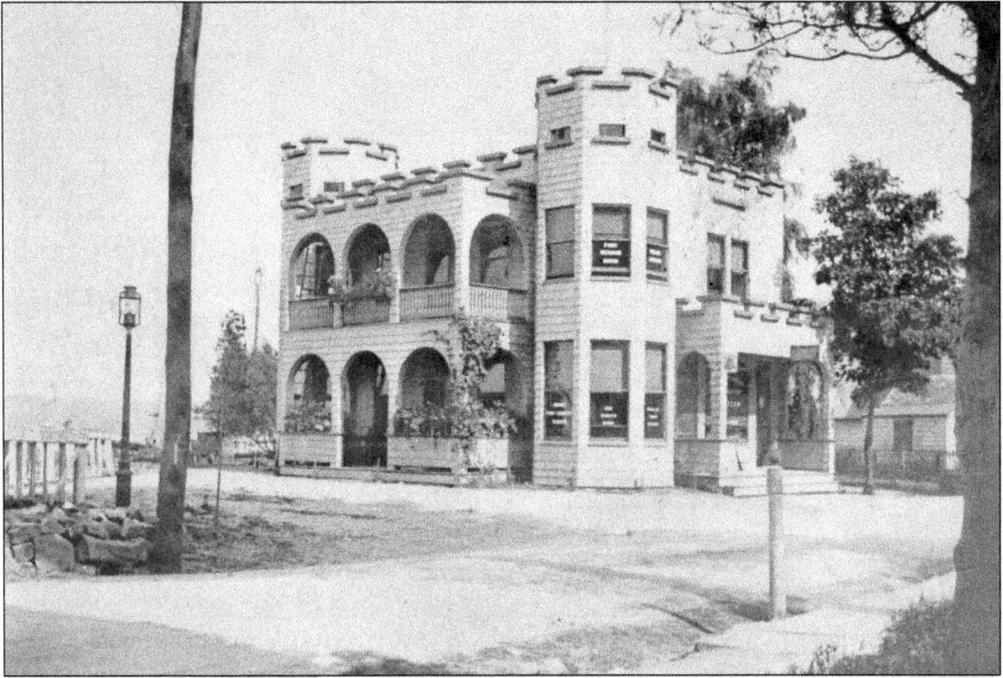

The Ice Cream Parlor, pictured around 1910, sold cigars, soft drinks, and candy, and was a prominent fixture of Fort Comfort. In 1912, a fire destroyed Fort Comfort Inn and a smaller inn was built along Piermont Avenue, and guests entered and exited through stone battlements and gateposts that remain there today. Today, the area where the Ice Cream Parlor stood is occupied by the Tappan Zee Marina. (Courtesy the Brawners.)

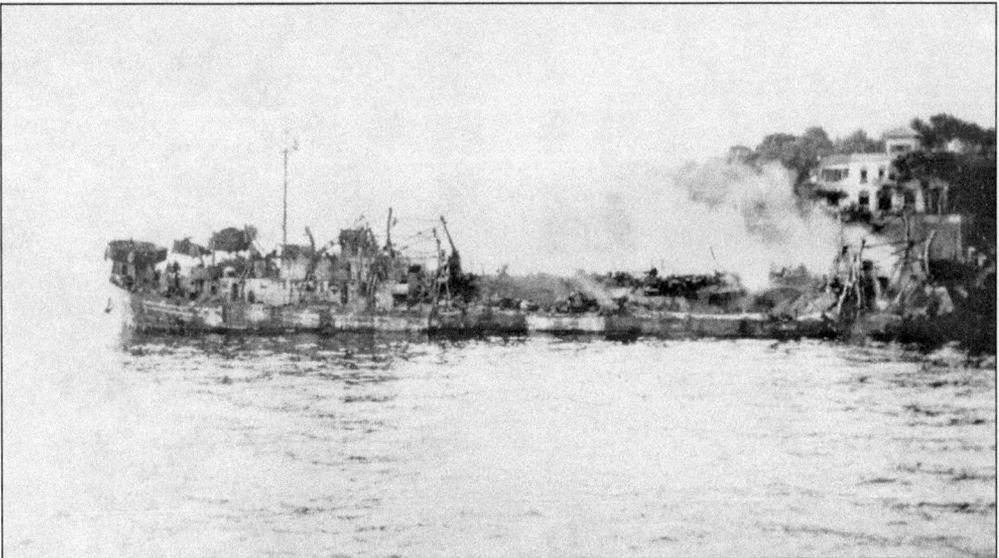

Like most of the buildings that comprised Fort Comfort, the bath house, bathing pavilion, and docks were made up almost entirely of wood. In 1920, these structures were destroyed by a devastating fire that reduced these popular attractions to smoldering ruins. Later, a restaurant called the Fort Comfort Inn operated near what was Fort Comfort Park until 1975 when it, too, was destroyed by fire. (Courtesy Nyack Library.)

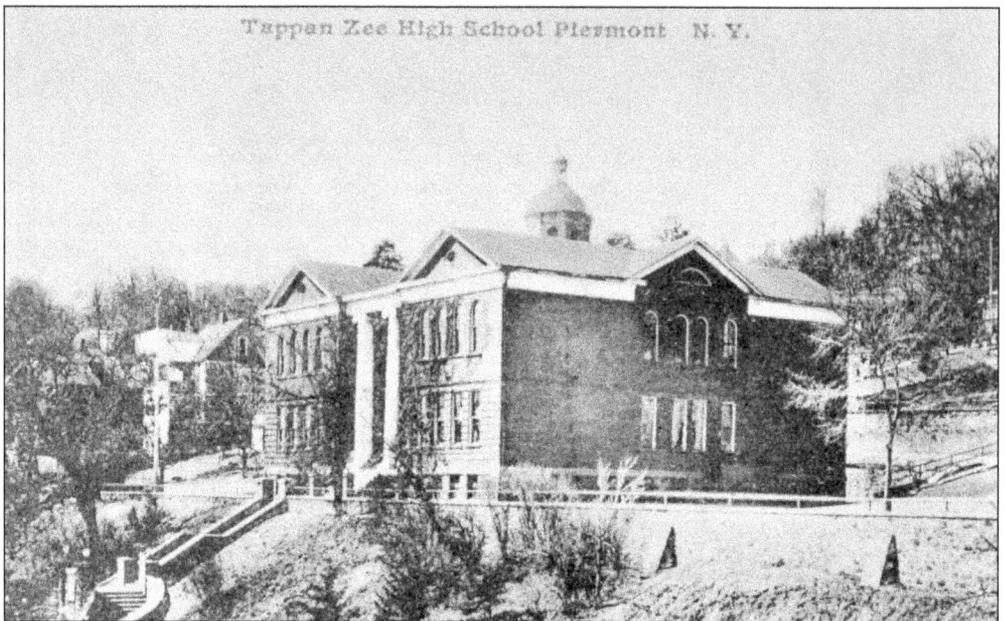

The classic-columned Tappan Zee High School with its long, graceful staircase to Piermont Avenue was built on Hudson Terrace in 1900. Used for both grade school and high school, grades four through eight were on the ground floor and grades nine through 12 were on the second. The last commencement was held in 1960 when the new Tappan Zee High School opened in Orangeburg. The building was torn down in 1971. (Courtesy the Brawners.)

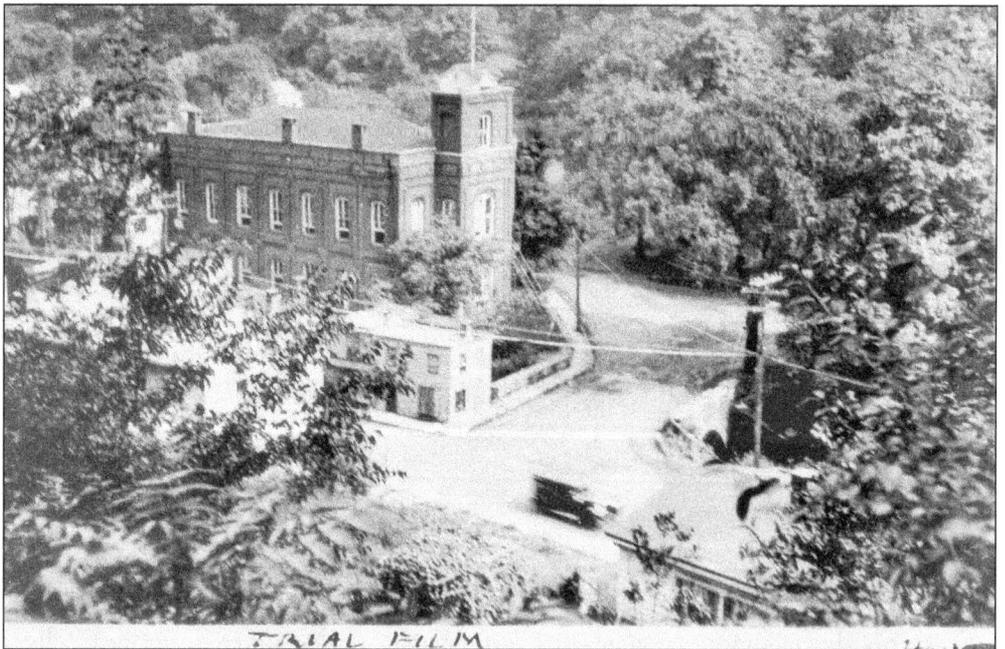

The Silk Mill, pictured in 1928, was built in 1876 as Haddock Hall and used as village hall, a library, and general store. During the 1900s, it served as a Venetian palace in a 1914 silent movie, a yacht motor and clothing factory, and a mill for making textiles, parachute ripcords, and ribbons. It is listed in the National Register of Historic Places and is today a private residence. (Courtesy HSRC.)

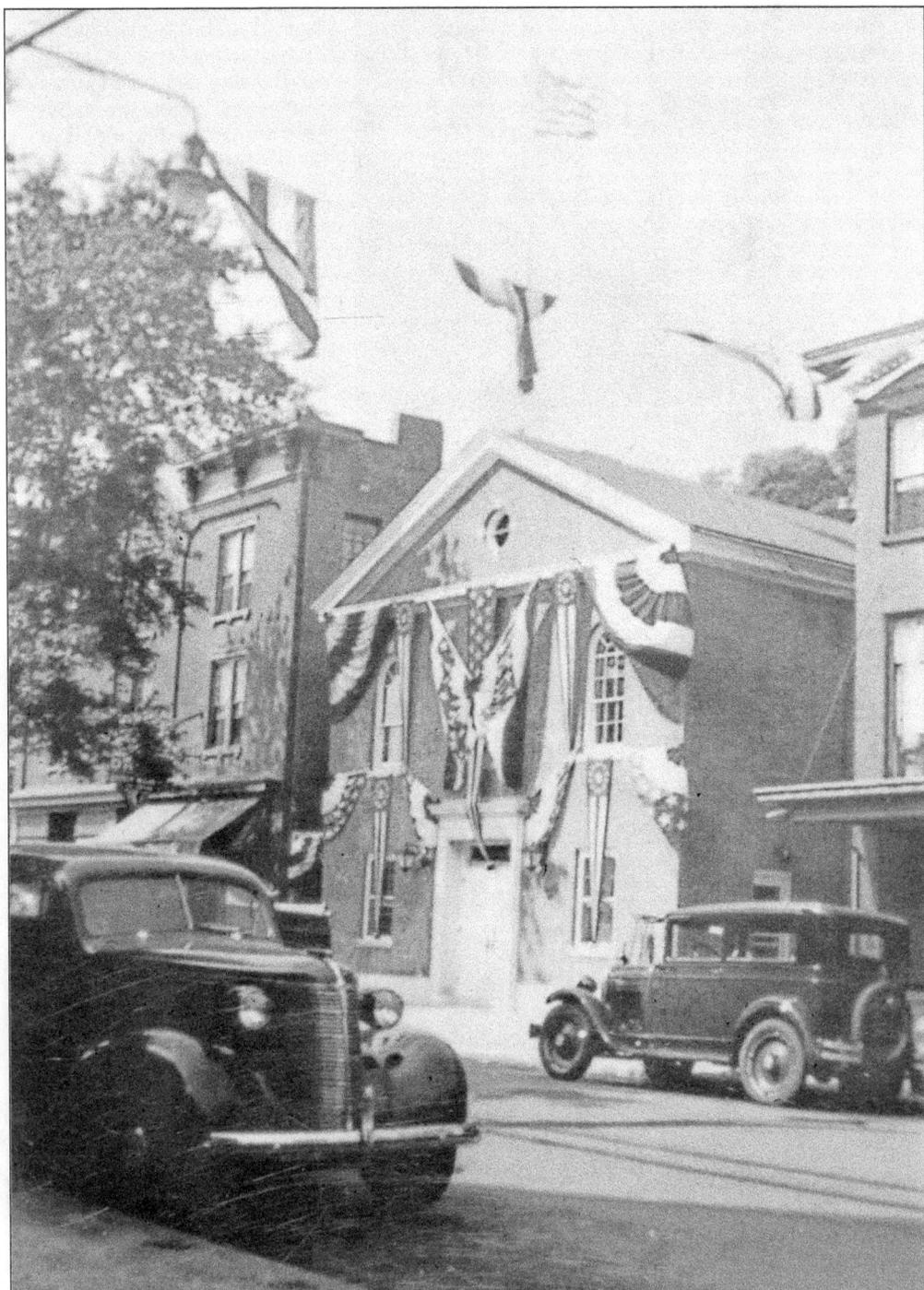

Piermont Village Hall sits on the site of the former Baptist Church built in 1819. The church disbanded in 1900. Both church and property were sold for $500, and the church was torn down in 1937. The hall was built in 1938 under the Depression-era Works Progress Administration. During construction, workers uncovered the cornerstone of the original Baptist Church and set it into the wall of the village hall entrance. (Courtesy the Brawners.)

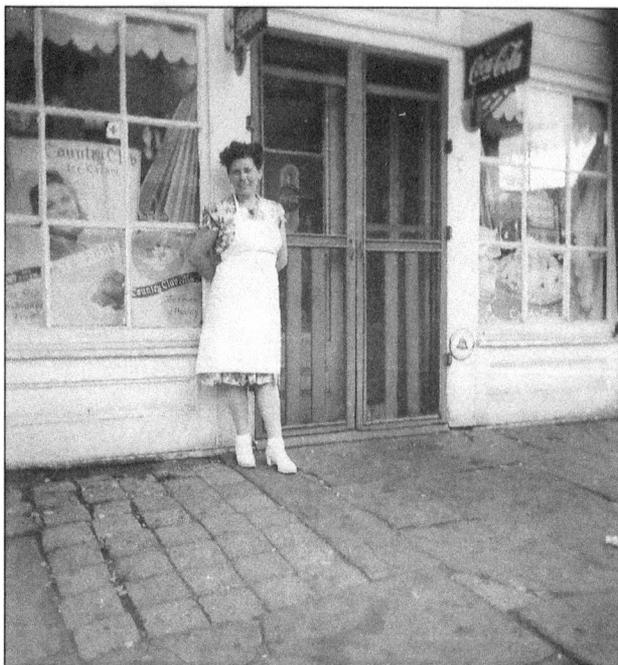

From 1930 to the mid-1950s, Anna, pictured in 1935, and John Yokel owned this neighborhood confectionary store on Main Street. Yokel's was a popular spot for anything and everything from candy bars to cupcakes and sandwiches to cigars. There was also a soda fountain where customers could relax and enjoy an ice cream cone or a Coke or other beverages, including sodas made by Cascadian Bottle Works in Grand View. (Courtesy Ellen Cherecwich.)

Mine Hole is both the name of a mine and a neighborhood along the north side of the Sparkill. Even today, the origins of the mine remain a mystery and until 1943 it was a source of spring water. Since long before the American Revolution, the neighborhood's houses and businesses were home to African Americans. The Mine Hole district, pictured in spring 1939, shows a few of the buildings on the creek and its outdoor plumbing. (Courtesy HSRC.)

Near the intersection of Ferdon and Piermont Avenues, Henry Ludlow operated a gristmill along the Sparkill in the early 18th century. A dam was built to provide waterpower for the mill wheels, and the pond that the dam created exists to this day. The intersection, pictured in 1940 shows several buildings constructed in the 19th century that still remain. The building on the right is Canzona's Market. (Courtesy Nyack Library.)

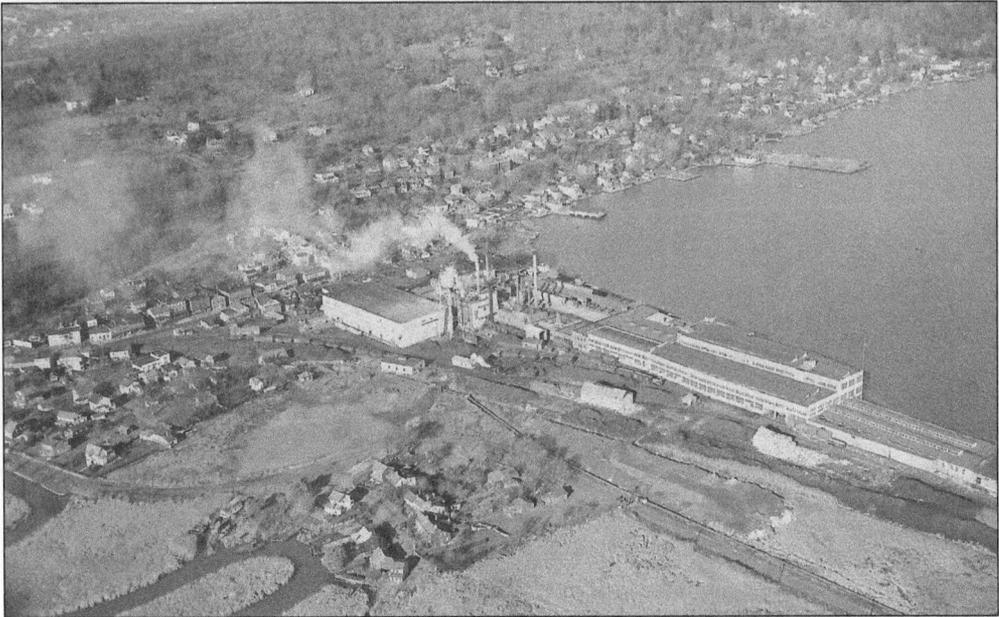

This aerial view of the Robert Gair Paper Factory, taken c. 1940s, clearly shows the breadth of Gair's major importance to the people and economy of Piermont. In addition to the piers and railroad tracks that continually brought materials in and paperboard products out, the small, historic area of Bogertown can be seen, along with the ages-old marshes nearby. (Courtesy Geraldine Leote.)

45

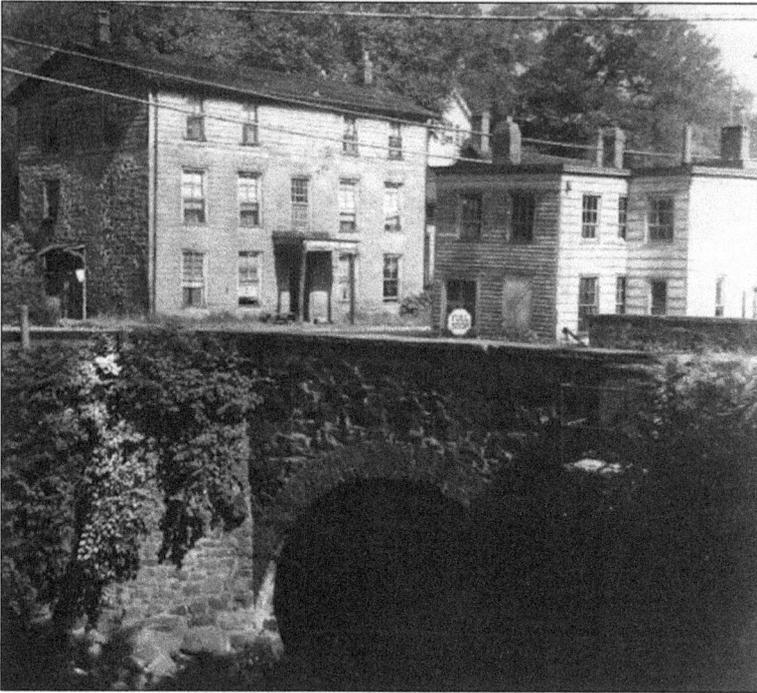

This distinctive stone-arch bridge near the Mine Hole district and mine spanned the Sparkill to connect South Piermont and Ferdon Avenues. Pictured in the 1930s, it was built in 1874. Its design, construction, longevity, and historic value to the neighborhood and Piermont were recognized in 2005 when it was placed in the National Register of Historic Places. (Courtesy Nyack Library.)

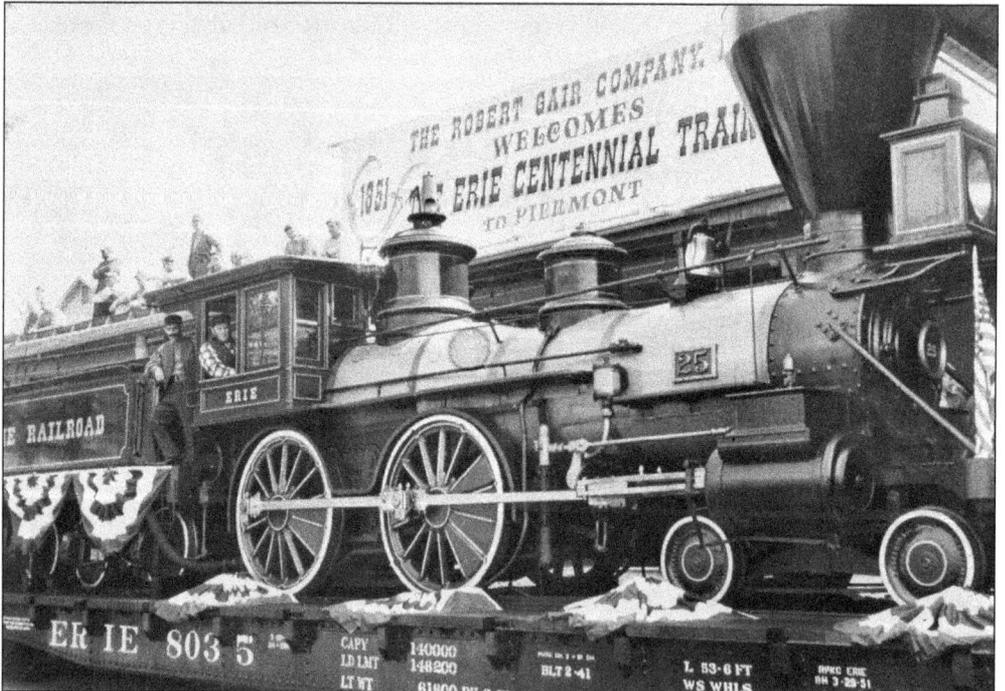

On May 14–15, 1951, Piermont celebrated the centennial of the Erie Railroad with a reenactment of the train's inaugural run from Piermont to Dunkirk. A replica of the original engine and passenger coaches were carried on flatcars and pulled by two diesel engines. Reenactors represented the crew and Secretary of State Daniel Webster, who, in 1851, experienced the train's initial journey from a rocking chair fastened to a flatcar. (Courtesy the Brawners.)

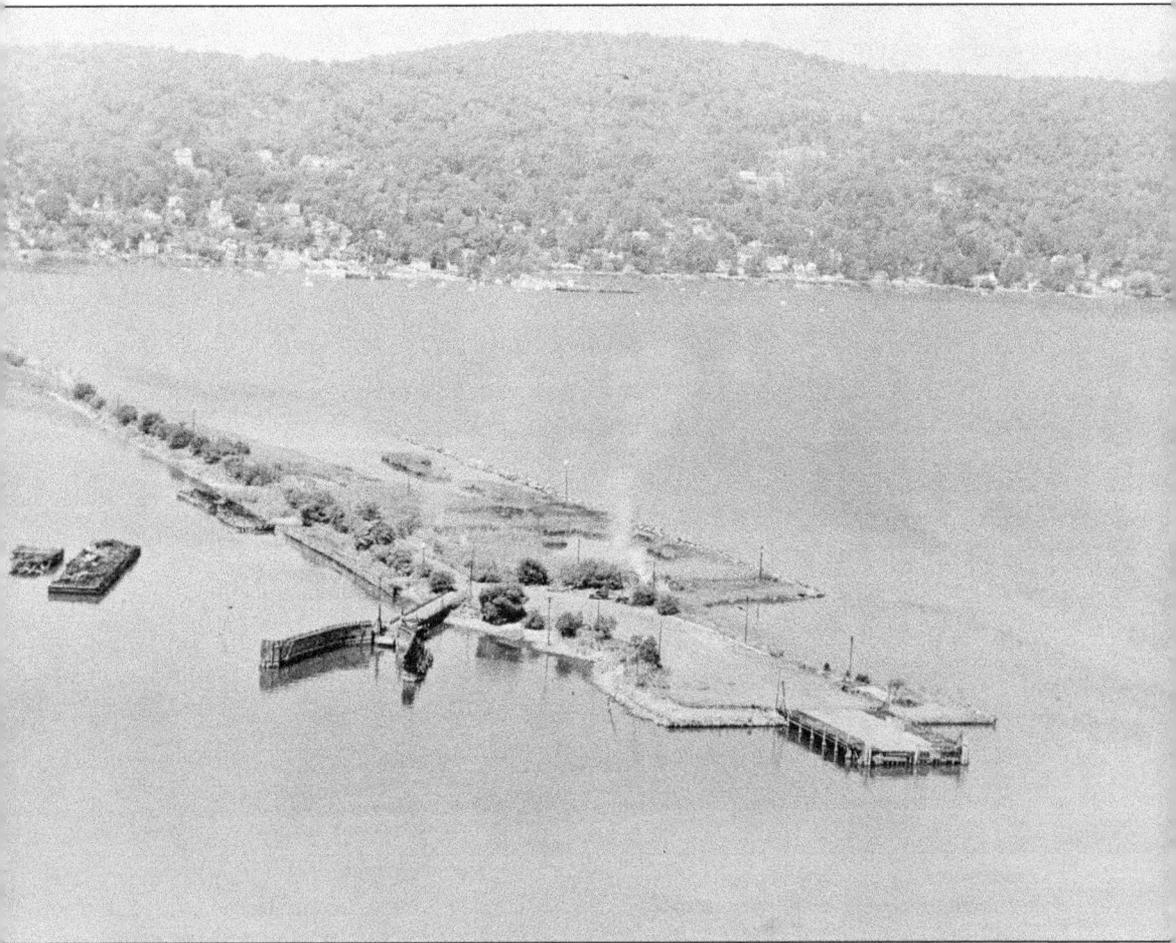

After World War II and the closing of nearby Camp Shanks, Piermont Pier was no longer the always-busy structure it had been in the past. Extending nearly a mile into the Hudson, the pier, shown c. 1952, still had the ferry slip and dock used by troops leaving for and returning from Europe. Today, the pier is a favorite recreational spot for everyone from walkers and joggers to fishermen and sightseers. (Courtesy Nyack Library.)

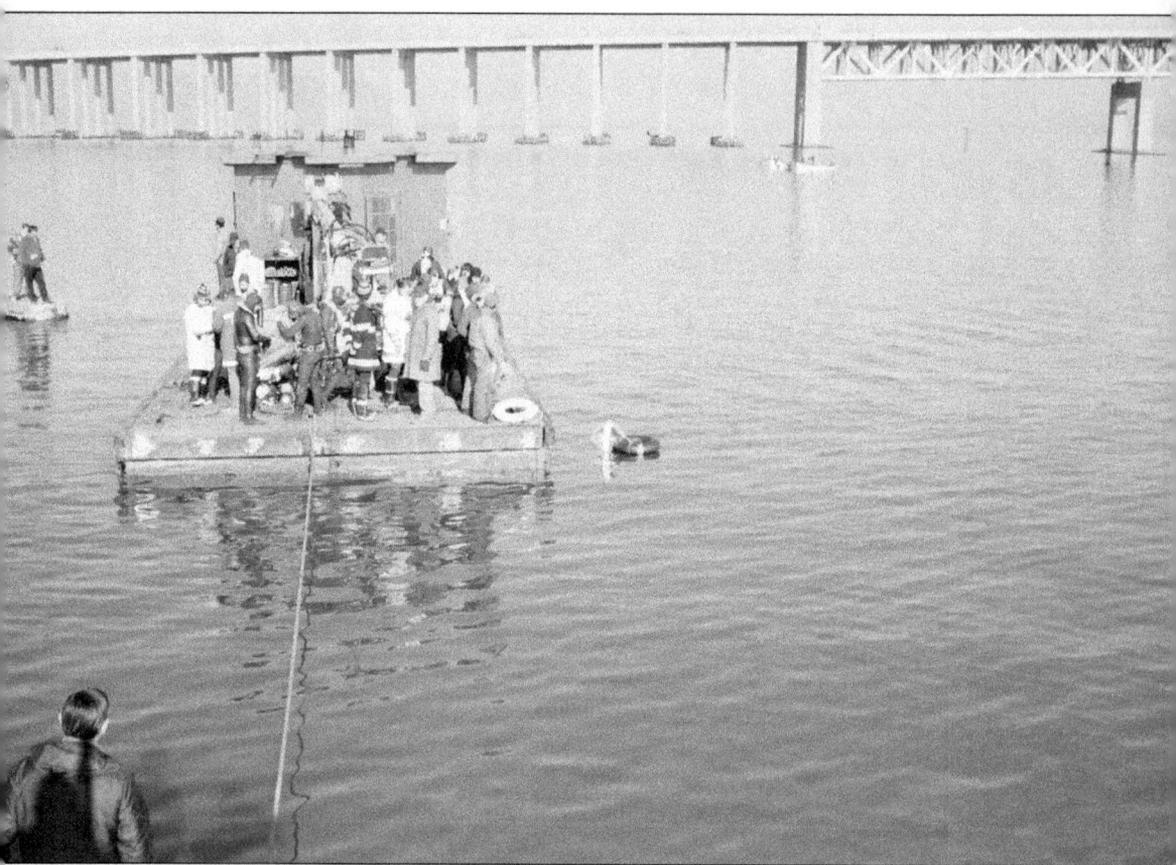

A year after the opening of the Tappan Zee Bridge in 1955, New York's first volunteer underwater rescue and recovery team was formed by the Piermont Fire Department. Trained to respond to swimming, boating, and other river emergencies, the team, pictured in the mid-1970s, prepares to recover wreckage and remains from a mid-air collision of two light planes over the Hudson. Other departments have since formed river rescue teams. (Courtesy Phil DeLorenzo.)

Four

SPARKILL

Named in 1870 for the tidal creek that played a vital role in the early settlement and success of Orangetown, the Hamlet of Sparkill was known first as Blanch's Crossing, then Tappan Slote, and Upper Piermont. It was part of lands included in the Van Purmerant and Tappan Patents of the late 1600s.

It was here at the head of the Sparkill that shallow-draft sloops passed through in the late 17th, 18th, and early 19th centuries carrying people and freight from the Hudson into Orangetown's interior and back out again with people and produce for transport to New York. Aside from the disruptions created during the American Revolution, life before and after the war was peaceful.

Beginning in the 1820s and into the late 1800s, steamships and railroads changed life for everyone. Depot Square, the hamlet's business center, was a busy and important intersection for passengers and freight on the Erie Railroad that connected Piermont to western New York in the 1850s, and the Northern Railroad that linked Sparkill with Jersey City in 1859 and Nyack in 1870. Since the early 1900s, little has changed architecturally in the square, which also included one of the area's first A&P grocery stores, and Sparkill's first post office, established in 1872.

In 1847, Eleazar Lord, the influential landowner and three-time president of the Erie Railroad donated 200 acres of land that became Rockland Cemetery, which was destined at first to be America's national cemetery, but passed over for Arlington Cemetery in Virginia. In 1928 the landmark Route 9W viaduct was constructed over the Sparkill. Two historic churches, the Christ Episcopal Church, built in 1864, and the St. Charles AME Zion Church, established in 1865, remain active in Sparkill. Along what is now Route 340, St. Agnes Home, one of the largest Catholic orphanages in the New York area, opened in 1884, and the regionally renowned St. Thomas Aquinas College was established in 1954.

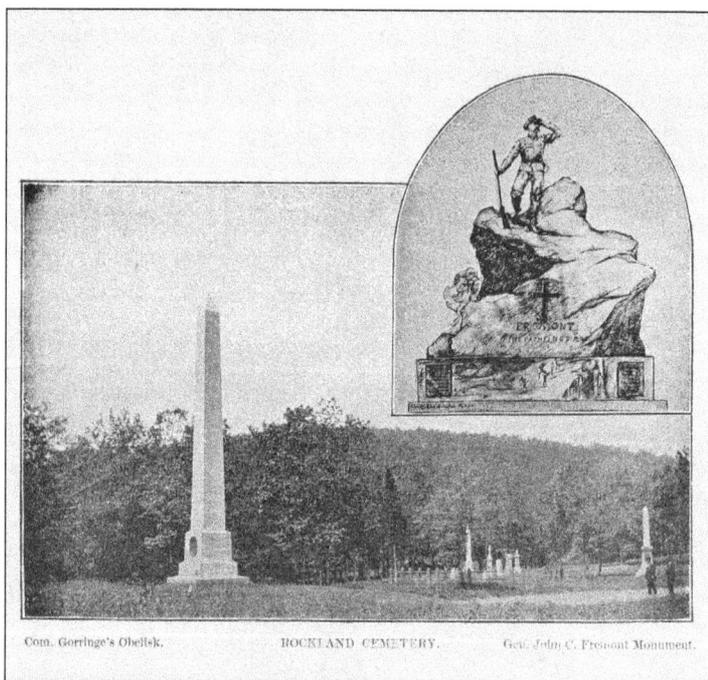

Com. Gorringe's Obelisk. ROCKLAND CEMETERY. Gov. John C. Fremont Monument.

Established in 1847 on property donated by Eleazar Lord, Rockland Cemetery was once considered for use as the National Cemetery. Lord and his wife and daughter; John C. Fremont, surveyor of America west of the Mississippi; and Martin R. Williams, founder of the Piermont Paper Company, are buried here. The obelisk monument is a tribute to Navy commander Henry Gorringe, known for removing Cleopatra's needle, located today in New York's Central Park. (Courtesy OHMA.)

This church was built in 1865 and rebuilt in 1897. The wife of congregant Charles K. Taylor donated money to complete the church, provided a house was built for her. When Charles Taylor died, the church became St. Charles A.M.E. (African Methodist Episcopal) Zion Church. Many families attending this church came from the tiny community of Skunk Hollow near exit 4 of the Palisades Interstate Parkway. This community ended about 1905. (Courtesy Nyack Library.)

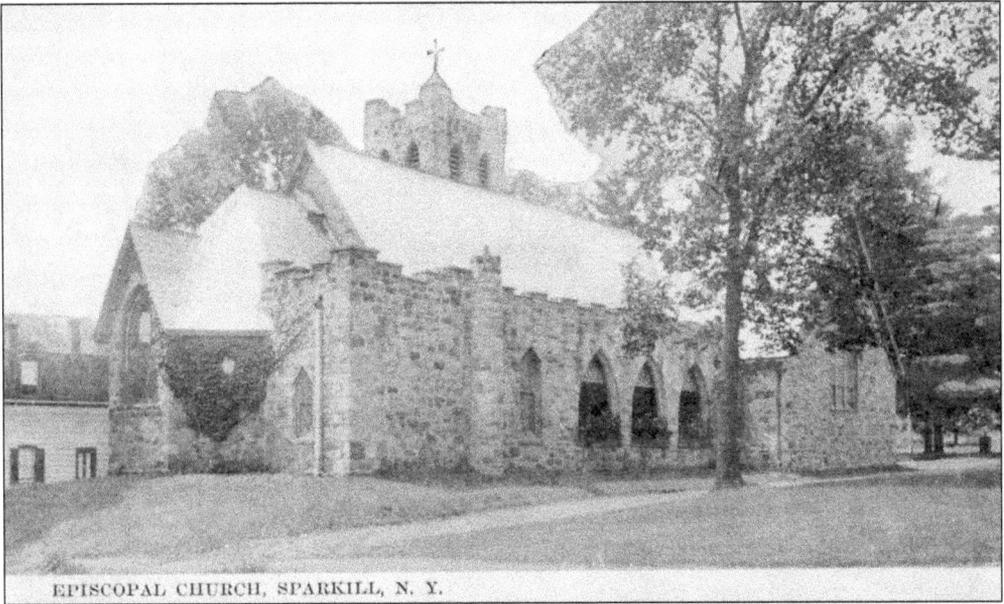

EPISCOPAL CHURCH, SPARKILL, N. Y.

Completed in 1864, Christ Church had several additions in the early 1900s. Designed by Charles Babcock, a founding member of the American Institute of Architects, its rose window was donated from the former Wayside Chapel in Grand View. Because of the border line separating Sparkill and Piermont, the altar is in Sparkill and the rest of the church is in Piermont. It is in the National Register of Historic Places. (Courtesy Robert Knight.)

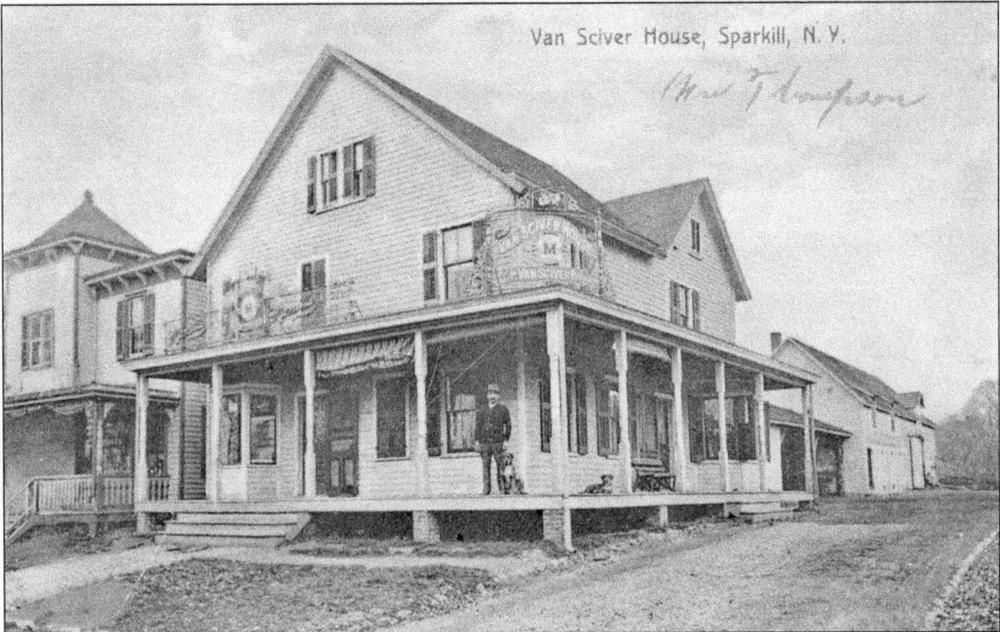

Van Sciver House, Sparkill, N. Y.

Located on Main Street, the Van Sciver House, pictured in 1908, was also a hotel called the Hudson House in 1883. The name was changed to the Sugar Loaf Hotel and Café and to the Park Hotel Café in 1903. Van Sciver was the next owner and ran the saloon until Prohibition. The name eventually changed to Bilbo's, then to the Depot. As of 2011, it is Woody's Parkside Grille. (Courtesy Robert Knight.)

The Dominican Congregation of Our Lady of the Rosary bought and remodeled a 19-room house here in 1884 and named it St. Agnes Home and School for destitute boys from New York City. By 1889, there were 11 buildings in all. After a fire on August 28, 1899, the home was rebuilt, but closed in 1977 and torn down two years later. Thorpe Village and Dowling Gardens are now on this site. (Courtesy OHMA.)

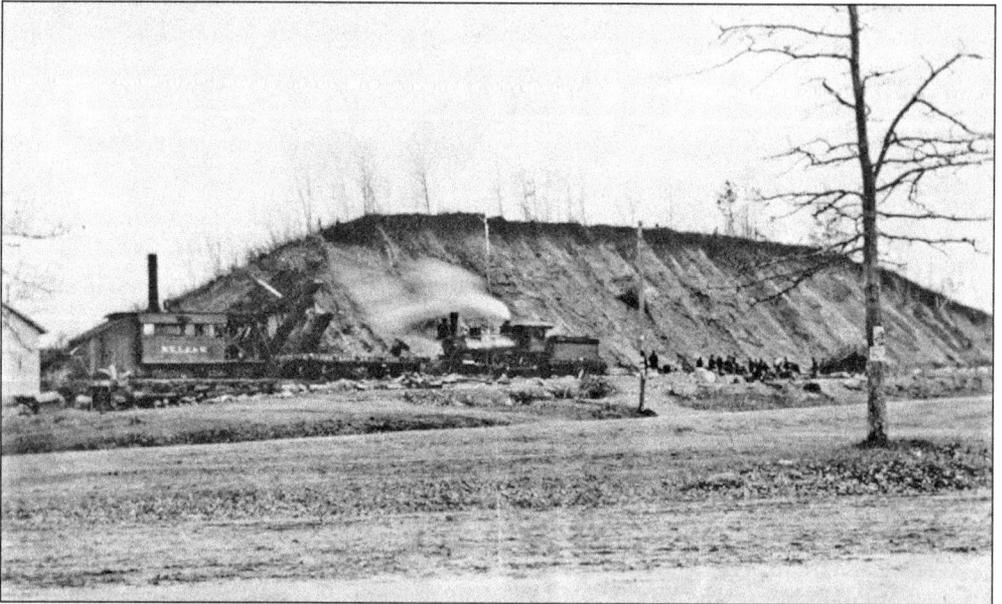

This 1887 photograph shows a steam shovel and a train digging and hauling dirt excavated from Sugar Loaf, a hill that was created from the glacial period. The dirt taken from this large hill was transported to Piermont, where it was used to build today's Piermont Pier. Eventually, this entire hill was leveled off. (Courtesy Nyack Library.)

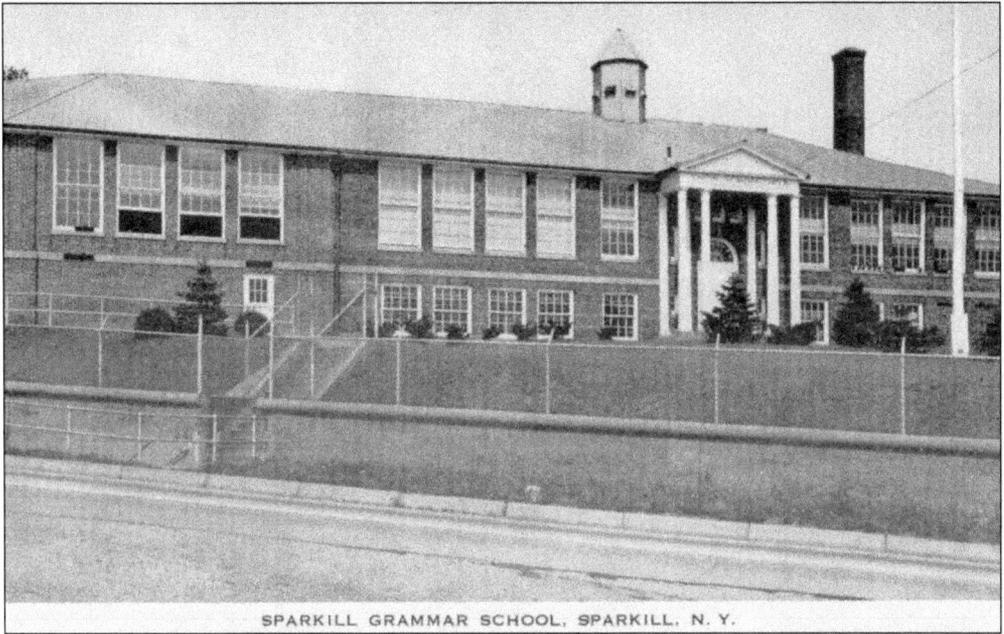

SPARKILL GRAMMAR SCHOOL, SPARKILL, N. Y.

The Sparkill Grammar School was built in the 1900s for grades one to eight. The top of a staircase leading to the school can be seen on the left-hand side of the photograph. Students living west of 9W crossed under this busy road through a tunnel to avoid traffic. The school was demolished in the early 1970s to make way for the Diplomat Gardens housing development now called the Overlook. (Courtesy Marilyn Schauder.)

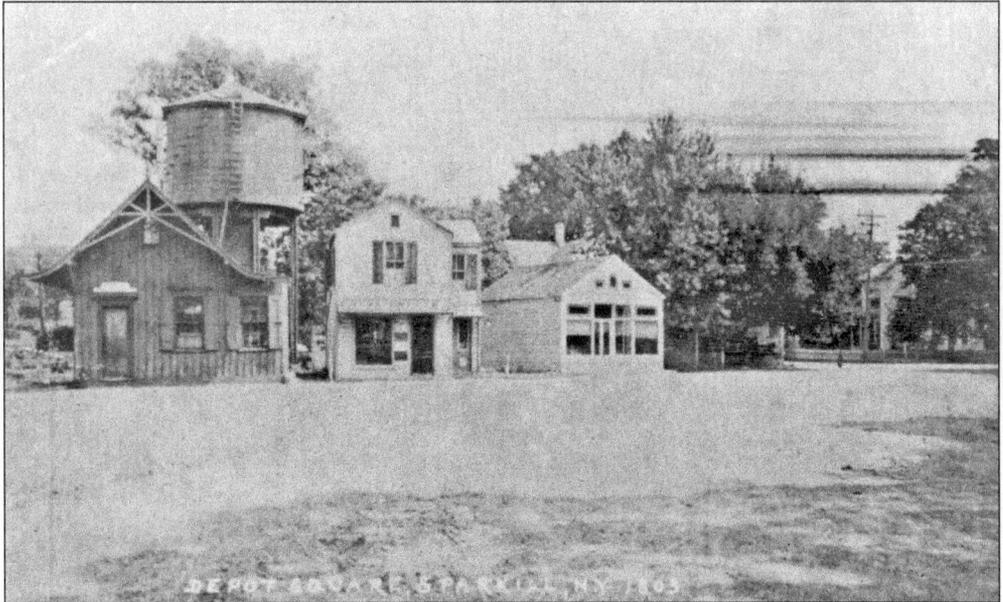

In Depot Square, c. 1900 before the park was built, the police station and the Bauer Building were not yet built either. The water tower used for steam locomotives is behind the station. The water tower was dismantled about 1948. The structure in the middle sold postcards and stationery but would later become an A&P, then Gallucci's grocery and soda fountain, and later Relish, a restaurant that is now closed. (Courtesy Robert Knight.)

UNION REPUBLICAN CLUB, Sparkhill, N.Y.

Although a sign on the Union Republican Club building says 1820, the changes to the building make it look younger. It was purchased by the New York State Free & Accepted Masons in the 1920s and was called the Waywayanda Lodge. It was bought in 2004 as part of the Camp Venture complex and is called today the George Strayton Center. However, the Masons still maintain a room here for their meetings. (Courtesy Robert Knight.)

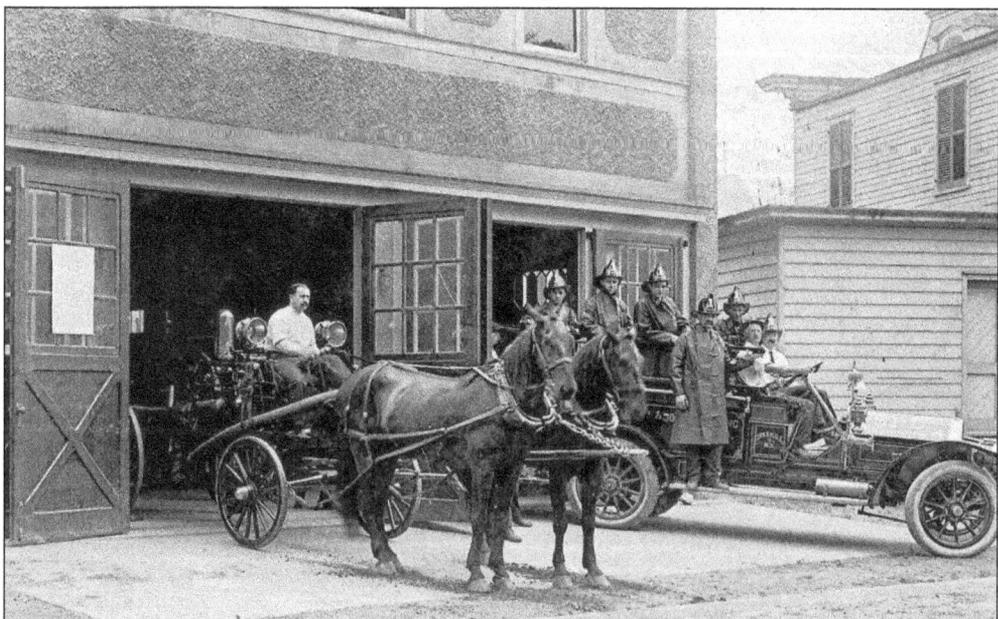

The John Paulding Engine Company was founded by Stephen Haire in 1901. Haire, a former New York City fire chief, suggested naming the firehouse after John Paulding, one of the three militiamen who captured Major André. Haire became the first chief, and the firehouse, which still serves the hamlets of Palisades and Sparkill. The new John Paulding Engine Company moved to its present site on Route 340 in 1970. (Courtesy OHMA.)

54

The coal yard bins of the old Erie Railroad can still be seen nestled in the rear of the former Sparkill Freight House. Openings in the bottoms of coal cars allowed them to drop coal into the bins. The yard belonged to a coal deliveryman named McAdoe. Most of the houses in the background are still there today. The old freight house to the right is now called Arbor Hill Garden Center. (Courtesy OHMA.)

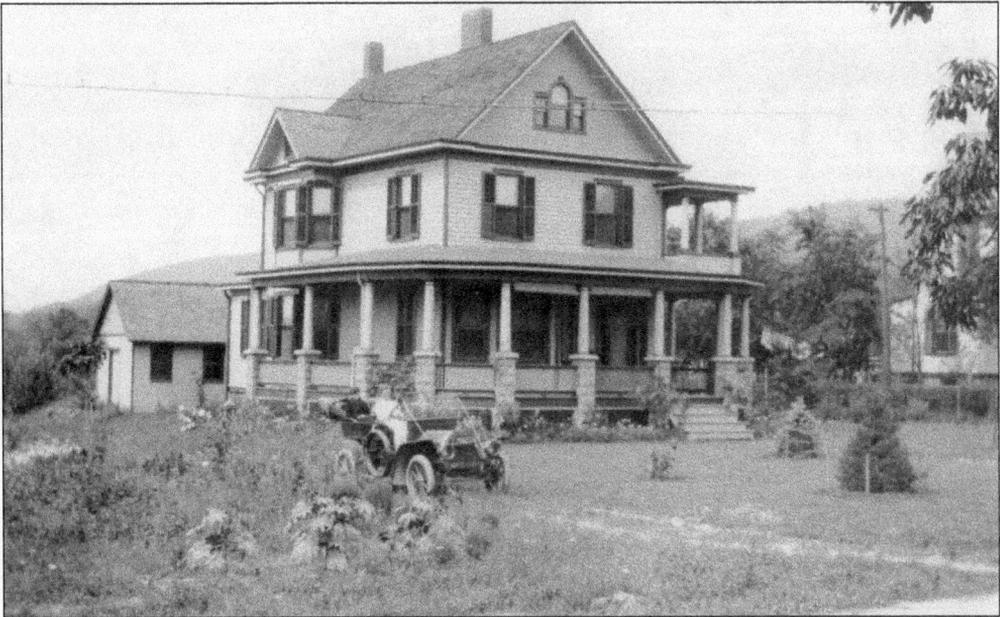

Bessie Clarke, pictured c. 1910, is seen sitting in her new Maxwell in the driveway of her home on Kings Highway. Maxwells were popular cars, sold as "perfectly simple, simply perfect," a sales pitch that appealed to women who were able to obtain a driver's license long before they won their right to vote in 1920. The early Maxwell automobiles were made in Tarrytown, New York. (Courtesy Sally Dewey Collection.)

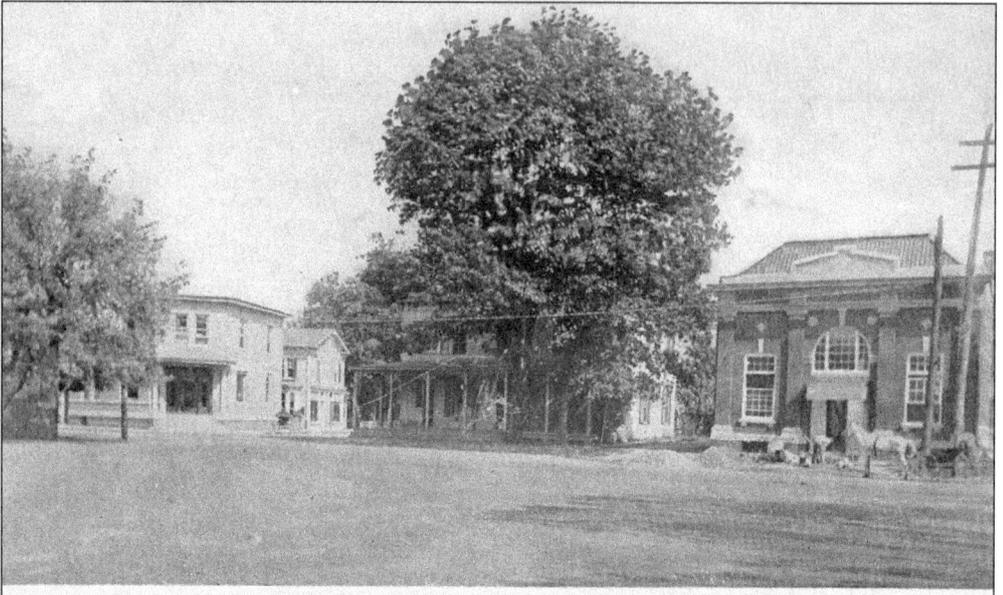

DEPOT SQUARE, Sparkill, N. Y.

The First National Bank of Sparkill, under construction in 1914, was on the site of what was once Sugar Loaf Mountain. Initially, Oswald Bauer was the attorney for this bank. In recent years, the bank went through a series of ownerships, including Barclays, Bank of New York, and finally Chase. It is located between Piermont and Tappan, and across from what was the Sparkill Erie Railroad Station. (Courtesy Robert Knight.)

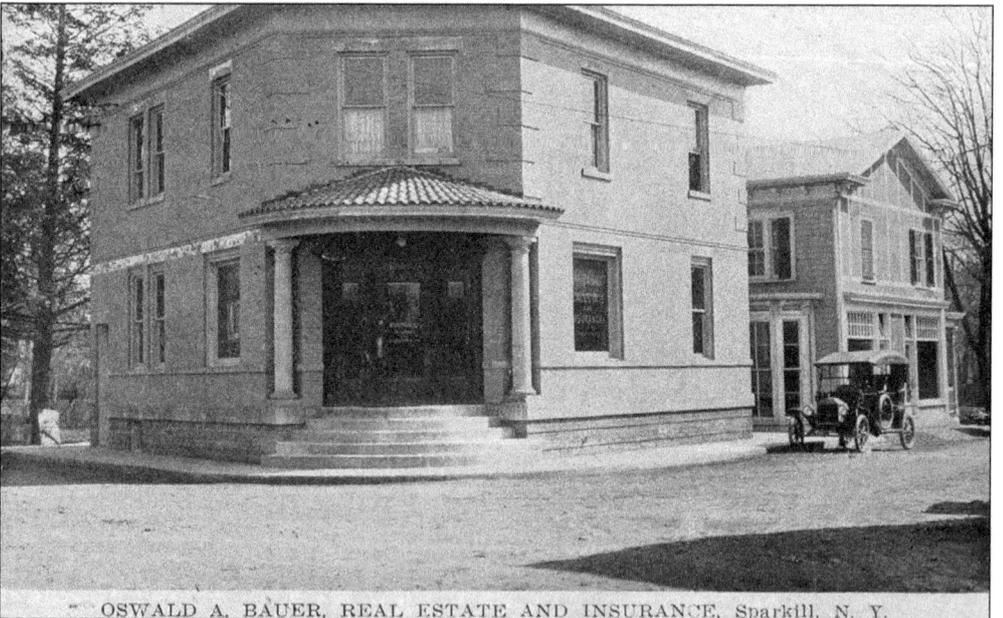

OSWALD A. BAUER, REAL ESTATE AND INSURANCE, Sparkill, N. Y.

Known today as the Bauer-Crowley Building, it was originally built by Oswald Bauer in 1909 to serve as a law and real estate office, which it still does today, more than 100 years later. Oswald Bauer was a lawyer and president of the Orangeburg Fair Association. He was also president of the Sparkill Publishing Company, publisher of the Sparkill Herald, and served as counsel for the First National Bank of Sparkill, now the Chase Bank. (Courtesy OHMA.)

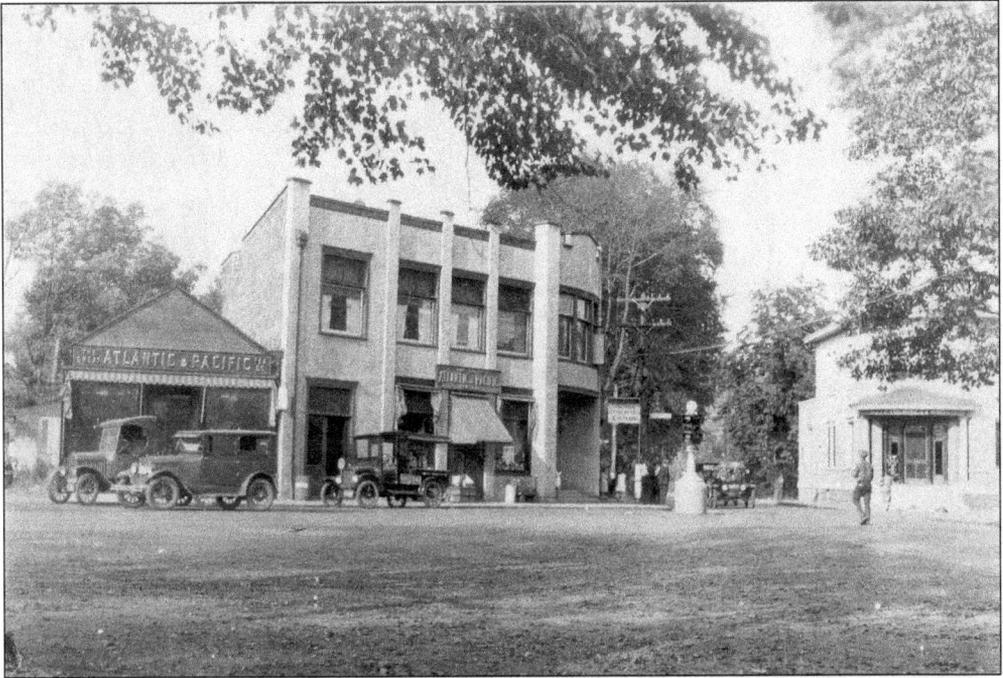

The Delco Building, pictured c. 1920s, is seen on the corner of Main Street and Union Avenue. Oswald A. Bauer, an influential attorney, was partly responsible for its construction. From 1935 to 1961, the building's second floor would become the Orangetown Police Headquarters and Justice Court. In 1961, the police department was moved to the new Orangetown Municipal Building in Orangeburg. The Sparkill Post Office is now located on the first floor. (Courtesy OHMA.)

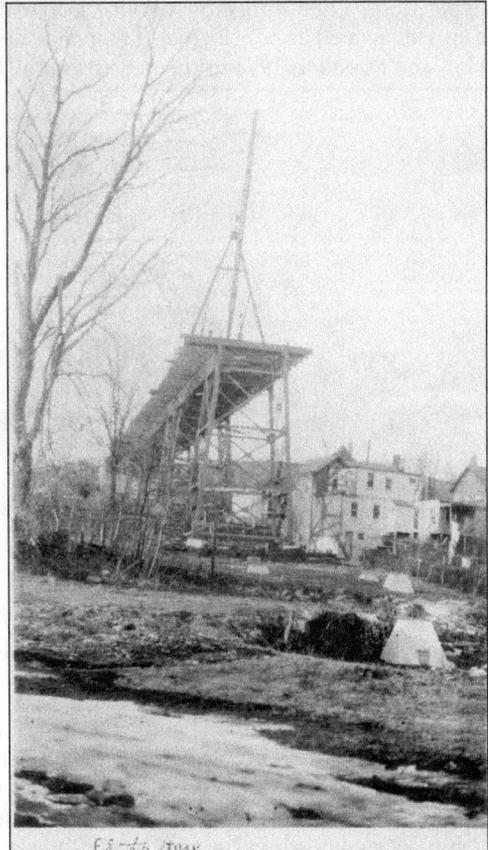

The building of the Sparkill Viaduct was prompted by a bus accident on July 23, 1926, that killed 11 passengers returning to Brooklyn after a day's outing at Bear Mountain. After this fatal accident, the State of New York approved construction of a wider, safer viaduct, which was completed in 1928. The viaduct spanned 1,260 feet length. Over time, this Sparkill landmark showed signs of aging, and was completely replaced in 2002. (Courtesy HSRC.)

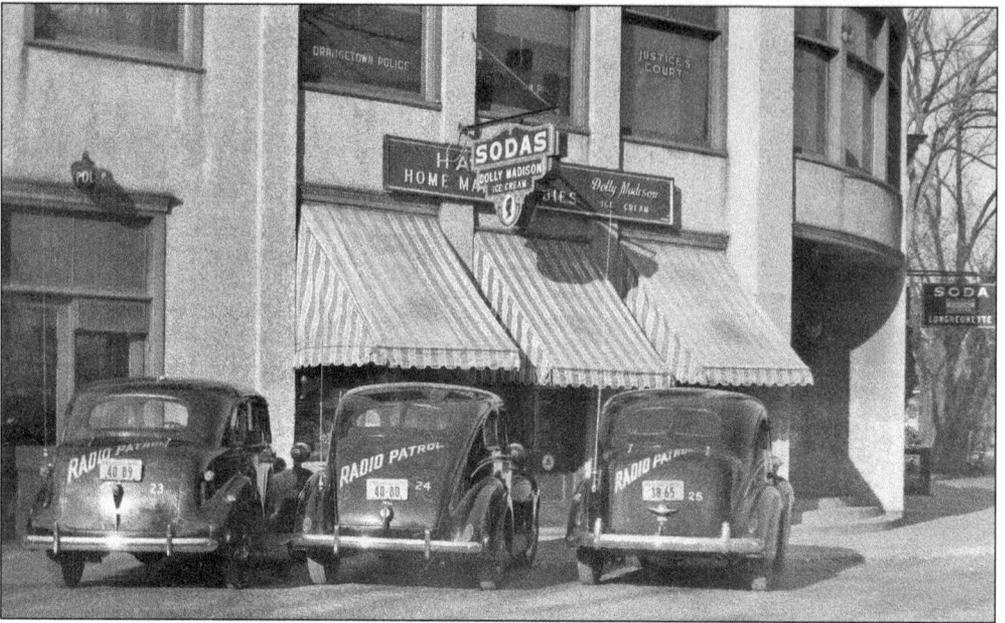

Taken in the 1930s, this photograph shows three Orangetown Police cars parked outside police headquarters in Depot Square. The police department and the justice court were located on the upper floor. The Orangetown Police Department was formally established in 1935 with Fred Kennedy named as police chief. The police department was moved in 1961 to the Orangetown Hall and moved in 1992 to the new town hall building. (Courtesy Sally Dewey Collection.)

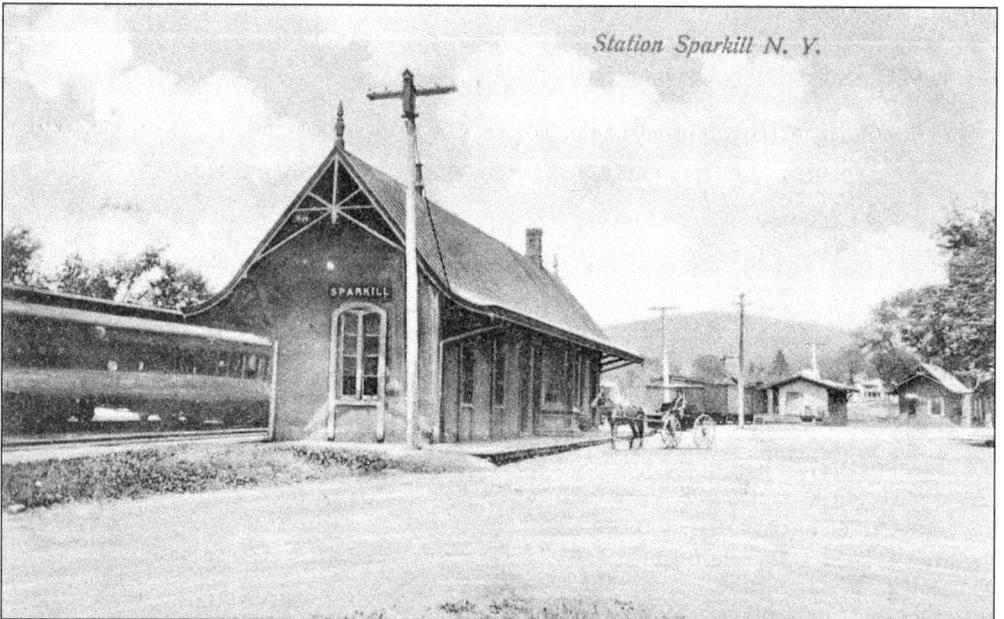

The Sparkill railroad station handled several trains daily going south to Weehawken and returning north to Rockland. The last passenger train here was on September 30, 1966, and the station was dismantled sometime before 1970. The nearby freight station is still standing at the intersection of Main Street and Highland Avenue, an intersection once known as Kipps Crossing. The freight house, located north of the coal bins, is now a nursery. (Courtesy Marilyn Schauder.)

Five

NYACK

Centuries before a Dutchman from New Jersey first settled here, the shoreline along today's Village of Nyack was already well known to the Lenape for its limitless bounty of oysters and fish. By one definition, Nyack derives its name from the native word *nay-ack*—"the fishing place."

Nyack was part of the Van Purmerant Patents of the late 1600s. Van Purmerant, who lived in what is now Jersey City, sold some of his land to a neighbor, Herman Douwsen Tallman, who left to settle in Nyack in 1675, making it the oldest community in Orangetown and Rockland County. Tallman farmed and built a mill and, in 1686, became the first appointed sheriff of Orange County.

Before the American Revolution, Nyack was a small farming settlement. In 1813, Tunis and Peter Smith bought a large tract of land. Together they engineered Nyack's rise as an important deep-water river port and a leader in shipbuilding, transportation, manufacturing, and business. The Smiths helped bring about the Nyack–Suffern Turnpike (today's Route 59) and in 1826, helped form the Nyack Steamboat Association, which built the first engine-driven boat constructed here. Steam-powered passenger and freight transport to New York flourished until 1870 when the Northern Railroad of New Jersey soon replaced it.

Nyack and South Nyack were incorporated as the Village of Nyack in September 1872. In February 1878, however, it was disincorporated after South Nyack voted to secede. Nyack did not reincorporate until 1883.

Railroads established Nyack as a commuter suburb, and vacation destination. For most of the 1800s, Nyack was also a manufacturing town, producing shoes, pianos, sleighs, carriages, and wagons. In the early 1900s, Nyack became a center for business and the shopping mecca of Rockland.

On the first day of the 20th century, Nyack Hospital opened, and as the 1900s progressed, theater and the arts also became part of the villagescape. Today, despite the nearby presence of the Tappan Zee Bridge and the New York Thruway, Nyack remains a peaceful place of tree-lined streets, a vibrant business district, and a historic riverfront that still inspires all who see it.

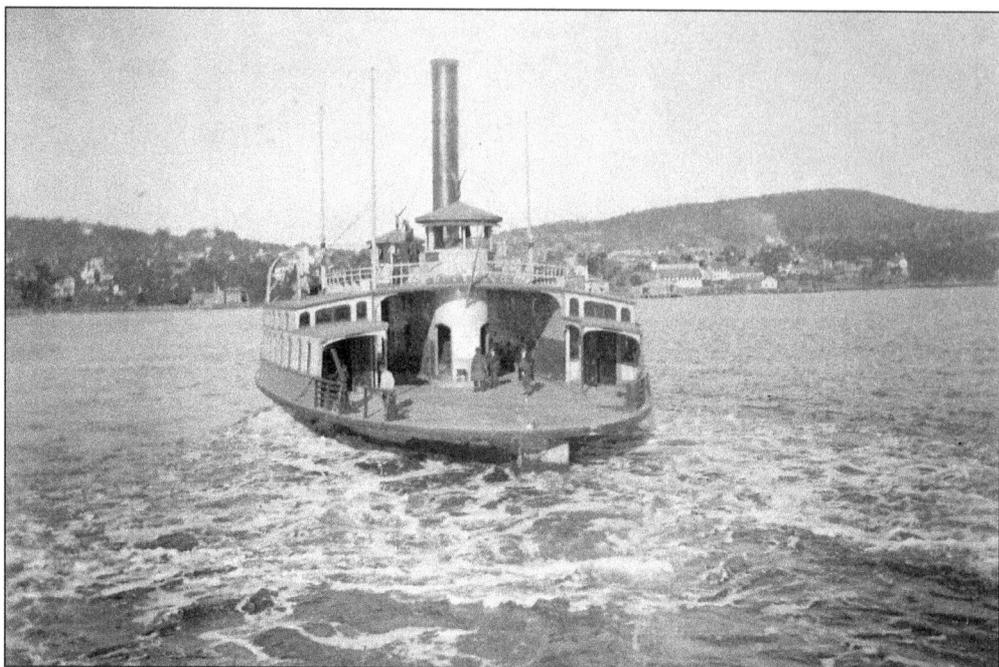

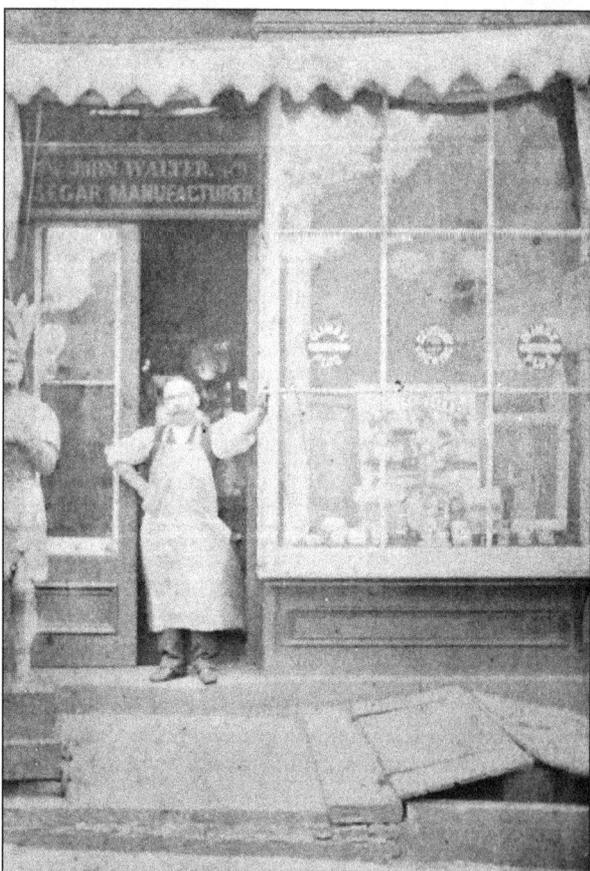

As faster, steam-powered ships began sailing up and down and across the Hudson in the early 1800s, Nyack quickly became an important shipbuilding and river transportation center. The first engine-driven boat constructed in Nyack was the *Orange* in 1827. Into the early 20th century, ships like the *Chrystenah* sailed to and from New York, and the ferry *Rockland*, shown c. 1900, carried passengers and vehicles to and from Tarrytown. (Courtesy Nyack Library.)

For most of the 1800s, Nyack was known as a manufacturing town. At its peak, 12 shoe factories were in business, the last of which closed in 1900. Other factories produced pianos, sulfur matches, woodenware, boilers, pipe organs, sleighs, carriages, and wagons. At the same time, smaller businesses like the John Walter Segar Manufacturer, shown in 1890 at the corner of South Broadway and Burd Street, also flourished. (Courtesy Nyack Library.)

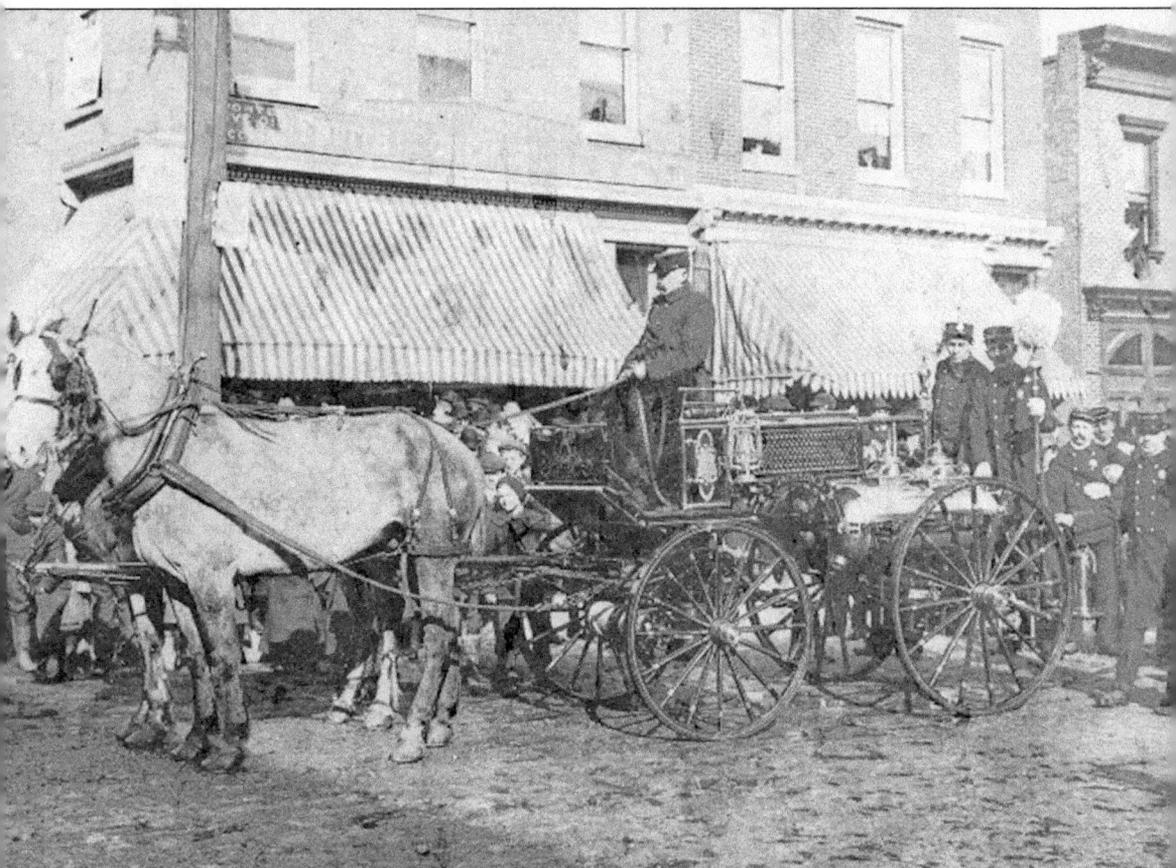

Today's Nyack Fire Department is made up of eight separate companies formed between 1834 and 1915. The first company organized in Nyack, and Rockland County, was Orangetown Fire Company No. 1, which began on October 4, 1834. Jackson Engine Company, first organized in 1867, is shown here in 1908 displaying a chemical engine, a horse-drawn apparatus built to carry large tanks of soda-and-acid mixture to extinguish fires. (Courtesy Nyack Library.)

In 1900, before there were automobiles and trucks, Gregory & Sherman Coal and Lumber Company, on Cedar Hill and Railroad Avenues, used horse-and-carriage rigs to deliver coal, lumber, mason's materials, and supplies to homes and construction sites. In business from the late 1800s until the Depression of the 1930s, Gregory & Sherman received and sold materials directly from trains whose tracks were located just yards away. (Courtesy Nyack Library.)

Nyack Hospital opened on January 1, 1900, to provide medical care, which, until then, often required a trip to New York City. The original two-story building had one operating room, nine beds, and a nurse's parlor. Its first annex was a house built for Pres. Grover Cleveland that was moved next to the hospital. By 2011, the hospital had more than 350 beds, nine operating rooms, and more than 650 staff physicians. (Courtesy Nyack Library.)

Balance Rock, shown here in the early 1900s, was left behind by glaciers millions of years ago. It became a popular attraction in the 19th and 20th centuries. Perched on a hill off Tweed Boulevard, it remained steadfastly in place despite many peoples' attempts over the years to dislodge it. In the late 1960s, the rock was deemed to be a hazard and was destroyed by the police department. (Courtesy HSRC.)

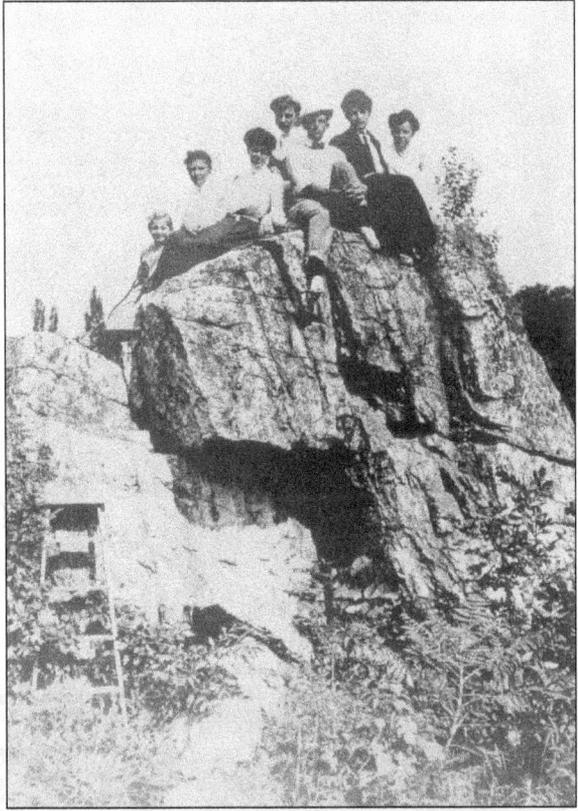

Every winter, blocks of ice were cut from the frozen Nyack Ice Pond by men from the Felter Ice Company. After being cut, ice was hauled to specially built icehouses, where it was stored, cured, and delivered for use in "ice boxes," the predecessors of today's home and commercial refrigerators. The pond, shown c. 1900, was on Main Street and Polhemus Avenue. It is now the site of a motel. (Courtesy Nyack Library)

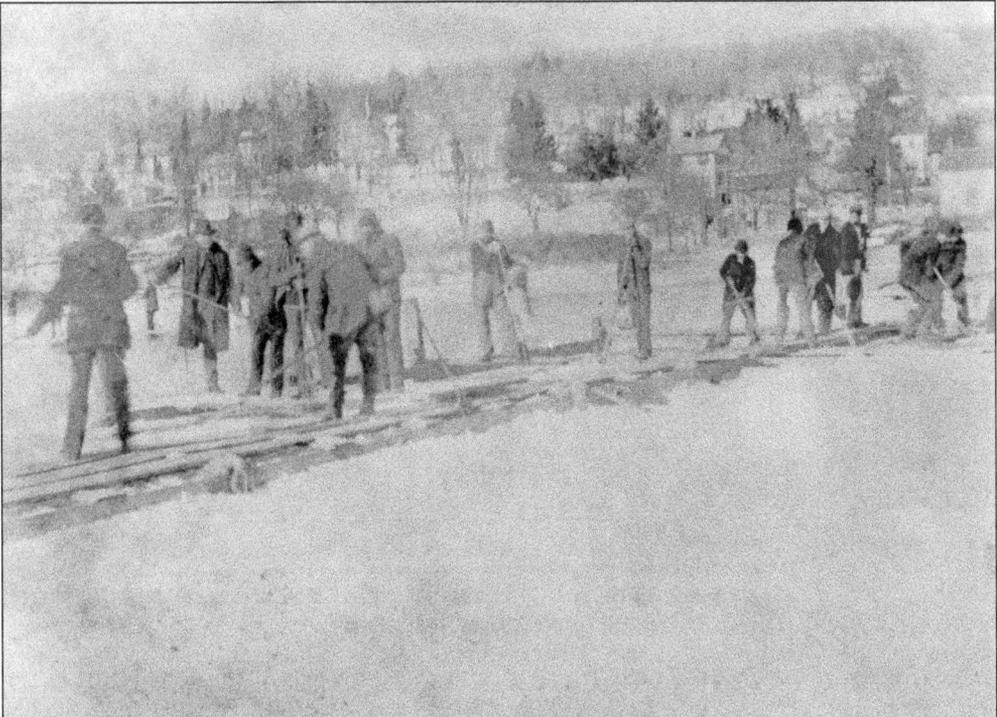

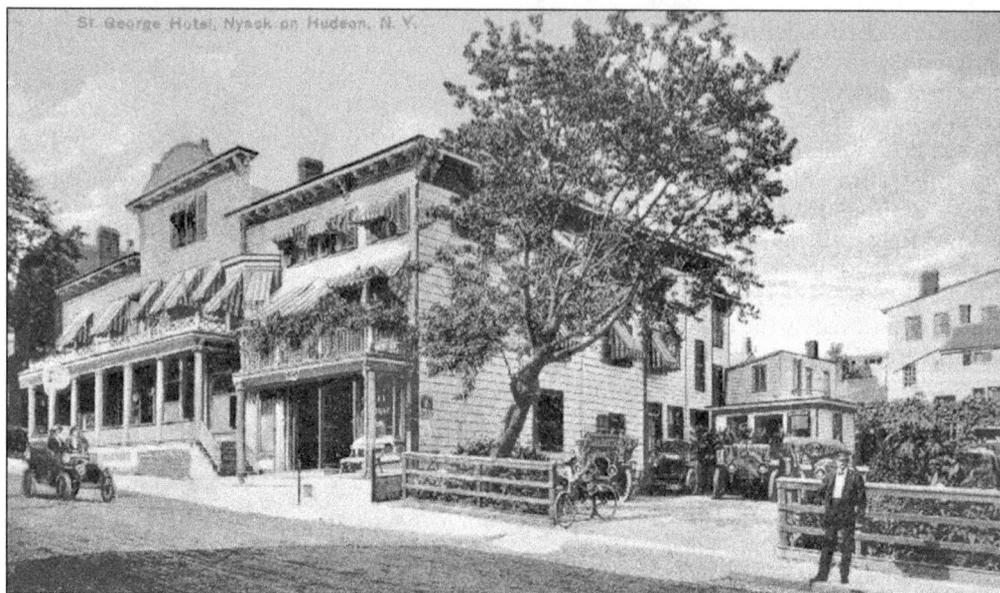

Railroads in the late 19th century helped make Nyack, and its scenic riverfront, a popular and easily accessible tourist and vacation destination. It was described by one New York newspaper in 1889 as the "Naples of America." Affluent New Yorkers, as well as celebrities and prominent citizens like Pres. Grover Cleveland, regularly enjoyed hotels and resorts like the St. George Hotel, Prospect House, and the Hi Ho Club. (Courtesy Nyack Library.)

The Nyack Gas Plant, shown here in 1902, manufactured gas for heating and cooking using a process that entailed heating coal, oil or both, and storing it in large tanks on Gedney Street. The plant was part of Rockland Light & Power, founded in 1899. It merged with another utility to form Orange & Rockland in 1958. The former Orange & Rockland building is today's Nyack Village Hall and former police station. (Courtesy Nyack Library.)

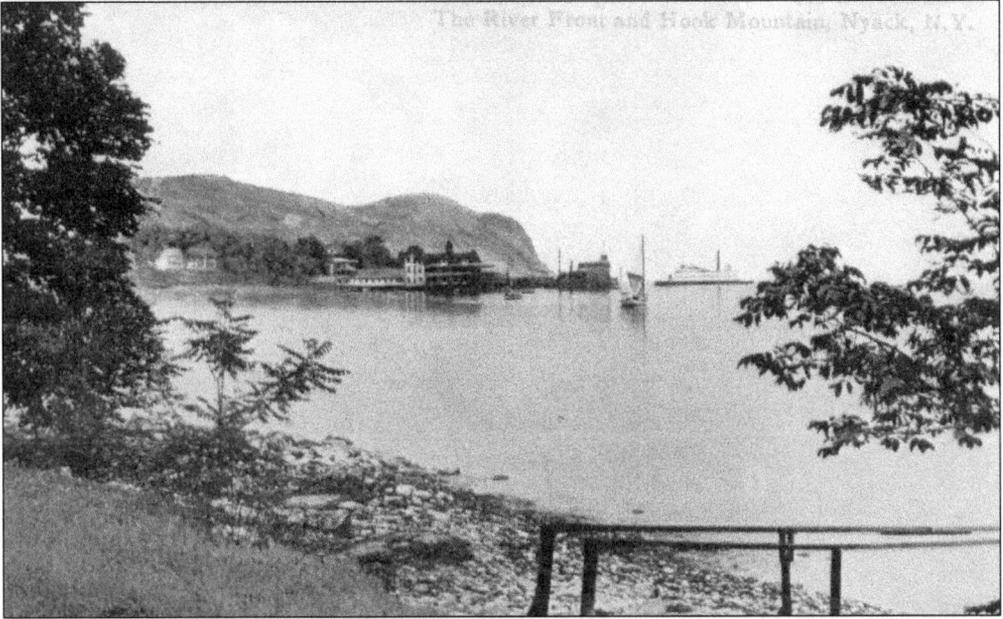

At the beginning of the 20th century, Nyack's riverfront was as bucolic as it was busy. The prominent Nyack Rowing Association, seen in the center, was built in 1882 for leisure and competitive rowing, as well as social events. A hurricane destroyed it in 1938. To the right, a Nyack-Tarrytown ferry prepares to dock. Regular ferry service continued until the opening of the Tappan Zee Bridge in 1955. (Courtesy Chris Gremski.)

First established as a community organization in 1879, the Nyack Library relocated several times until a permanent structure was established on South Broadway. Using land purchased from the DePew family and funds provided by Andrew Carnegie, the philanthropist noted for supporting local libraries, the cornerstone of the Nyack Library, also called the Carnegie Library, was laid in a ceremony in May 1903. The library officially opened on February 12, 1904. (Courtesy Nyack Library.)

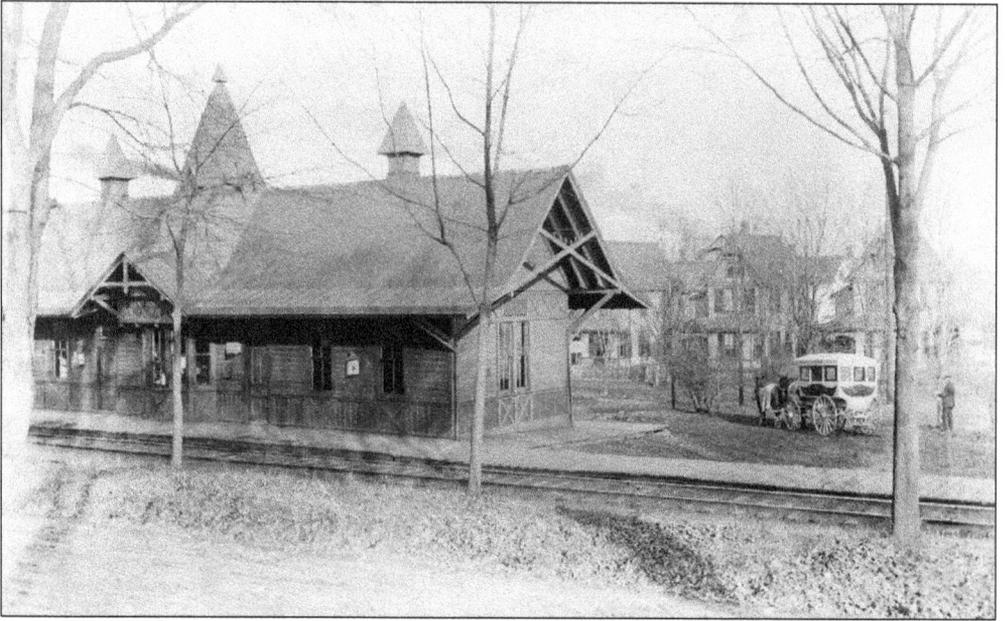

The coming of the railroad in 1870 and the faster, more efficient transport it provided not only brought tourists here, but it also established Nyack as a New York commuter suburb. The station on Railroad Avenue was the end of the line, and a hand-operated turntable was located nearby. A horse-drawn taxi service, shown here around 1900, waits for the train's arrival. Commuter rail service was discontinued in the 1960s. (Courtesy Nyack Library.)

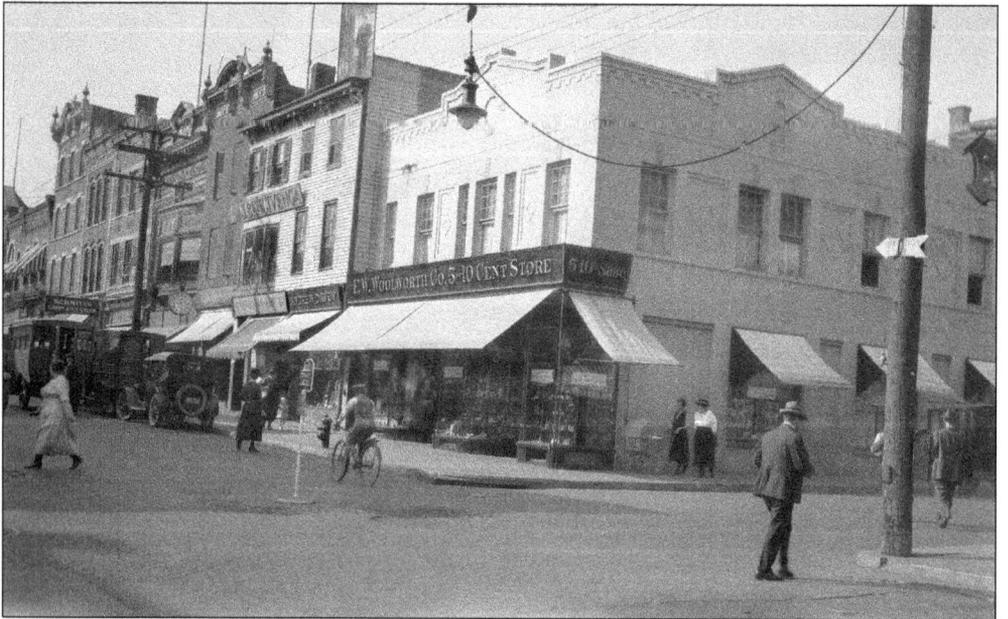

In the late 19th century and well into the 20th century, the area near the railroad became a center for shopping. At the busy intersection of Main Street and Broadway in 1928, popular stores over the years, like Woolworth's, as well as fashionable department stores like Harrison & Dalley's and an array of clothiers, restaurants, saloons, and other businesses made this part of Nyack the main shopping district of Rockland. (Courtesy OHMA.)

The Clarkstown Country Club was founded in 1918 by Pierre Bernard, a businessman and charismatic occultist known as "Oom the Omnipotent." Here, high-society visitors like the Vanderbilts and conductor Leopold Stokowski could spend a week or an entire season studying yoga and the arts, participating in plays and athletics, boating on the Hudson, and enjoying the sight of elephants and other exotic animals roaming the grounds. (Courtesy Nyack Library.)

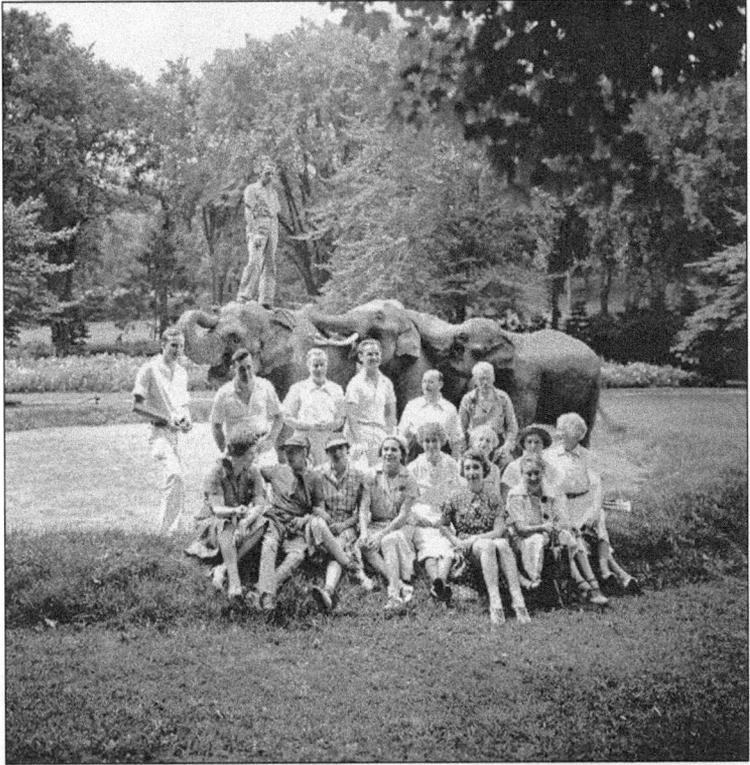

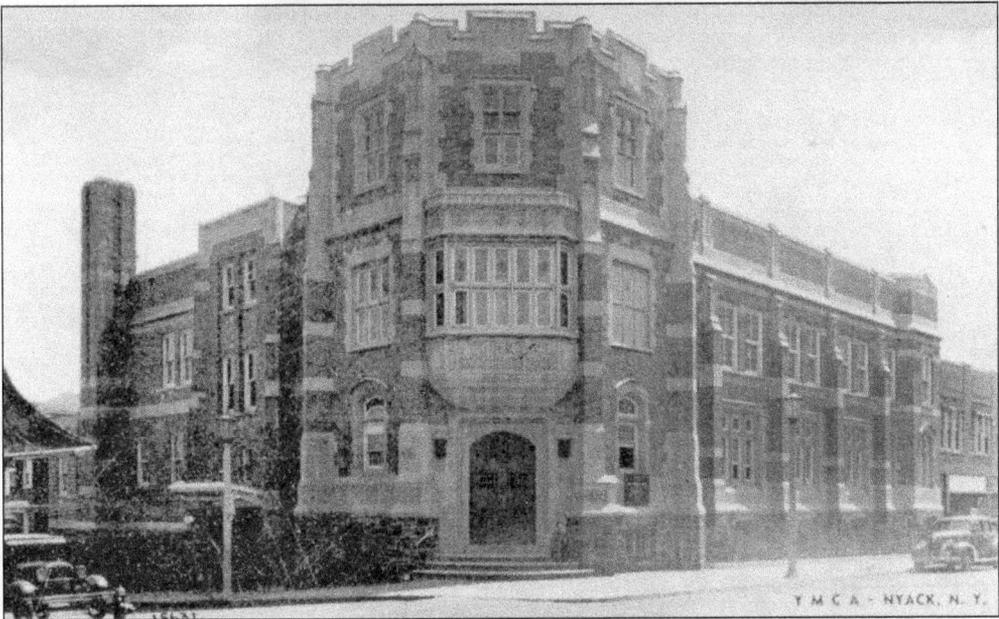

The Young Men's Christian Association (YMCA) of Nyack was founded in 1888 using part of a nearby hotel on Main Street. Its present building on South Broadway was built in 1928 using donated land and money, including sizeable sums raised by Nyack women who, until 1930, were not permitted to become members. Today, the Y has become Rockland's leading provider of childcare, with programs and facilities available to everyone. (Courtesy Marilyn Schauder.)

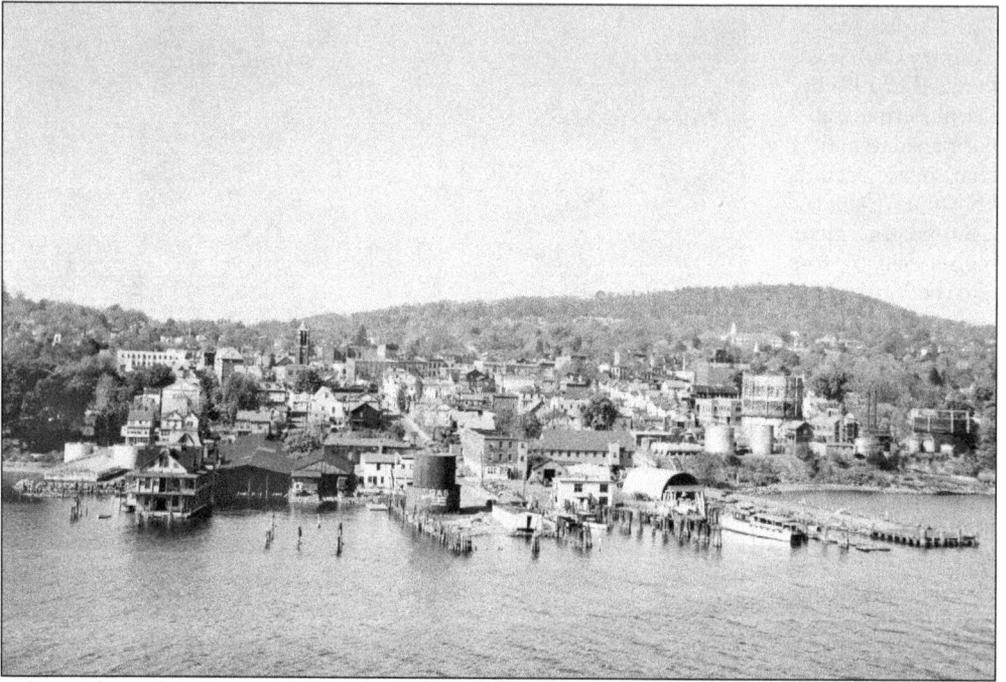

Before the Tappan Zee Bridge, the Nyack waterfront, shown here in 1947, was, for the most part, dominated by businesses related to ships and fuel storage. Today, most of these structures, including the old ferry slip, have given way to parkland, and the shore includes space for leisure craft. The oil storage tanks along Gedney Street have been removed, and a large apartment complex was built in their place. (Courtesy Nyack Library.)

The Green House, pictured in 1900, was built in 1817 at the end of Main Street by John Green. Green worked with Nyack founders Tunis and Peter Smith and others to fund the Nyack-Suffern Turnpike (today's Route 59) and form the Nyack Steamboat Association, which contracted for the building of the Orange, the first engine-driven boat built in Nyack. It is, as of 2011, the oldest standing house in Nyack. (Courtesy Nyack Library.)

Six

PEARL RIVER

What now includes Pearl River was originally part of the Kakiat Patent granted to two Irish businessmen, Daniel Honan and Michael Hawdon, in 1696. In 1713, their lands were split into north and south moieties (portions of land) and divided, sold, and bequeathed to others in the decades after the American Revolution.

In the 18th and 19th centuries, this was a region of farms, mills, and peaceful everyday life. In 1870, Julius Braunsdorf, called the "Father of Pearl River," donated the land that brought in the New Jersey and New York Railroad and money for the rail station that, although renovated many times, remains today.

Thanks to Braunsdorf—and the railroad—this became known as a company town. In 1872, he opened the Aetna Sewing Machine Company to produce his patented home sewing machines. That same year he established the first post office here, and from then on, the hamlet was known as Pearl River. Independent of Edison, Branusdorf invented a carbon-arc light bulb in 1873 and designed generators, one of which powered the first electric lights in the nation's Capitol.

Over the 20th century, two more inventor/scientists came to Pearl River. In 1894, Talbot C. Dexter moved his Dexter Folder Company into Braunsdorf's factory. His automatic folding machines changed the way newspapers, books, and magazines were folded and assembled. In 1906, Dr. Ernest Lederle established the Lederle Antitoxin Laboratories on Middletown Road. In 1930, it became Lederle Laboratories, a division of American Cyanamid, and during World War II, Lederle was a major supplier of blood plasma. By 1994, it became American Home Products and employed more than 3,000 people. It was acquired by Pfizer, another pharmaceutical company, in 2009.

From the 1870s into the early 1920s, Pearl River was a major source of fresh flowers for New York City, and its rural charm attracted tourists to health spas and summer homes. In the 1930s, Pearl River was branded as the "Town of Friendly People" to promote businesses and commercial construction. Today, it is known for the New York's second-largest St. Patrick's Day Parade and a spirit that makes it "Still the Town of Friendly People."

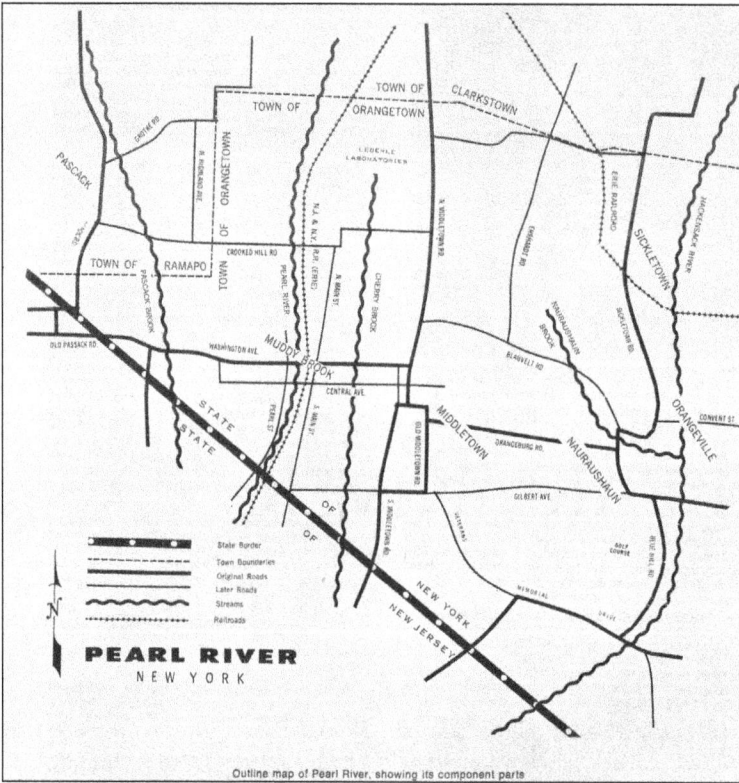

Outline map of Pearl River, showing its component parts

PEARL RIVER
NEW YORK

State Border
Town Boundaries
Original Roads
Later Roads
Streams
Railroads

As population grew and land developed here in the 18th and 19th centuries, six communities within today's eight square miles of Pearl River emerged: Orangeville and Nauraushaun in the east, Sickletown in the north, Middletown and Muddy Brook in the center, and Pascack in the west. With the establishment of the first post office in Muddy Brook by Julius Braunsdorf in 1872, these communities became the hamlet of Pearl River. (Courtesy Robert Knight.)

Julius Braunsdorf, often called the "Father of Pearl River," emigrated from Germany. An inventor, entrepreneur, and city planner, he helped bring in the railroad in 1870 and paid for the building of the rail station. In 1872, his Aetna Sewing Machine Factory produced his patented home sewing machines. Braunsdorf also built stores, the Pearl River Hotel and employee tenements, and firmly established Pearl River as a company town. (Courtesy the Atlas of Rockland County, 1876.)

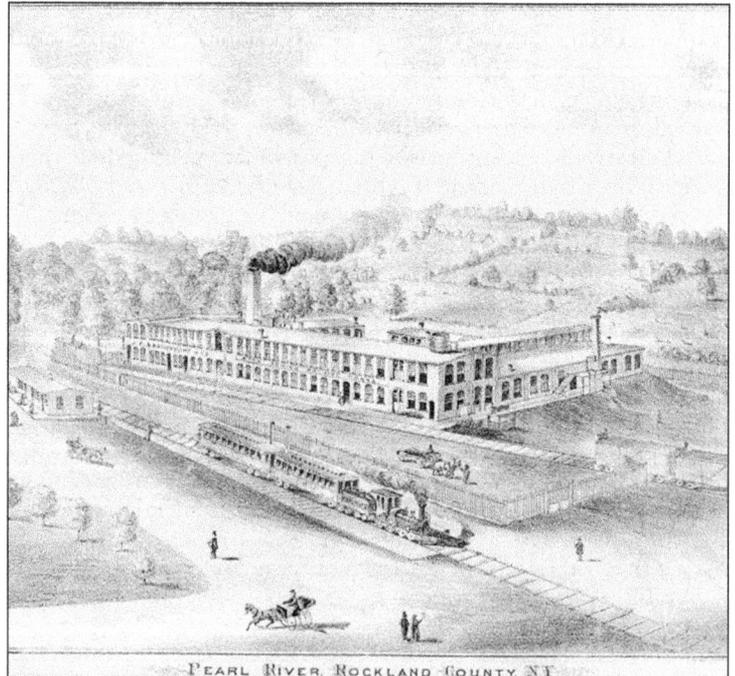

PEARL RIVER, ROCKLAND COUNTY, N.Y.

Julius Braunsdorf moved here from New York in 1864 and built an elegant home along North Middletown Road in 1874. Braunsdorf was also keenly interested in electricity and invented a carbon-arc light bulb, which he introduced to great fanfare in 1873. He also designed and patented generators, one of which is thought to have powered the first electric lights in the US Capitol and is in the Smithsonian Institution. (Courtesy the Atlas of Rockland County, 1876.)

No one can say for sure how Pearl River got its name. Some contend that it came from the small pearls found in mussels that thrived then in the Muddy Brook. Others believe that the railroad created the name in order to make its station stop here look more appealing on passenger schedules. Still others maintain that Braunsdorf himself insisted on Pearl River to enhance the hamlet's business image. (Courtesy Pearl River Library, photograph by Joseph Barbieri.)

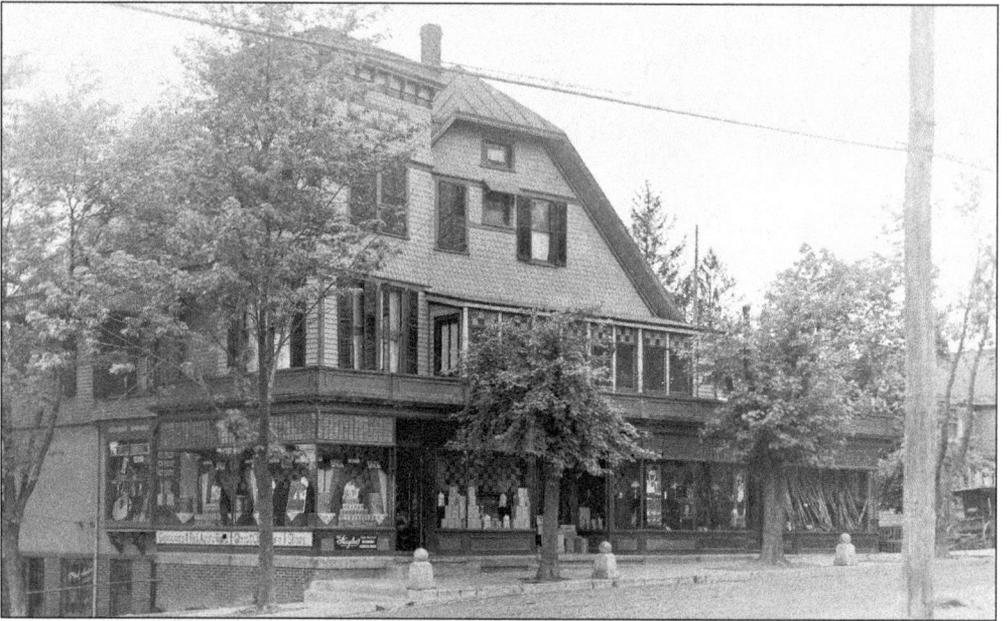

Hunt's General Store on North Main and Central Avenue was built as a store and apartment building in 1894 by Louis Hunt, who also constructed Hunt Avenue and many of the houses on it. Hunt operated the business until 1905, when he sold the store and building to George W. Hadeler. For several years Hadeler also sold clothing and groceries before specializing in hardware and supplies as the iconic Hadeler Hardware. (Courtesy HSRC.)

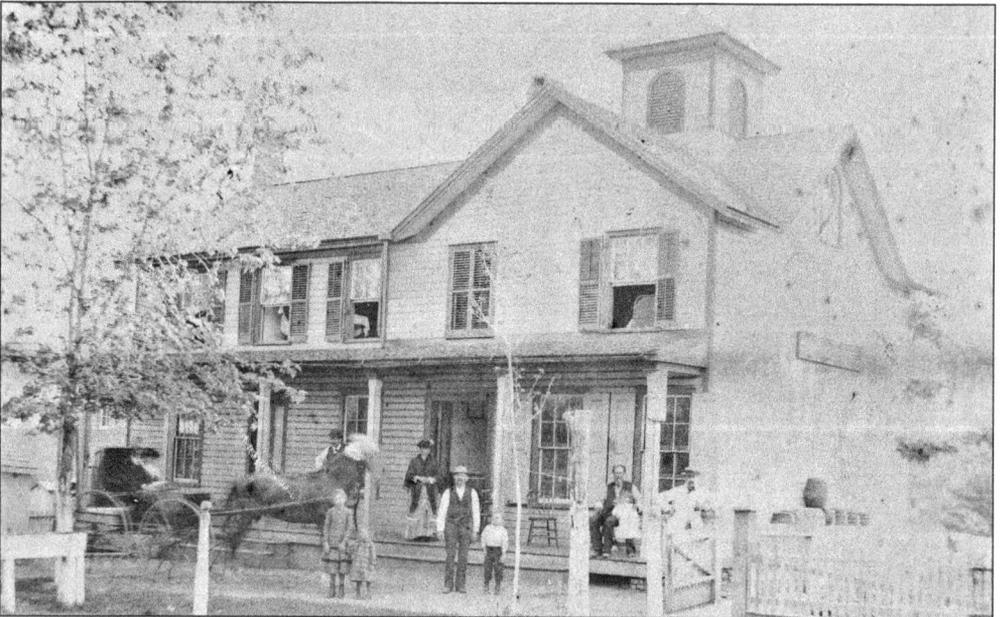

In the late 1800s, several hotels and inns were established in Pearl River, including the Pearl River Hotel on South Main in 1872, which is still in use as a tavern. In 1894, Charles Bader built this house near the rail station. It later became Bader's Hotel, which also contained a barber shop, market, and other stores. Bader's was demolished in 1935 to make way for the present-day Pearl River Post Office. (Courtesy OHMA.)

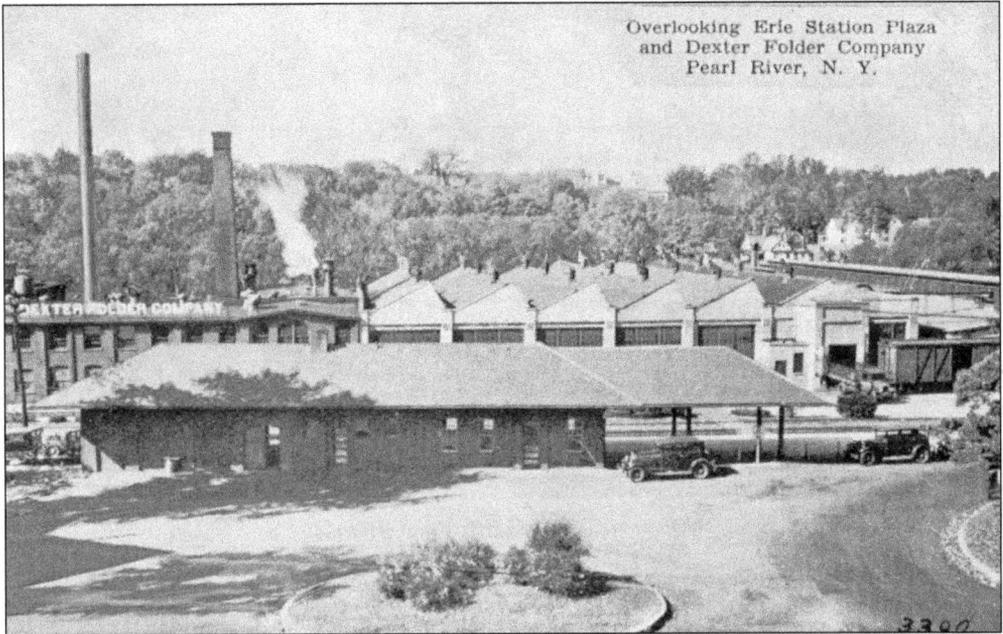

Overlooking Erie Station Plaza
and Dexter Folder Company
Pearl River, N. Y.

Talbot C. Dexter moved his Dexter Folder Company into the former Braunsdorf factory in 1894. A prolific inventor in his own right, Dexter's patented automatic folding machines not only changed the way newspapers were folded and assembled but books and magazines as well. Dexter also produced printing equipment and precision materiel for the military during World War II. After years of having operated under various names and owners, it closed in 1972. (Courtesy HSRC.)

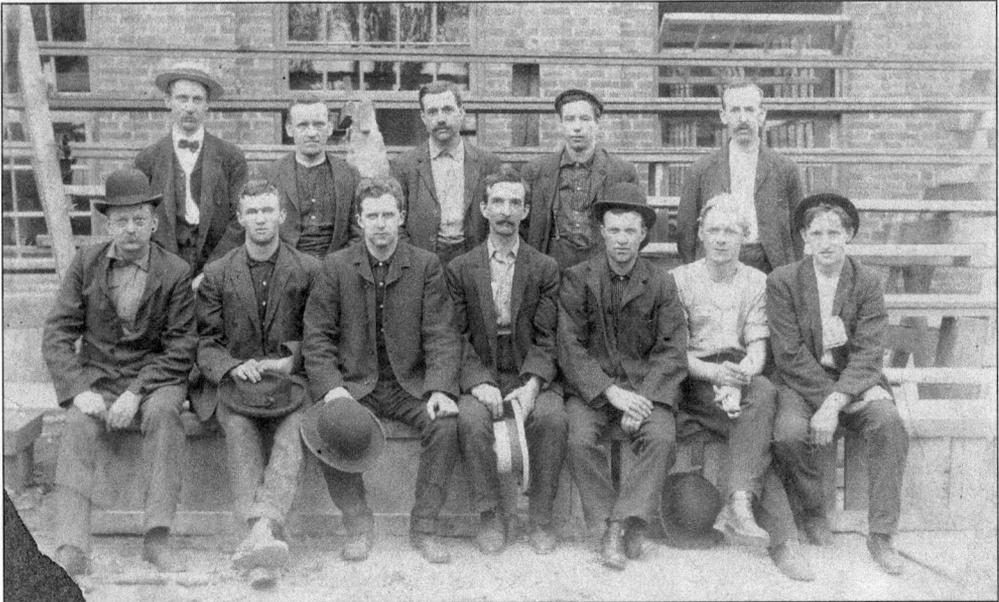

Over the years, Dexter Folder became an integral part of everyday life and Dexter employees, like these shown in 1910, became involved in nearly every social and civic organization. Dexter constructed new factory buildings, built affordable housing for employees, and grew from 50 workers in 1894 to more than 550 in 1966. Dexter had its own band, orchestra, and baseball team, and maintained a widely admired flower garden in the town center. (Courtesy OHMA.)

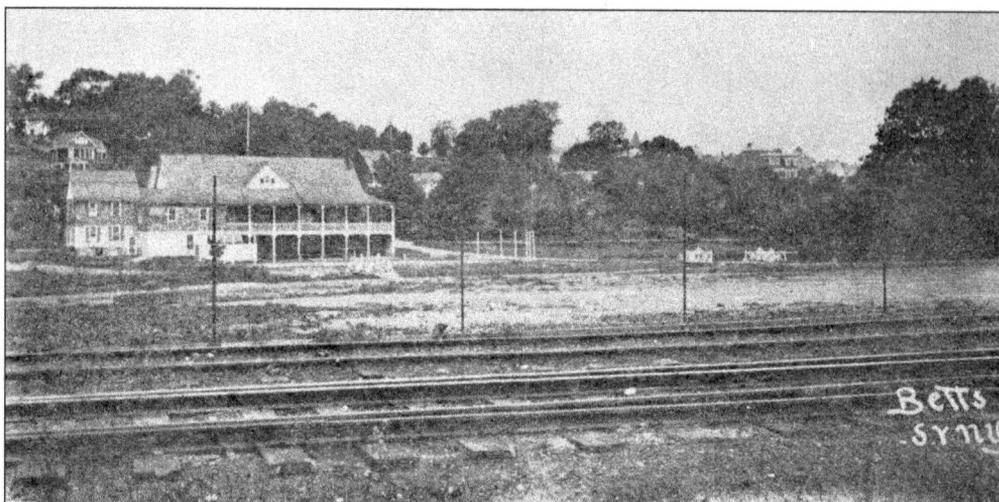

UNIQUE CLUB HOUSE, Pearl River, N. Y.

From 1897 to 1963, the Unique Club on South Pearl Street was a community center built on Dexter property for dances, sports, and recreation. It housed the first Pearl River Library and had a basketball court used by the Pearl River High School team, a shooting range, ice cream fountain, two bowling alleys, and a large stage for meetings, plays, musicals, and some of the first movies shown in Pearl River. (Courtesy Nyack Library.)

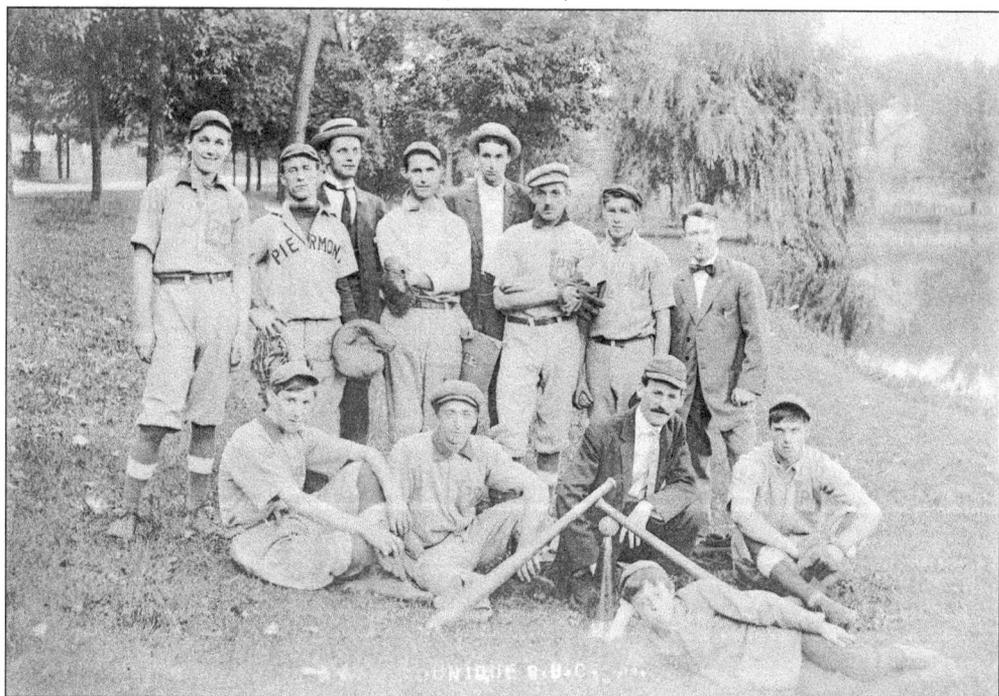

On the grounds outside the Unique Club, there were Rockland County's first outdoor tennis courts, an archery range, and a large baseball field where the Unique Baseball Club played its home games. Pictured here c. 1915, are members of the Pearl River Unique team, and at least one player from a Piermont team. The photograph was taken between South Pearl Street and the Muddy Creek, near Jefferson Street. (Courtesy OHMA.)

When Dr. Ernest Lederle purchased the land that would become Lederle Laboratories from George Turfler in 1904, the sale included this 1790s farmhouse. Pictured c. 1910, the house would be used as the residence of Lederle's plant superintendent until 1942. It then became a focal point of the hundreds of tours conducted at Lederle every year thereafter. This iconic house was disassembled in 1983. (Courtesy Lederle Archives.)

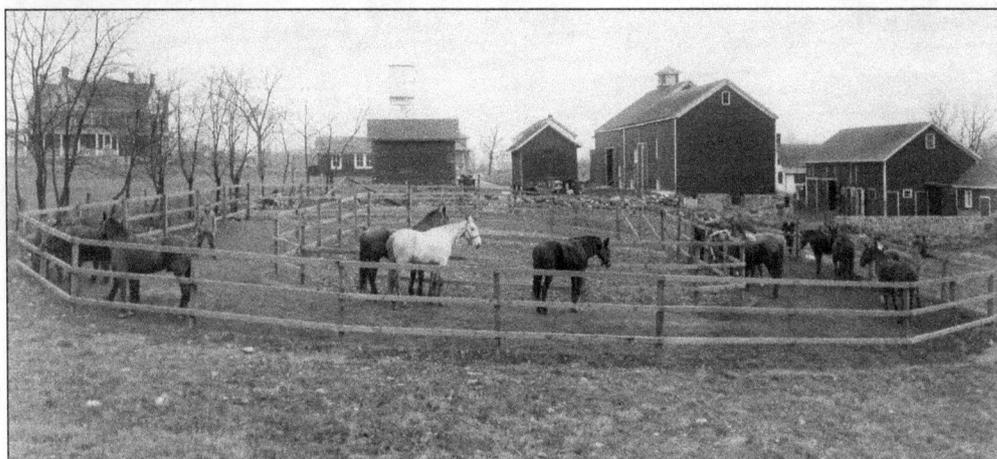

Dr. Ernest Lederle was a former New York City health commissioner who dramatically curtailed the spread of diphtheria there in the late 19th century. In 1904, he bought 99 acres of farmland on North Middletown Road and incorporated Lederle Antitoxin Laboratories in 1906 to produce diphtheria antitoxin and other formulas for human and animal use. The Lederle property included stables and corrals for antitoxin testing on horses and other livestock. (Courtesy Lederle Archives.)

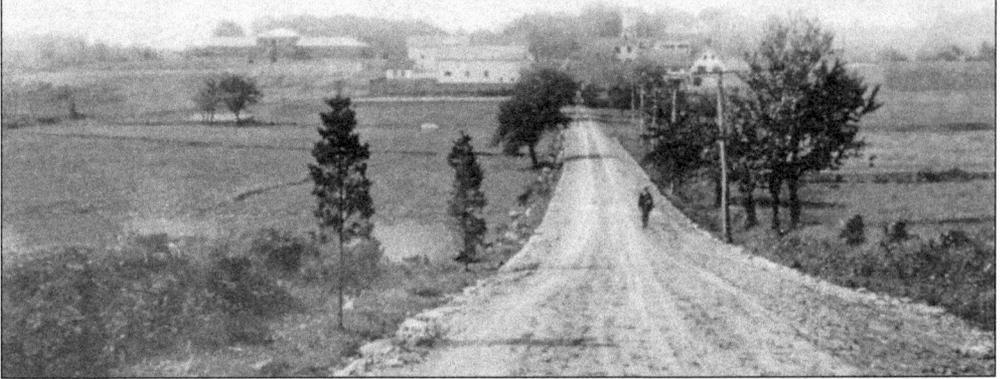

Lederle Farm, Property of Lederle Antitoxin Laboratories, Pearl River, N. Y.

In the early 1900s, Lederle Antitoxin Laboratories was still largely rural in appearance but had expanded to include more facilities and 100 employees. By 1922, it employed 450 people, and in 1930 became Lederle Laboratories, a division of American Cyanamid Company. It soon developed into a leading center of research, testing, and manufacturing and distribution of antitoxins, vaccines, antibiotics, and vitamins. During World War II, Lederle was a major supplier of blood plasma. (Courtesy Robert Knight.)

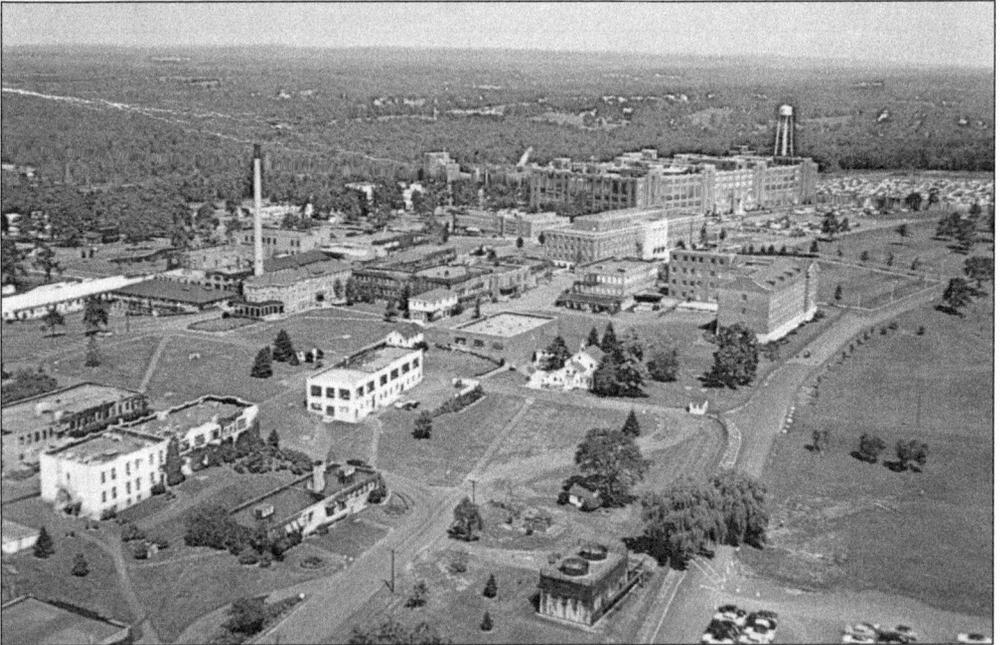

By the 1950s, Lederle's original 99-acre farm had grown considerably since American Cyanimid acquired it in the 1930s. By the 1970s, it comprised more than 150 buildings on 510 acres. It was sold to American Home Products Corporation and the Pearl River operation employed nearly 3,400 people. It was later sold to Wyeth, who named it Wyeth-Lederle. It then became Wyeth-Ayerst and was eventually acquired by Pfizer in 2009. (Courtesy HSRC.)

Before being cleared and filled in for farms, factories, schools, and houses, much of early Pearl River was woods and marshes. The land that makes up today's main park and ball field between Franklin and Central Avenues was originally marshland. The spot on which these two women stood in 1900 was filled in to build Pearl River's Central School in 1923. The Pearl River Methodist Church is visible behind them. (Courtesy OHMA.)

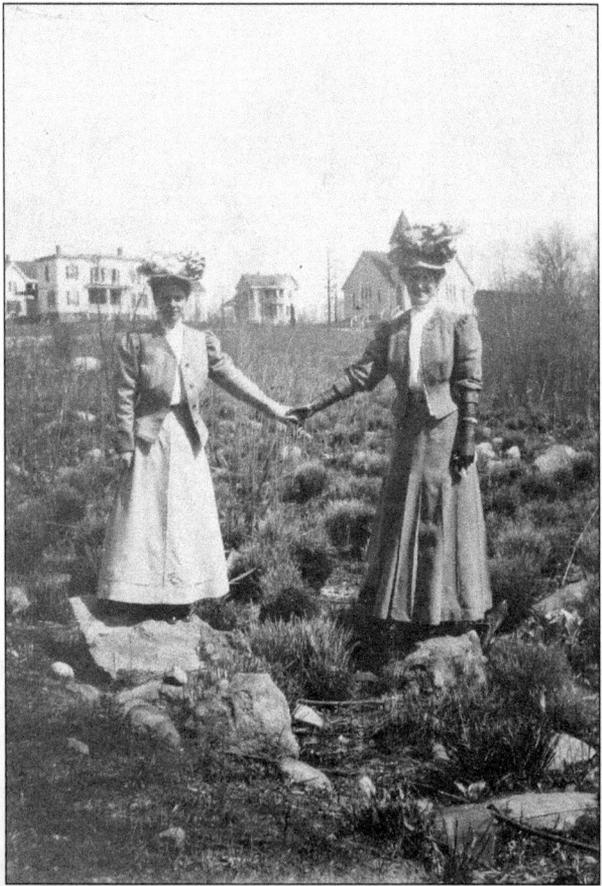

Pearl's River's Central School was built just west of John Street in 1923 for kindergarten through 12th grade. At its peak, about 700 students attended school here. After a new high school was built in the 1960s, the building continued as the middle school until the late 1960s, then as the elementary school until three separate schools were built in different nearby locations. This school building was demolished in 1982. (Courtesy HSRC.)

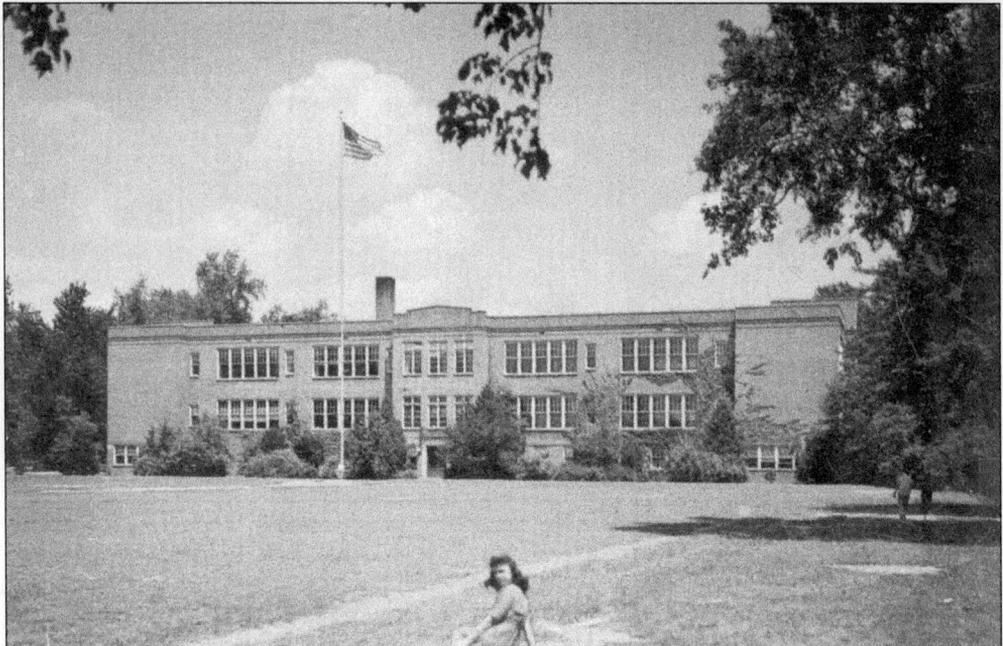

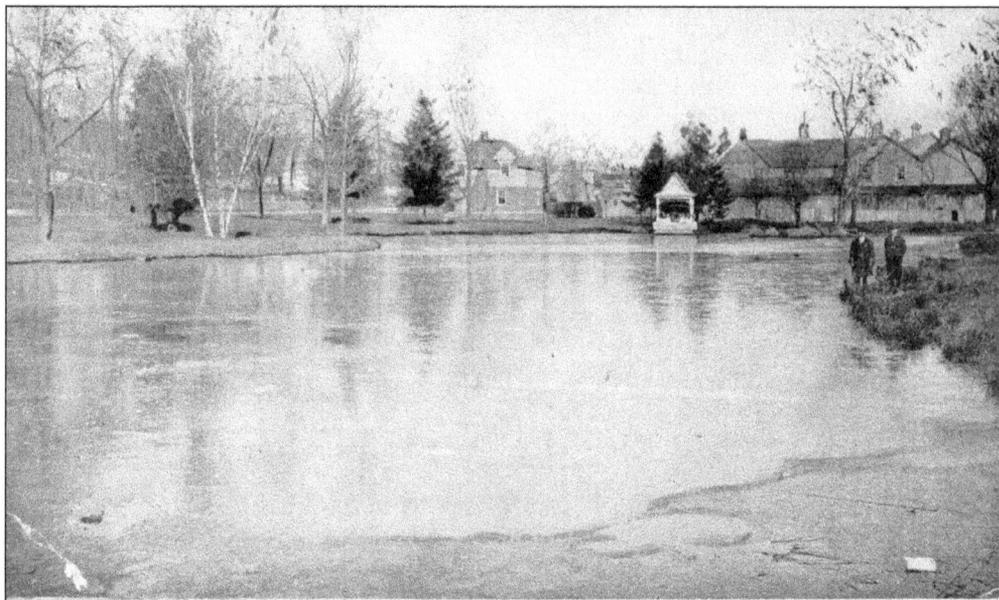

SERVEN'S LAKE, PEARL RIVER, N. Y.

In the late 19th and early 20th centuries, an area just west of Pearl Street near West Central was filled by a small lake known as Serven's Lake, named after James Serven, a successful local businessman. In the warm-weather months of summer, guests could relax in a quiet inn nearby and enjoy row boating and swimming. In winter, ice skating was a popular pastime as well. (Courtesy Robert Knight.)

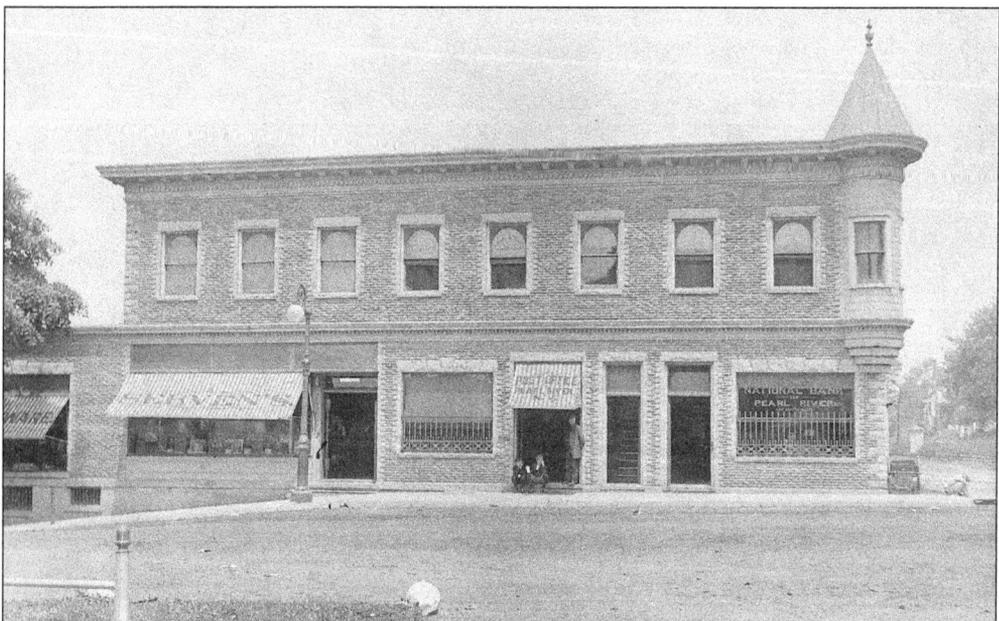

This building on Central Avenue was constructed by James Serven in 1915. It contained his hardware store, the Pearl River Post Office, and the First National Bank. In December 1921, two bank employees were killed in a holdup by Henry J. Fernenkes, who escaped without taking any money. The murders were retold in radio show dramas and detective magazines. Fernenkes was arrested years later in Chicago and died in 1935. (Courtesy OHMA.)

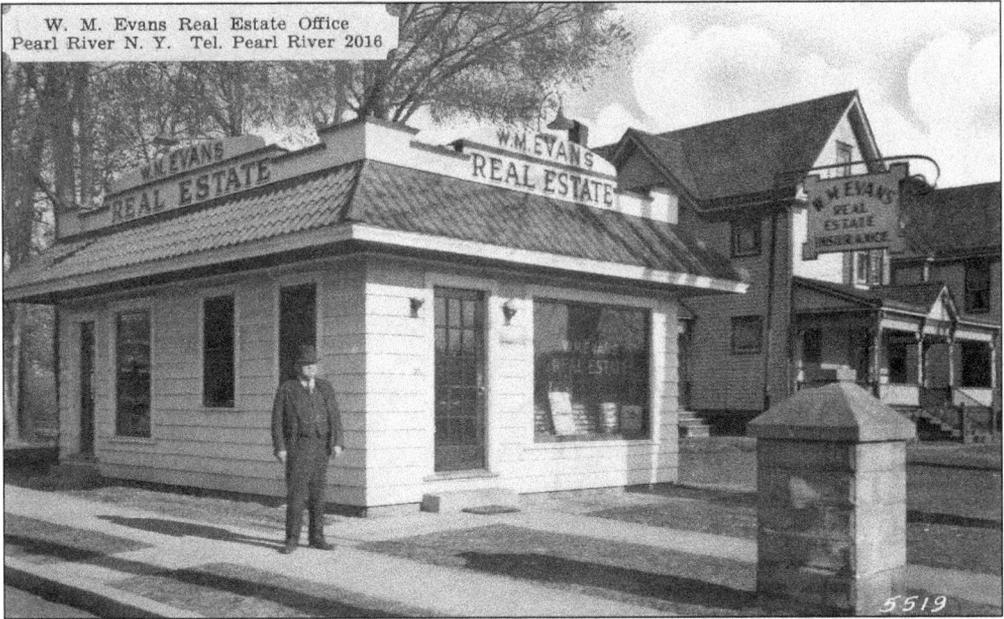

W.M. Evans' Real Estate and Insurance Company c. 1910, was located on the corner of William Street and Central Avenue. His home was right next door. His office building was later moved several yards north to become Herb Peckman's first liquor store. When Peckman eventually built a new store, this original Evans structure was moved to Pomona where today it is part of Gilligan's Clam Bar and Grill Restaurant. (Courtesy Robert Knight.)

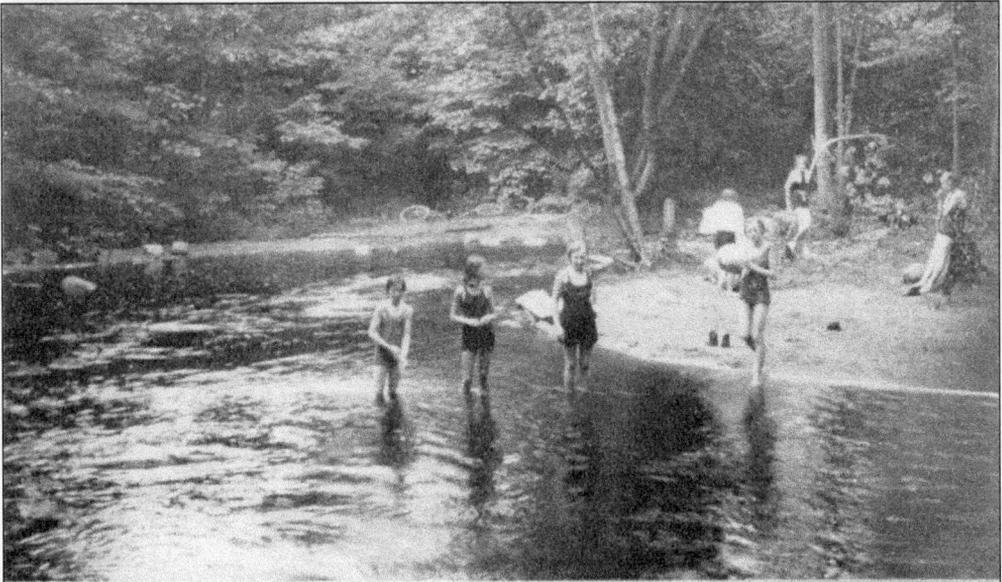

043 The Swimming Hole in the Pascack River, Pearl River, N. Y.

Along East Washington Avenue where a bridge passes over the Pascack River, the water and shore nearby were a popular swimming hole for kids to walk and ride their bikes to in the summer. Pictured in the 1930s, this cool, shaded spot was called the "Bathing House" by local kids. Similar spots to gather and swim in Pearl River could be found nearby along the Pascack. (Courtesy Robert Knight.)

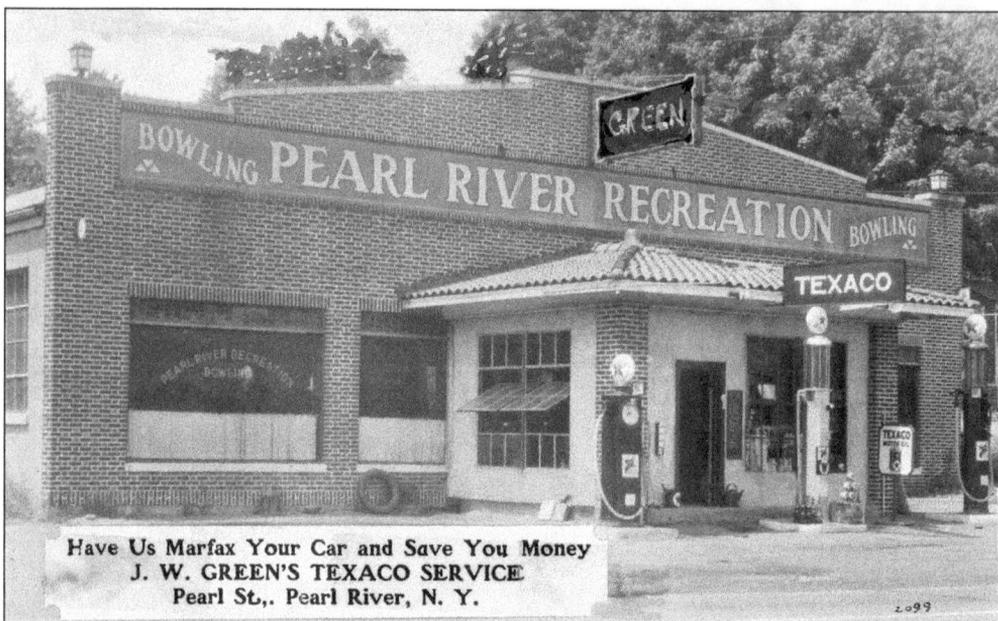

Have Us Marfax Your Car and Save You Money
J. W. GREEN'S TEXACO SERVICE
Pearl St,. Pearl River, N. Y.

In the 1930s, Green's Texaco Station on Pearl Street was a Pontiac dealership. It was gradually converted to a more profitable bowling alley. Bowling became so popular that four more lanes were added, and it became known as Green's Pearl River Recreation. It was here that Fred Schmidt and Walter Schneider of the Dexter Folder Company invented the first automatic pinsetter in 1936. As of 2011, the building is a plumbing supply warehouse. (Courtesy HSRC.)

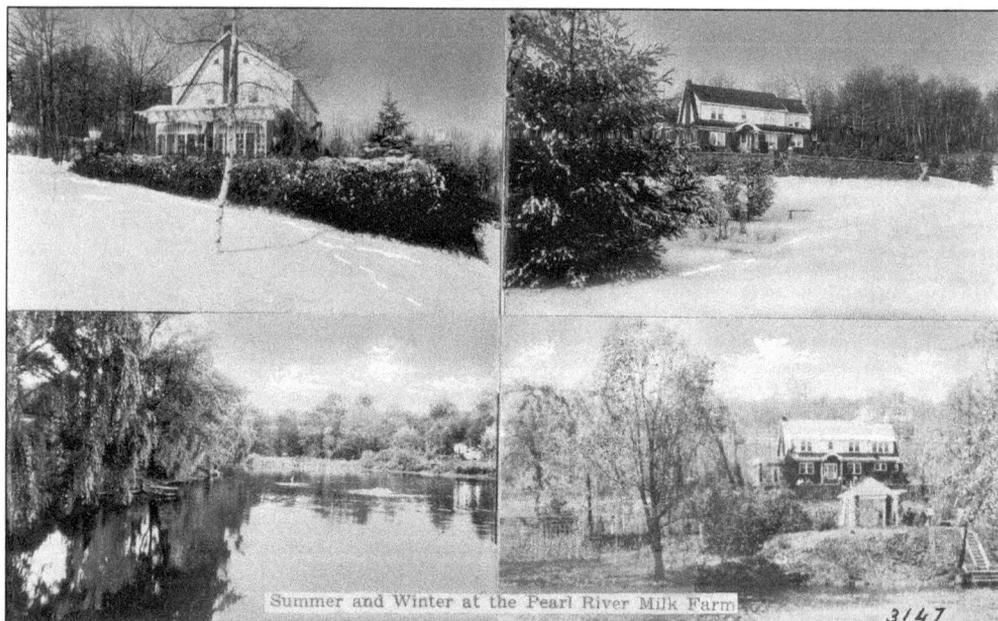

Summer and Winter at the Pearl River Milk Farm

From the 1870s to the 1920s, the farms and greenhouses along Middletown Road turned Pearl River into a major source of fresh flowers for New York. Its rural charm also attracted city dwellers, who came to rejuvenate in spas and resorts like the Pearl River Milk Farm on Crooked Hill Road. In the 1960s, the spa was sold to Africa Inland Mission, then in 2010 to the Pearl River School District. (Courtesy HSRC.)

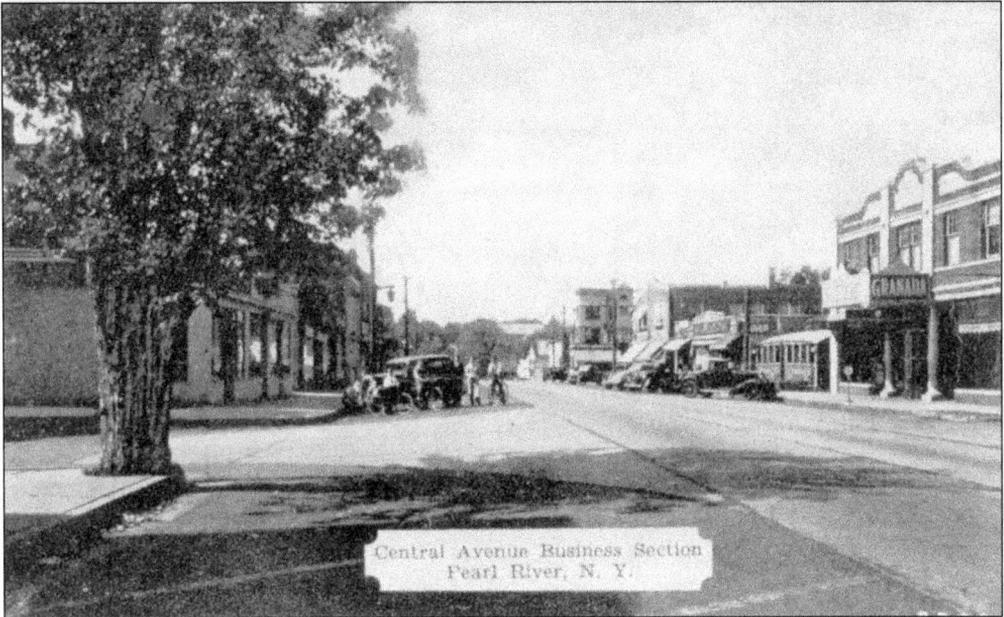

Central Avenue Business Section
Pearl River, N. Y.

Except for a few different buildings and businesses, the corner of Williams Street and East Central appears much as it did in the 1930s. The Granada Theatre, built in 1922, was a Vaudeville playhouse. Later named Pearl River Theatre, it closed around 2000. The old Granada Theatre building has since been renovated for use by small businesses, but the two prominent columns of the main entrance have been restored. (Courtesy HSRC.)

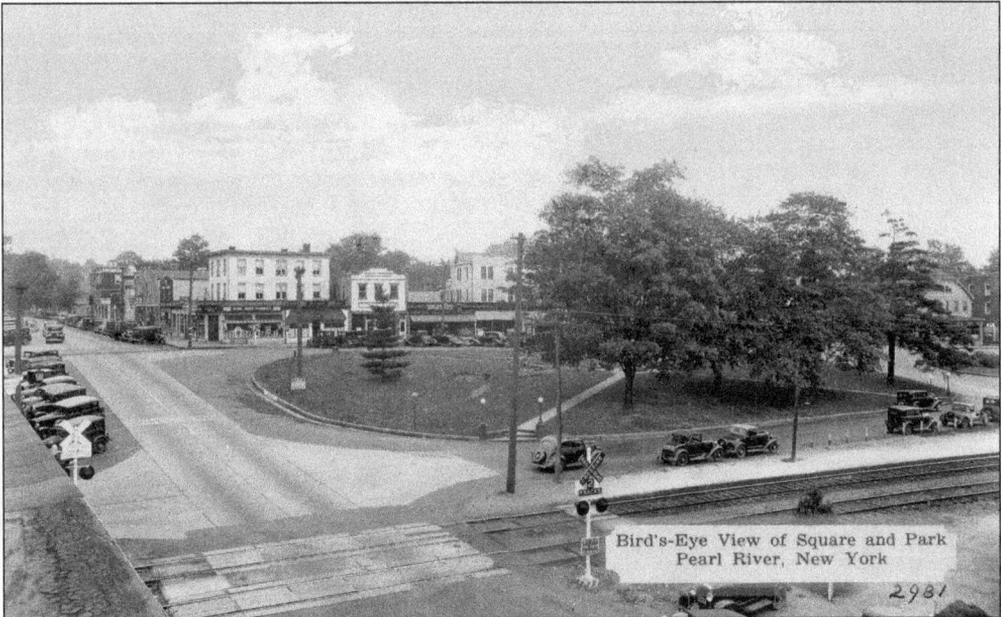

Bird's-Eye View of Square and Park
Pearl River, New York
2981

Braunsdorf's plan for a wide, central avenue and cross streets still formed the grid of Pearl River's business district in the 1930s and still does today. Braunsdorf designed Central Avenue after the broad boulevards of Europe, and paralleled it with Franklin Avenue, named after his favorite inventor, Benjamin Franklin. Connecting cross streets were named for his sons, William, John, and Henry. The park between South Main and the tracks is Braunsdorf Park. (Courtesy HSRC.)

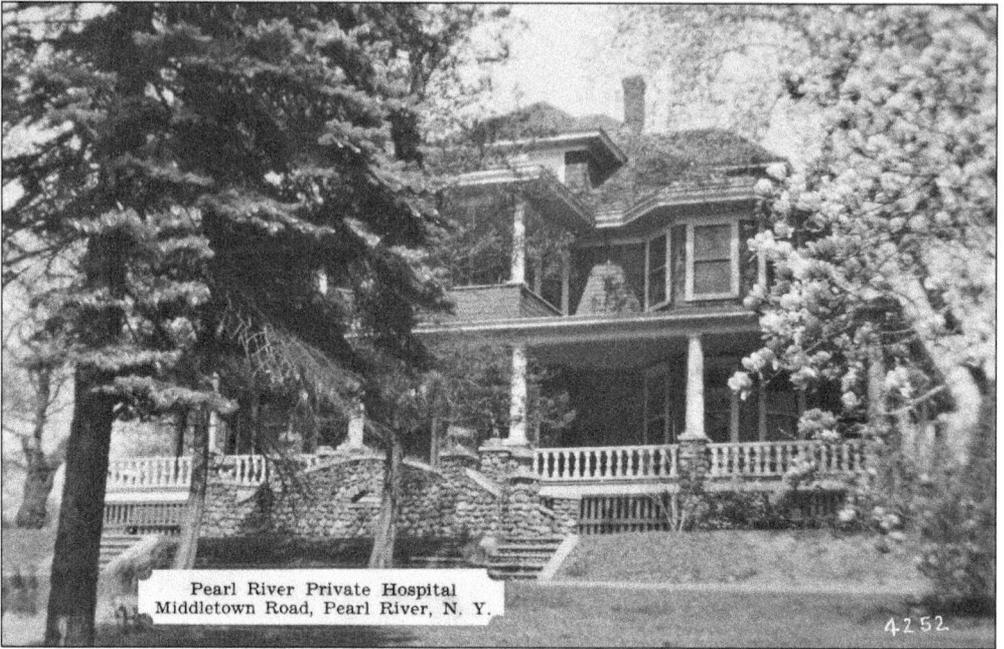

Pearl River Private Hospital
Middletown Road, Pearl River, N. Y.

4252

Pearl River Hospital was founded in a 19th-century home on South Middletown Road in 1935 by Gertrude Eybers and her daughter Margaret Sallander. Facing bankruptcy in 1949, it was auctioned to Dr. Harry Gegerson who planned to revive and expand its capacity from 24 beds to 76. Unable to operate profitably, however, it closed in 1974 and eventually became a nursing home. It was demolished in 2002 for senior citizen housing. (Courtesy HSRC.)

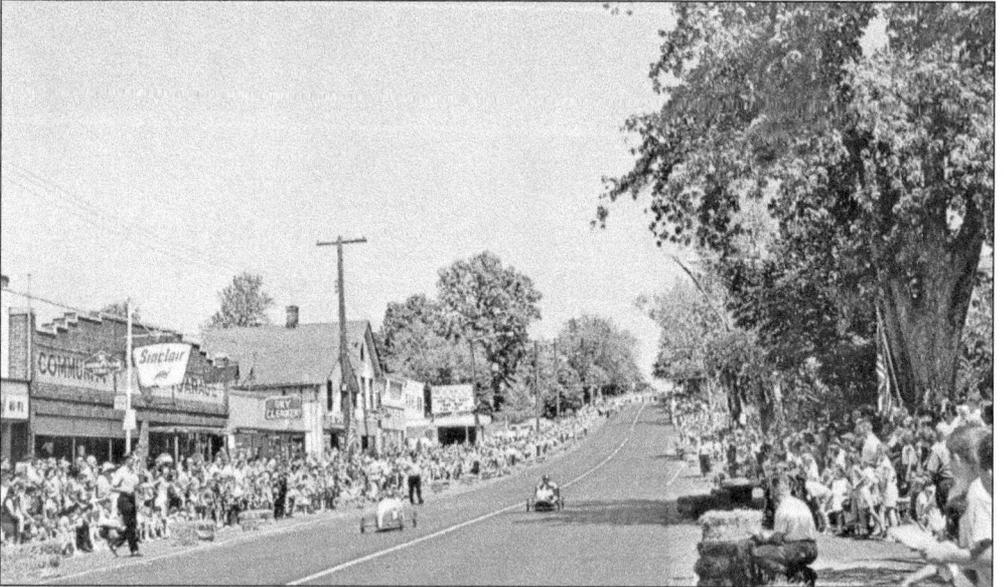

The Soapbox Derby was, from 1949 to 1963, an annual event on East Central Avenue. Sponsored by the Rotary Club, it drew young drivers from all of Rockland County. After Pearl River was awarded the derby's regional charter in 1964, drivers from Rockland and beyond could participate in this American tradition, with winners advancing directly to the national championships. The derby was discontinued in the 1970s but revived again in 2000. (Courtesy HSRC.)

Seven

ORANGEBURG

It has been said that Orangeburg is the hamlet created by commerce, a community known for the two rail lines that intersected here—the Erie and the West Shore—that were used for transporting passengers, produce, and products to New York and within Orangetown.

The territory that makes up Orangeburg was part of the Tappan Patent of 1686 and, over the years, was referred to as Orangetown and Orangeburg Station. In the mid-19th century, it was a sparsely populated, highly productive area typified by the farms and pastures that produced and shipped fresh milk, strawberries, and tomatoes to the city by rail.

In 1861, the first post office was established in the Erie rail station, discontinued a year later and reestablished in 1880. As electricity began to illuminate Orangetown in the late 19th century, S.R. Bradley established the Fiber Conduit Company in 1893 along today's Route 303. The company made petroleum-based piping for carrying electric power lines underground, a business that continued until widespread use of cheaper PVC forced it to close in 1972. Bradley also built a power-generating plant in the 1920s, which led to the formation of Rockland Light and Power Company, a predecessor of Orange and Rockland Utilities. Hollings-Smith and Bell & Co., two pharmaceutical companies that manufactured various pills used for colic, headaches, and indigestion, operated on Greenbush Road from 1897 to 1971. Horse racing was another entertainment held at the nearby Orangeburg Fairgrounds.

In the 1930s, the expansive Rockland State Hospital was built here to care for the mentally ill. And in 1942, Orangeburg's landscape was altered forever by the creation of Camp Shanks, which, from 1943 to 1945, processed more than 1.3 million soldiers for deployment to Europe and processed 290,000 German and Italian prisoners of war.

After the war, the camp became Shanks Village, which provided housing for returning veterans until March 1956. Soon after, and into the 1960s, what was once Camp Shanks/Shanks Village and centuries-old farmland was sold to make way for housing developments, which, thanks to the Tappan Zee Bridge and Palisades Parkway, brought hundreds of new families to Orangeburg.

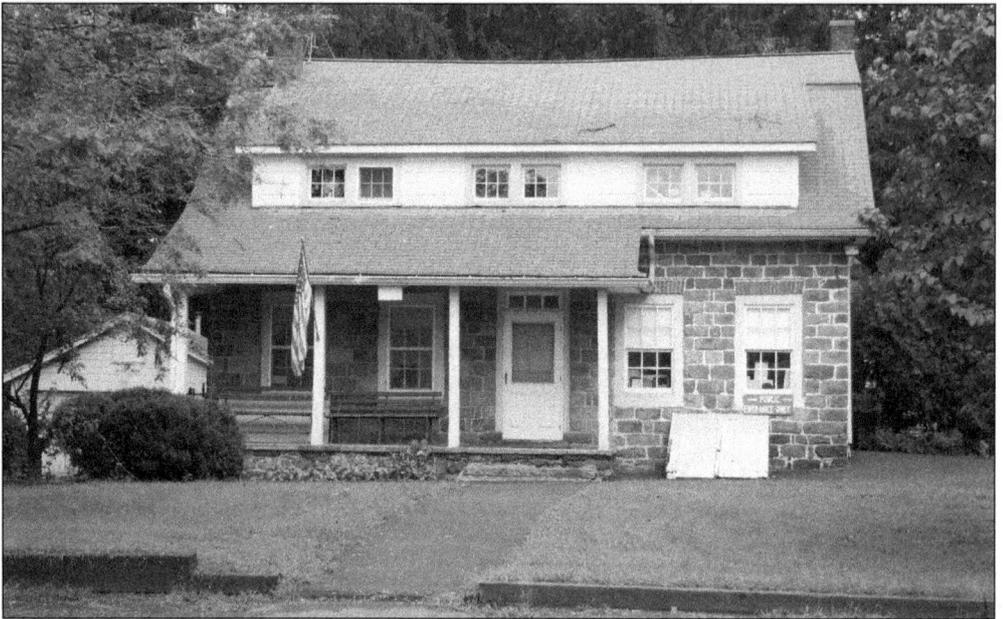

Built before 1778, the Peter DePew house appears on a wartime map drawn by Robert Erskine, Geographer and Surveyor General of the Continental Army. DePew's house was built in the typical 18th-century style of the Lower Hudson Valley: two windows on either side of the door and a classic gambrel roof. Today, it serves as the administrative office of the Orangetown Department of Parks and Recreation. (Photograph by Elizabeth Skrabonja.)

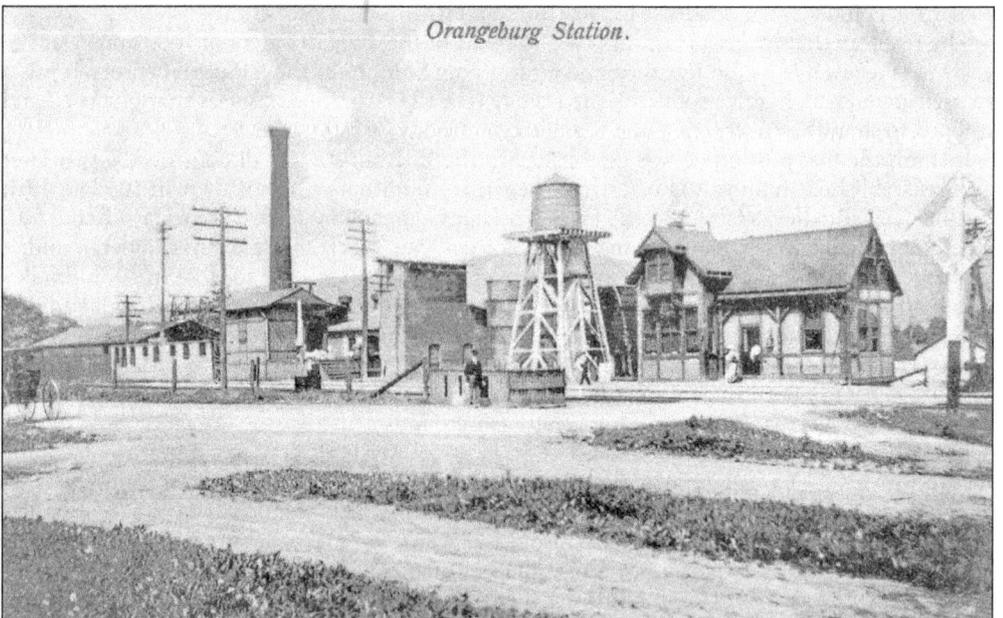

Built in 1883, the busy West Shore rail station was located near the water tower and smoke stacks of the Rockland Light and Power Company, founded by Stephen R. Bradley. Since electric lighting had come into use, power ran through lines strung from poles. But Bradley envisioned that power could be installed instead underground using wood-fiber tubing soaked in pitch. In 1893, Bradley established the Fiber Conduit Company in Orangeburg. (Courtesy HSRC.)

84

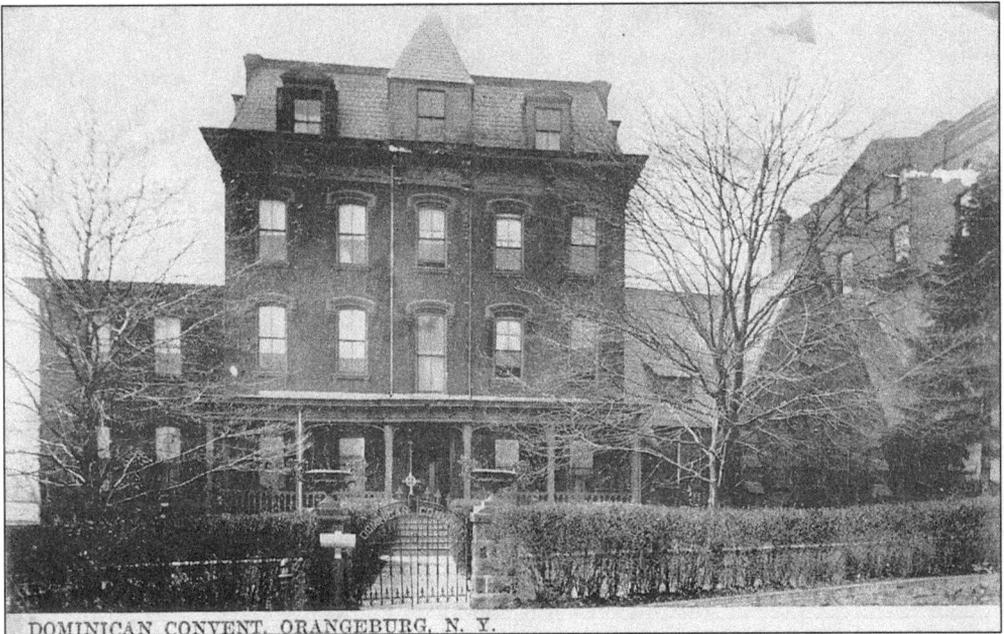

DOMINICAN CONVENT, ORANGEBURG, N. Y.

In 1878, Dominican Sisters from New York purchased a large house on Western Highway to establish St. Dominic's convent and home for orphaned and homeless immigrant children. Over the years, the convent and St. Catharine's cooperated closely. When St. Catharine's School opened in 1957, the Sisters served as staff and teachers. Today, the original St. Dominic's has grown to include St. Dominic's Home, a cemetery, and parts of Dominican College. (Courtesy Robert Knight.)

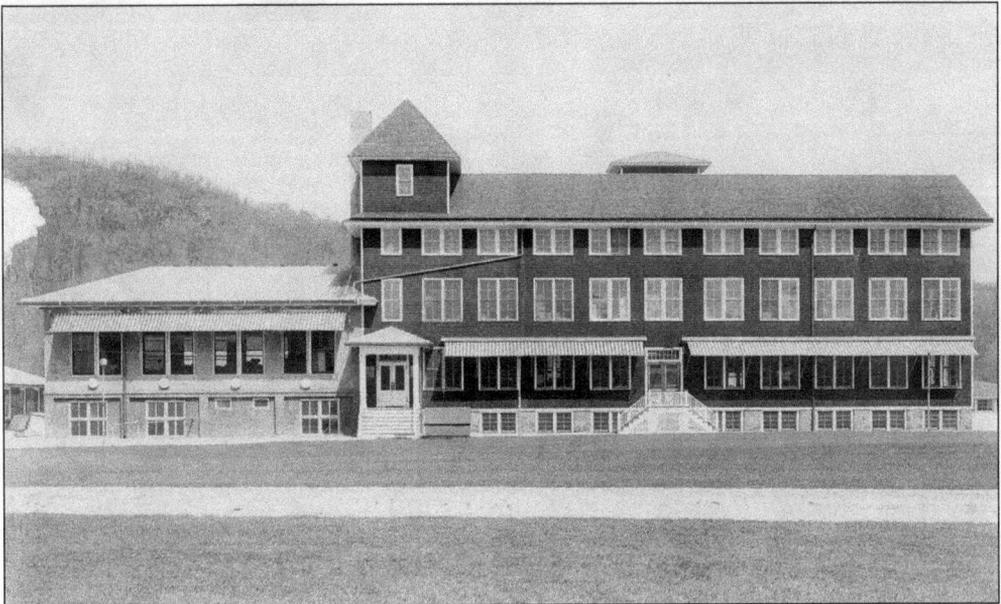

The Bell & Co. and the Hollings-Smith Co. pharmaceutical companies were founded by John L. Dodge, son of a Union army surgeon. Dodge developed successful treatments for ailments like indigestion, insomnia, and colic. In 1971, Bell & Co. closed after it sold the formula for its most popular acid-indigestion product to Hollings-Smith Co., which closed in 1977. Today, the building that was Dodge's factory is still called the Bell-Ans Building. (Courtesy Catherine M. Dodge.)

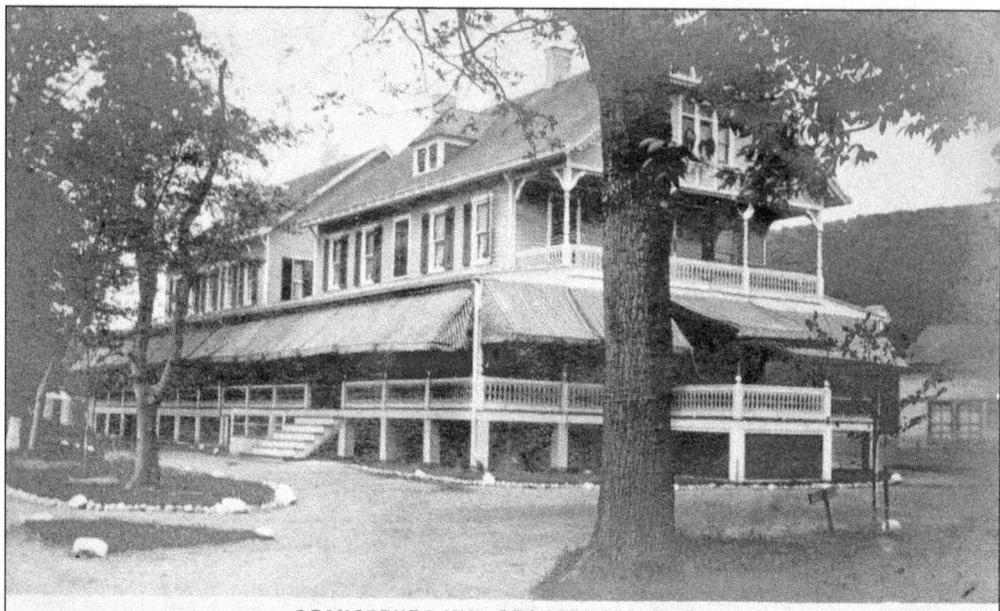

ORANGEBURG INN, ORANGEBURG, N. Y.

Across from the Clausland Cemetery on Greenburg Road, John L. Dodge built the Orangeburg Inn in 1897, which stood on part of the 40 acres that made up the Orangeburg Fair Grounds. The fairgrounds were a major entertainment attraction for people throughout the area. Here, people could watch horse racing, enjoy the Ferris wheel, local food, play games, and see exhibits related mostly to agricultural life. (Courtesy Chris Gremski.)

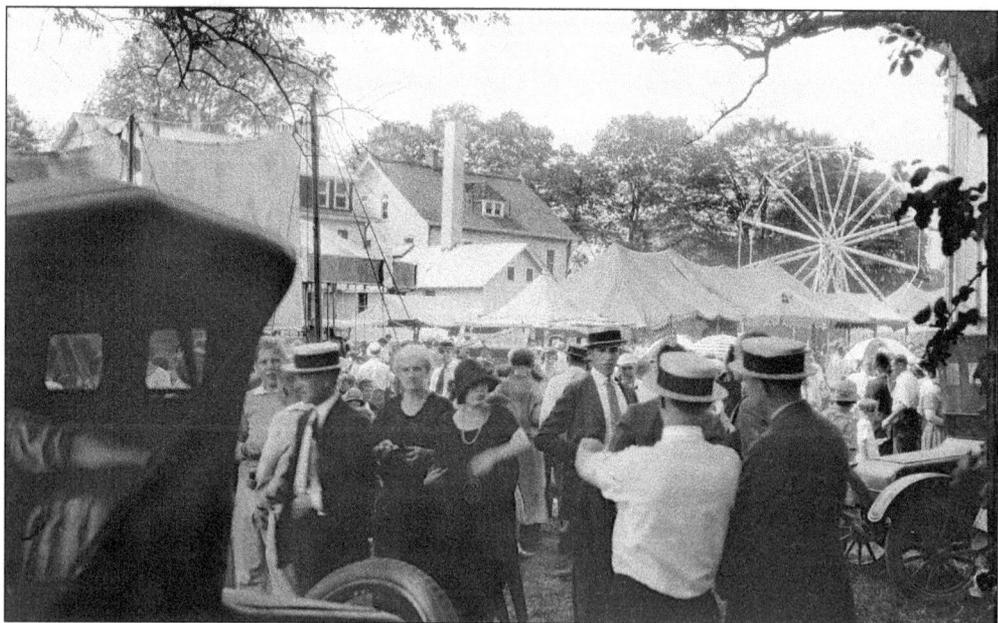

In the 1920s, the busy Orangeburg Fair had a number of attractions, including a Ferris wheel and pony rides. But the biggest events were in the tents where homegrown flowers, and homemade cakes, breads, honey preserved fruits and jellies, and other foods and crafts were judged for blue ribbons and cash prizes. Horses were judged for show and speed, and cattle, sheep, pigs, and poultry were also judged for health and development. (Courtesy OHMA.)

The Rockland County Industrial Fair began in 1843 as an agricultural exhibition fair in Spring Valley and later in New City. When it moved to Orangeburg in the early 1900s, it became known as the Orangeburg Fair. Attractions included automobile and motorcycle tricks, performing elephants from the Clarkstown Country Club, and balloon rides. The fair ended during World War II, and attempts to revive it after the war were unsuccessful. (Courtesy Nyack Library.)

By World War I, the Orangeburg Fair was traditionally held over Labor Day weekends. This four-day event was held on the Dodge family's Bell & Co. property east of Greenbush Road, near where Wide World of Volkswagen was once located. Horse shows and harness racing were wildly popular events and attracted large crowds. Harness racing came to an end in the late 1930s. Dog racing and stock car races replaced it. (Courtesy OHMA.)

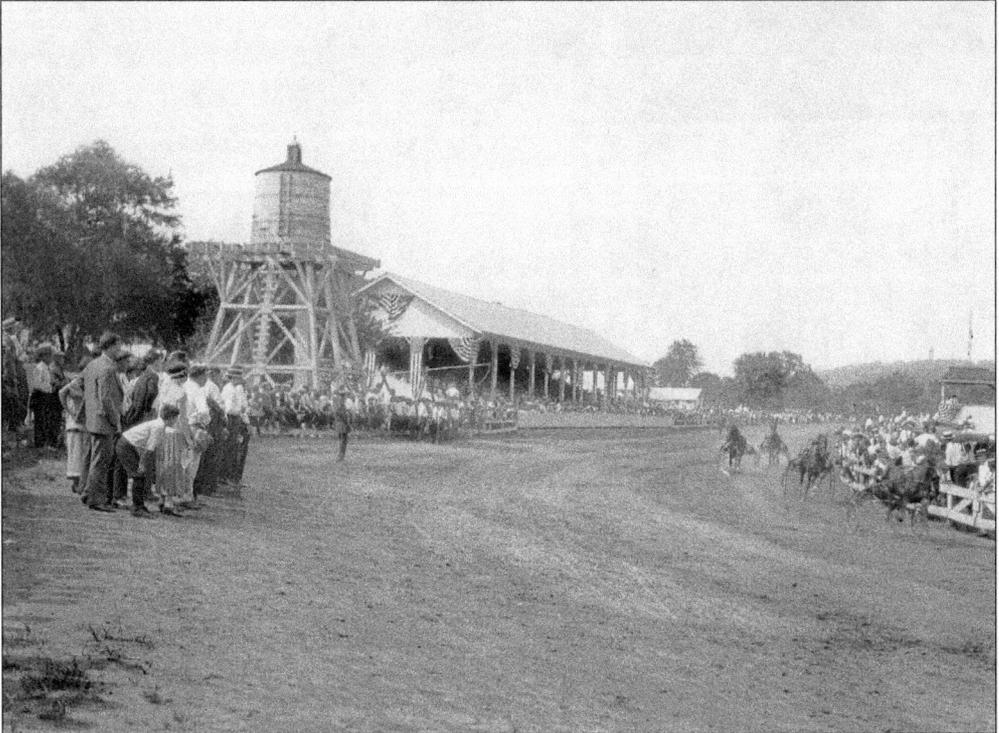

This early-1900s photograph shows a group of men and a team of four horses grading a road somewhere in Orangeburg. The dirt road they are working on was in use long before Route 303 was constructed nearby in the 1920s. Today, a larger, modern, and better-equipped Orangetown highway department works on nearly 200 miles of streets, highways, and roads in Orangetown. (Courtesy the Brawners.)

In the late 1920s, the State of New York purchased more than 600 acres to build the Rockland Psychiatric Hospital. At its peak, it had a patient population of 9,650, and a staff of nearly 10,000. It was a self-sufficient entity with vegetable gardens, a dairy, and chicken coops. Huge kitchens provided the cooking and baking. After psychotropic drugs were introduced, many patients were treated on an outpatient basis. (Courtesy Chris Gremski.)

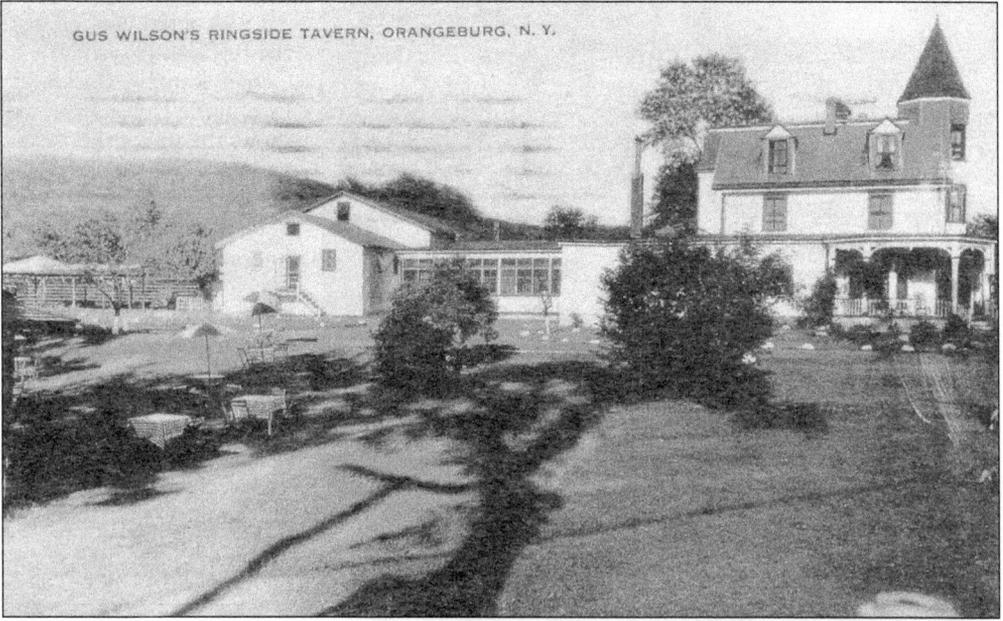

GUS WILSON'S RINGSIDE TAVERN, ORANGEBURG, N. Y.

Gus Wilson's camp, above, was the famous Orangeburg place where boxers trained and stayed. In the 1920s, Wilson trained Jack Dempsey, a fighter who went on to win the world heavyweight title. The building is still standing. The building on the far left housed the venerated boxing ring and is, as of 2011, an automobile parts store. These buildings are along Route 340 near Route 303. (Courtesy Larry Kigler.)

Another notable boxer who trained at Gus Wilson's was Jack Sharkey, who fought Max Schmeling for the heavyweight title in 1932. That same year, Sharkey posed with child-actor Jackie Cooper at Wilson's camp. In 1931, Cooper starred with Wallace Beery in a boxing movie called *The Champ*. The film won two Oscars: Wallace Beery for best actor in a leading role and Francis Marion for best original story. (Courtesy Nyack Library.)

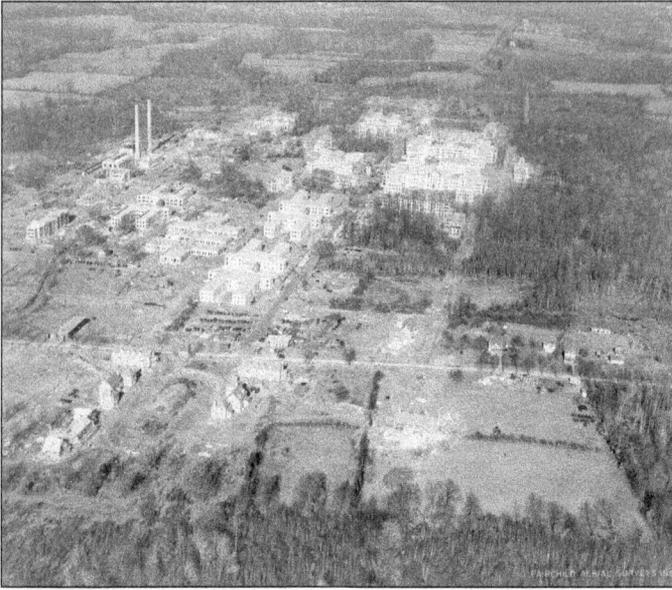

A 1930s aerial view of the Rockland Psychiatric Center, formally Rockland Psychiatric Hospital, shows the size of the property. Owned and operated by the State of New York, returning injured servicemen during World War II were given additional medical treatment before being shipped to other hospitals or home. As of 2011, this campus has been reduced to approximately 300 acres. The remaining acreage was sold mostly to the Town of Orangetown. (Courtesy OHMA.)

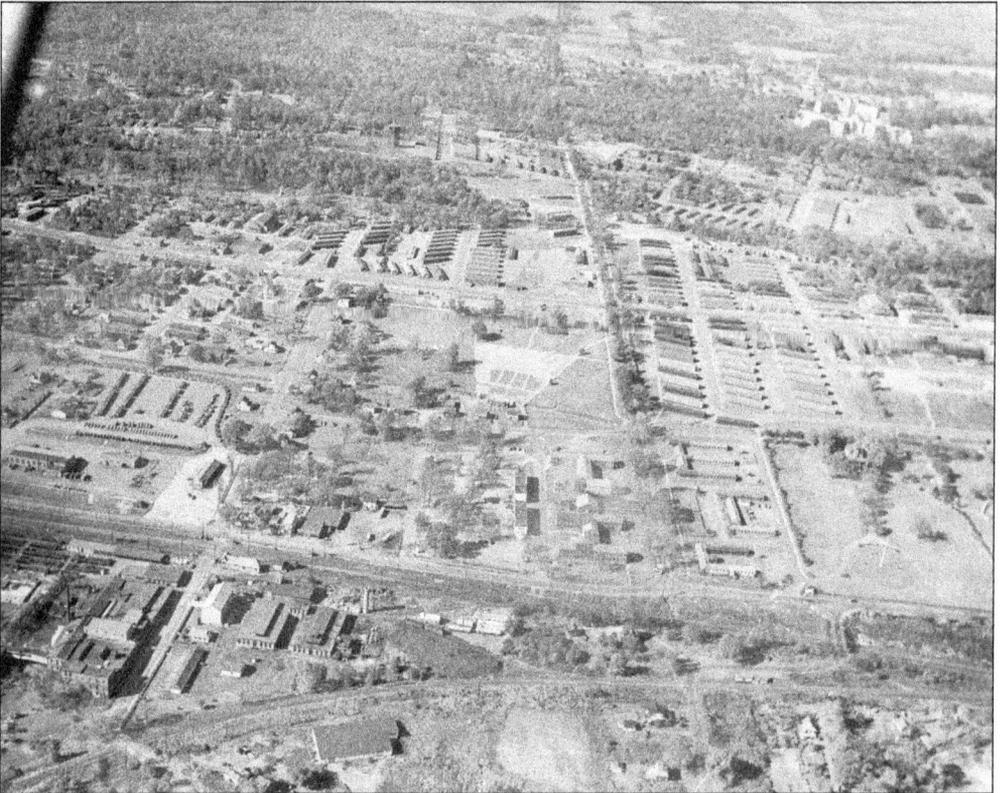

Camp Shanks stretched 2.5 miles along Western Highway, from Washington Avenue in Tappan to Blauvelt Road in Blauvelt and was bordered by the West Shore Railroad. The entire camp covered 2,040 acres and was the Army's wartime point of embarkation. The Camp Shanks amphitheater in the center of the photograph is where the Orangetown Center is now located. The Fiber Conduit buildings are in the lower left-hand corner. (Courtesy Scott Webber Collection.)

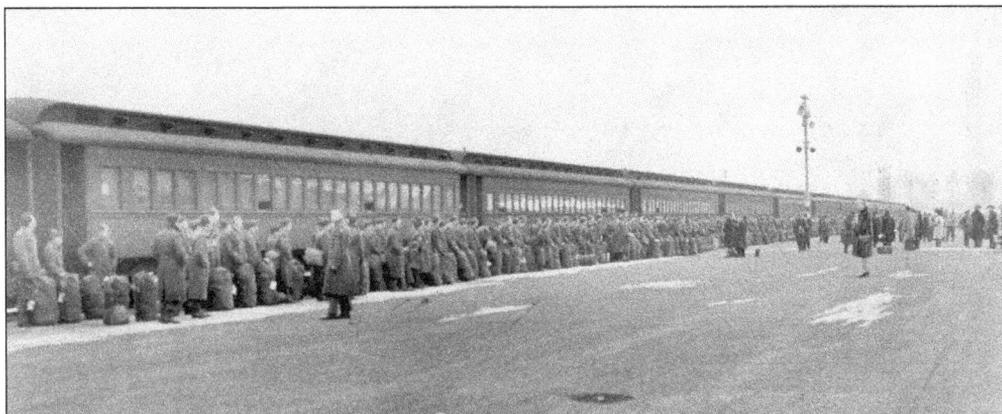

Newly processed soldiers from Camp Shanks wait for train transportation to either Weehawken or Jersey City where ships transported them to Europe. One ship, the *Queen Mary*, transported as many as 650,000 troops during World War II. Standing apart from these soldiers are parents, sweethearts, family, and friends saying their good-byes. After the war, many returning troops were transported back to Camp Shanks via the Piermont Pier. (Courtesy Scott Webber Collection.)

To build Camp Shanks, 1,365 acres were seized under the War Powers Act, and affected residents were given two weeks to vacate. It opened on January 4, 1943, and became one of the largest troop-staging areas of World War II. Here, soldiers were trained, equipped, and readied for deployment to Europe. In all, more than 1.3 million soldiers were processed here, and more than 500,000 were processed again on their return. (Courtesy Scott Webber Collection.)

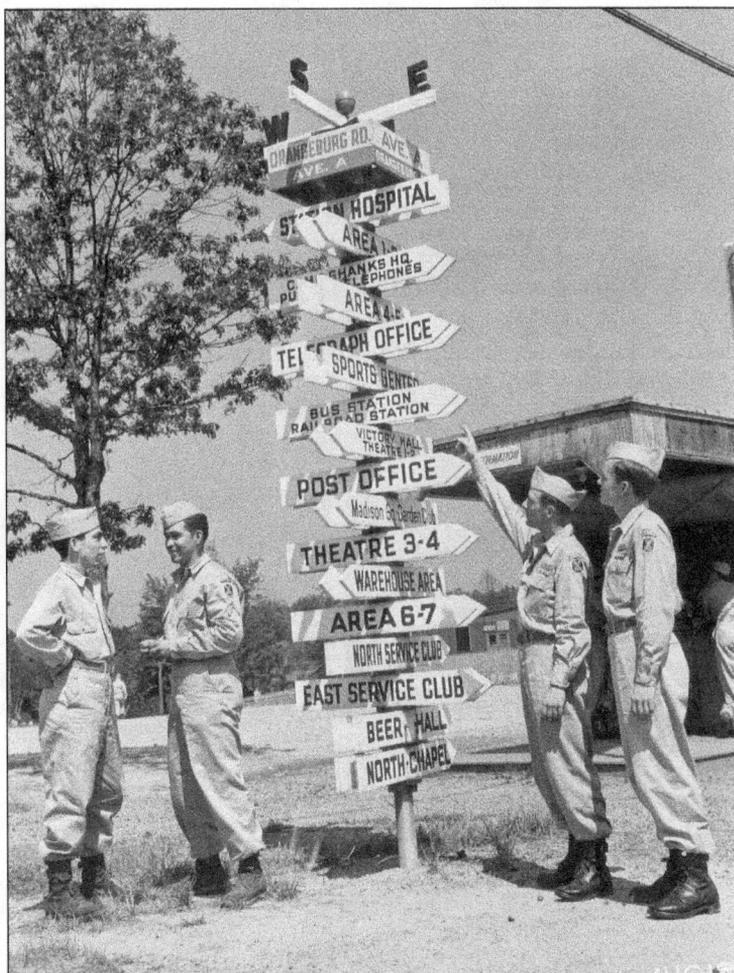

Of the more than 400,000 German, Italian, and other POWs held in the US during World War II, over 290,000 were processed through Camp Shanks. Because Italy had joined the Allied side in 1943, Italian prisoners were considered less of a threat, more congenial, and were allowed a degree of freedom not given the Germans. They were often allowed Sunday visits from relatives living in the New York area. (Courtesy Scott Webber Collection.)

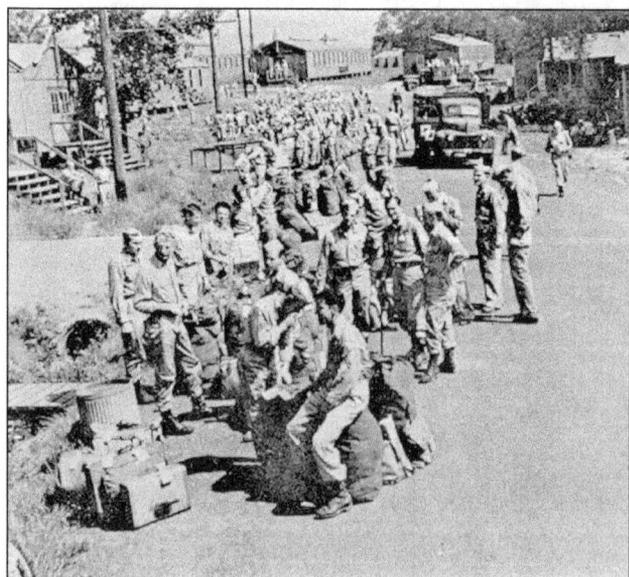

This picture taken at Camp Shanks in 1945 illustrates the classic GI practice of "hurry up and wait." These troops were members of the 85th Infantry Regiment of the 10th Mountain Division who assembled, no doubt hurriedly, and waited for transfer to a military reception facility at Camp Meade, Maryland. In all, there were 26 reception camps scattered across the country where returning soldiers were sent for further processing. (Courtesy Nyack Library.)

After World War II, there was a housing shortage for returning GIs and their families. From 1946 to 1956, Camp Shanks became Shanks Village. Barracks were converted into apartments ranging from a studio to three bedrooms. Rents were $29 to $38 respectively, and included gas, electricity, water, and an oil heater. Household goods could be rented for $1 per month. A total number of 1,430 apartments were created. (Courtesy Robert Knight.)

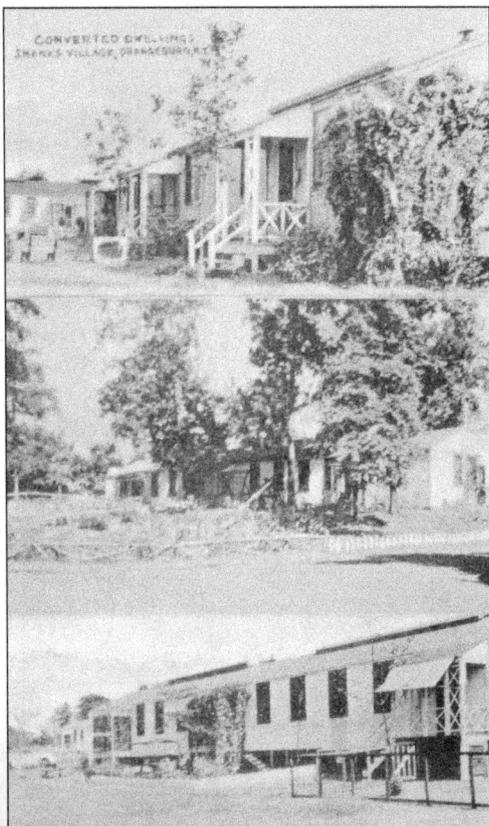

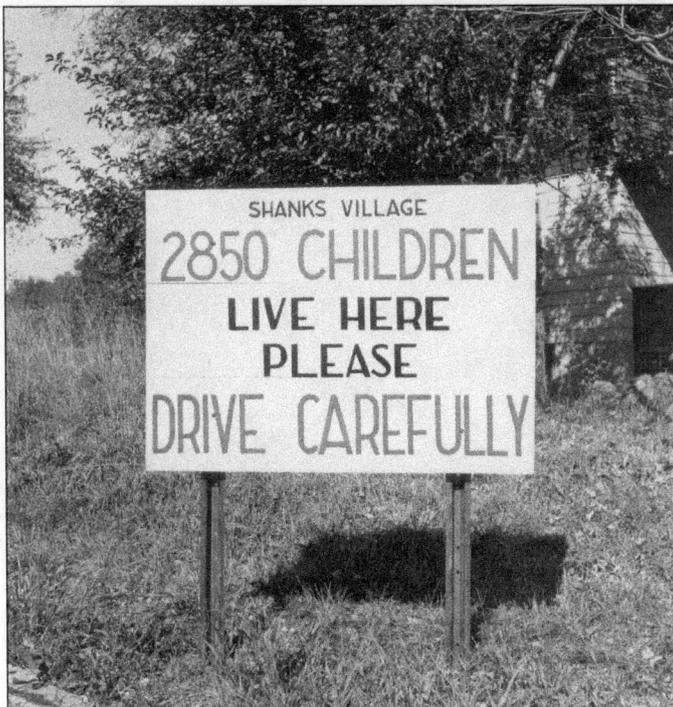

At one time, it was reported that there were 3,000 adults and nearly the same number of children in Shanks Village. This model community was noticed by anthropologist Margaret Mead and Eleanor Roosevelt, who called it an inspiring spot. Dwight Eisenhower, former Allied commander and president of Columbia University from 1948 to 1950, visited the children at the Shanks Village nursery. The nursery had three staff members and a nurse. (Courtesy Scott Webber Collection.)

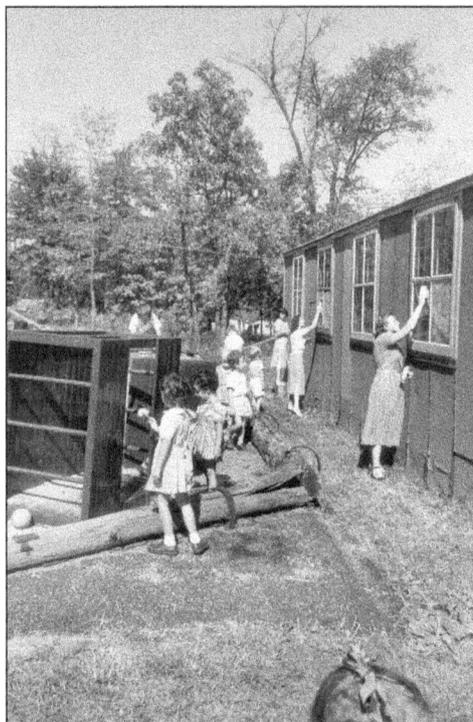

Many ex-GIs in Shanks Village went to Columbia University, Union Theological Seminary, Manhattan College, New York University, and schools in New Jersey. They also had full-time jobs. Their wives and children took care of the routines of everyday living, but there was a team-like spirit among them. These families established a food co-op and a nursery. It was both a successful experiment and a model of community living. (Courtesy Scott Webber Collection.)

In 1948, Orangeburg's Fiber Conduit Company changed hands to become the Orangeburg Manufacturing Company and was sold again in 1958 to form the Flintkote Company. To keep up with the postwar housing boom, the Orangeburg plant produced petroleum-based drain and sewer pipes. In 1957, a disastrous fire broke out and caused extensive damage. The plant survived, but by 1972, PVC piping was produced more cheaply elsewhere, so the Orangeburg factory closed. (Courtesy HSRC.)

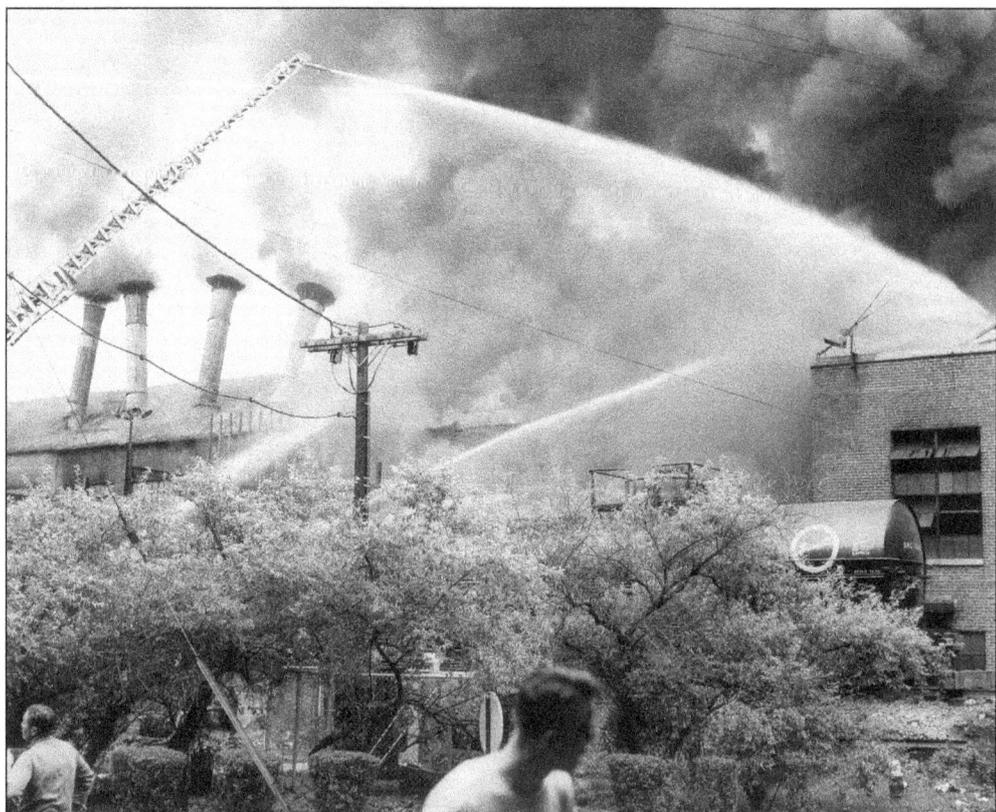

Eight

BLAUVELT

The Hamlet of Blauvelt was originally part of land included in the Tappan Patent of 1686. Among the 10 families who settled here, several people were members of the Blauvelt family, and together they named this green and productive settlement Greenbush.

Residents of Greenbush attended Sunday services at the Dutch Reformed Church in Tappan. After the American Revolution, several of them wanted a church of their own. They applied to the New York Presbytery and were granted permission to establish the Greenbush Presbyterian Church on Greenbush Road on October 8, 1812.

The first school here, the Greenbush Academy, was built in 1809. In the early 1800s, Judge Cornelius Blauvelt—farmer, merchant, builder, and state legislator—built a road, today's Route 340, to transport produce to Tappan Landing, now Piermont. He built a 500-foot pier there in 1824 to accommodate steamships. Blauvelt was instrumental in the building of Erie Railroad, which included a rail stop here. The Erie was completed in 1851. Local farmers used the railroad to ship fresh milk daily to New York, a run that became known as the "Milky Way." In Judge Blauvelt's honor, the people of Greenbush renamed the hamlet Blauveltville in 1836. The first post office was established in Judge Blauvelt's store that same year, and he served as its first postmaster.

In the mid-1850s, German Catholic immigrants from Manhattan began arriving, and in 1868 they established St. Catharine's Church. By the beginning of the 20th century, there were about 15 houses, two churches, a store, and a school here, and Blauveltville was simply called Blauvelt. In 1910, the New York National Guard built Bluefields, a rifle training range. From 1913 to 1918, the range became a YWCA camp for young working girls from New York City.

Passenger service on the Erie Railroad ended in 1936. The West Shore Railroad, which extended service through Blauvelt in 1873, ended passenger service in 1959. Today, Blauvelt remains a small, quiet residential hamlet where a number of the 18th- and early-19th-century sandstone homes built by the descendants of the original founding families still stand along present-day Western Highway.

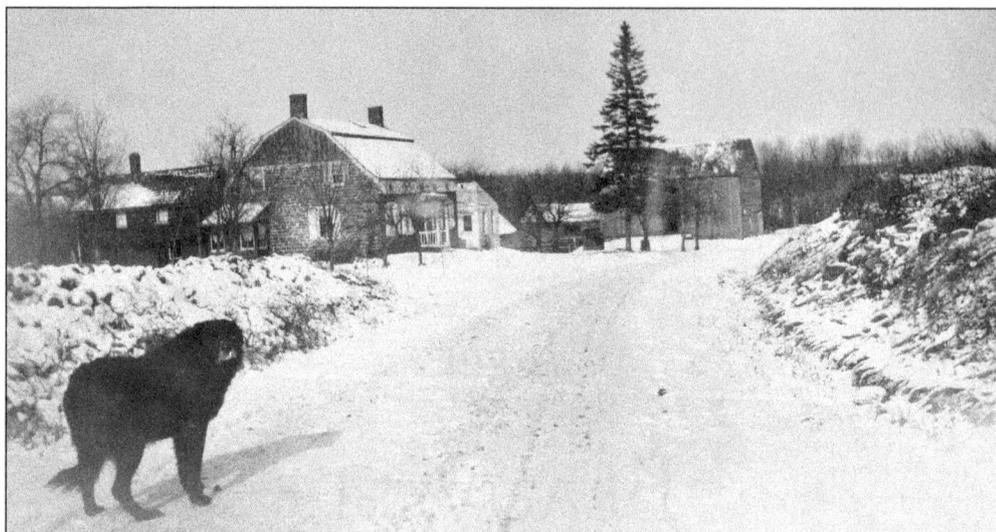

Pictured along Western Highway during the winter of 1900, the first section of this Dutch farmhouse was built by Johannes Blauvelt in 1755. Johannes Blauvelt fought in the American Revolution, serving as a captain in the Second Regiment of the Orange County Militia, and he was a founding member of the Greenbush Presbyterian Church in 1812. Descendants of the Blauvelt family occupied this house and its additions for 135 years. (Courtesy HSRC.)

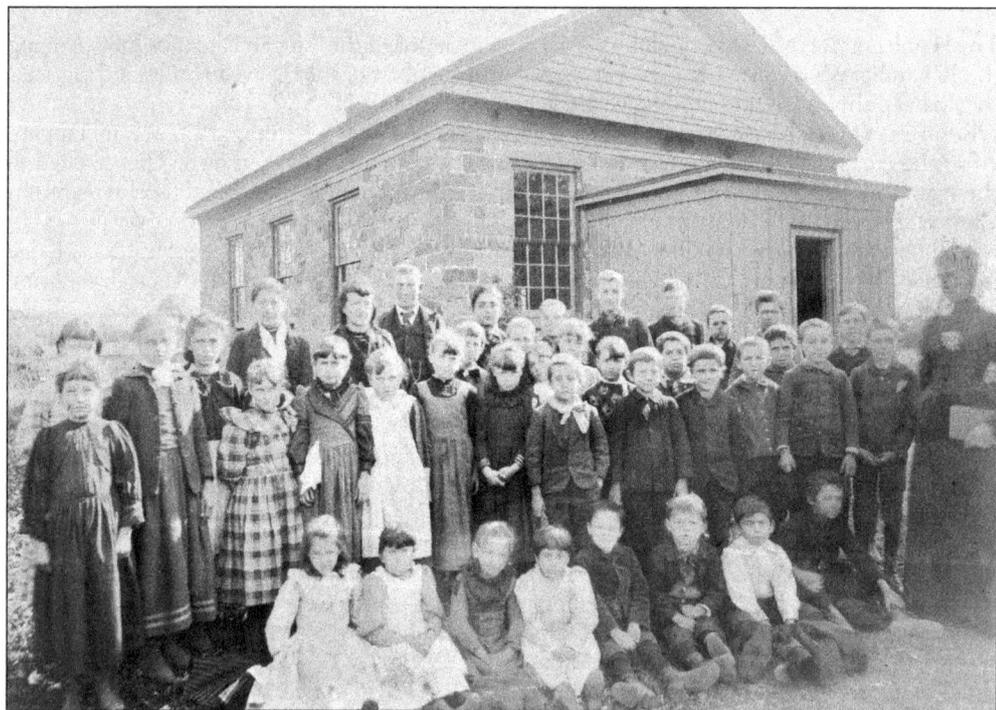

Greenbush Academy was the first school in Greenbush, a two-story stone structure built in 1809. It had a classroom and teacher's residence on the first floor and a large room upstairs for community use. In 1850, a new, one-story schoolhouse was built in its place, and after years of increased enrollment, an addition was built in 1908. The school, pictured here c. 1905, had 39 students and one teacher. (Courtesy HSRC.)

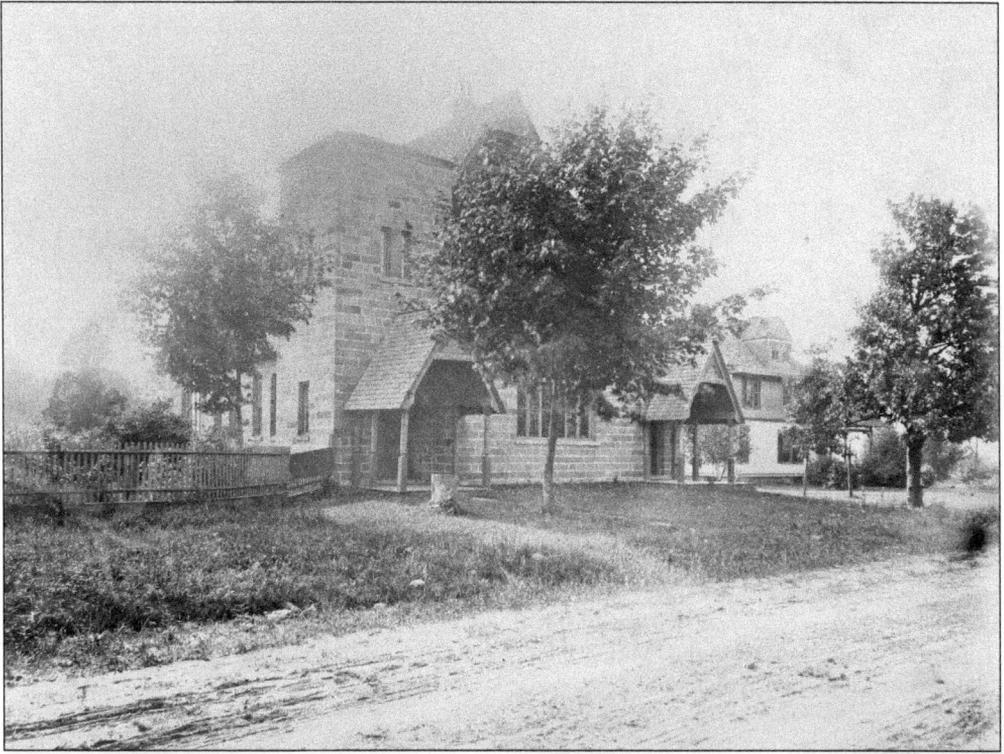

Refused permission from the Dutch Reformed Church in Tappan to establish an English-speaking church near their homes, a group of Greenbush residents established a Presbyterian church instead on the second floor of the Greenbush Academy in 1812. In 1823, the first church was built across the road but burned in 1835. A second church was built in 1837 but also burned in 1882. The present-day church, pictured c. 1890, was completed in 1883. (Courtesy HSRC.)

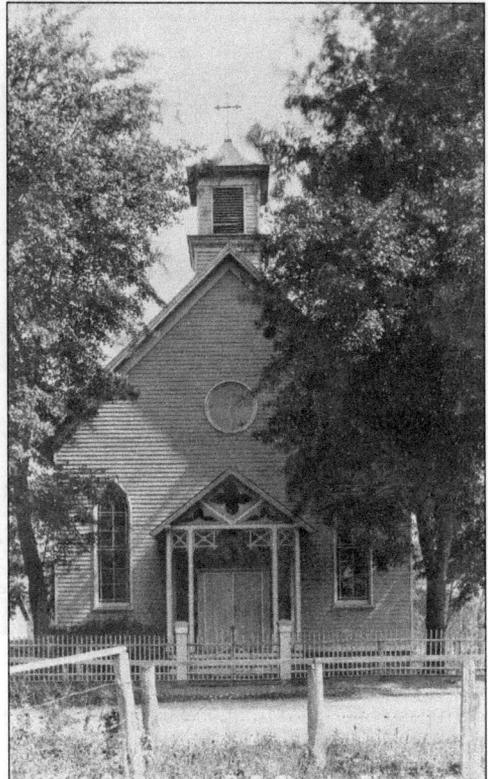

Drawn by Blauvelt's rural setting and good farmland, German Catholics from Manhattan began settling here in the mid-1850s. Their Sunday services, however, required a trek to St. John's in Piermont, a difficult task in winter. Wanting a church where they could conduct services in German, they established St. Catharine's in 1868 on land donated by George Lediger. The church, pictured c. 1900, burned down in 1964 and was rebuilt in 1968. (Courtesy OHMA.)

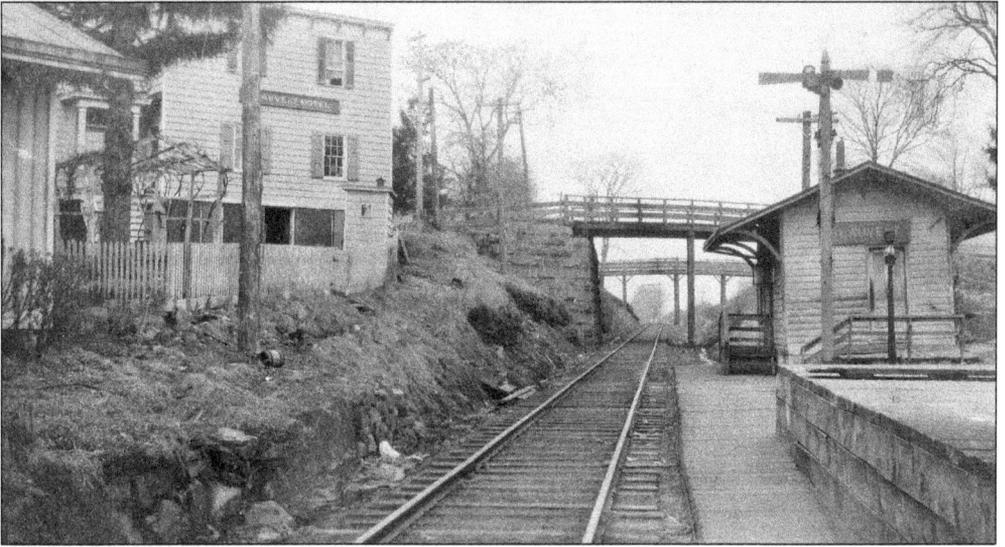

By the 1840s, the Erie Railroad connected Blauvelt to Piermont, where passengers and freight were transferred to New York. When the entire Erie system was completed in 1851, it also connected Blauvelt to western New York. Farmers shipped containers of fresh milk by train daily to the city, a run that became known as the "Milky Way." The Erie station, pictured c. 1920, was built before 1851. (Courtesy Robert Knight.)

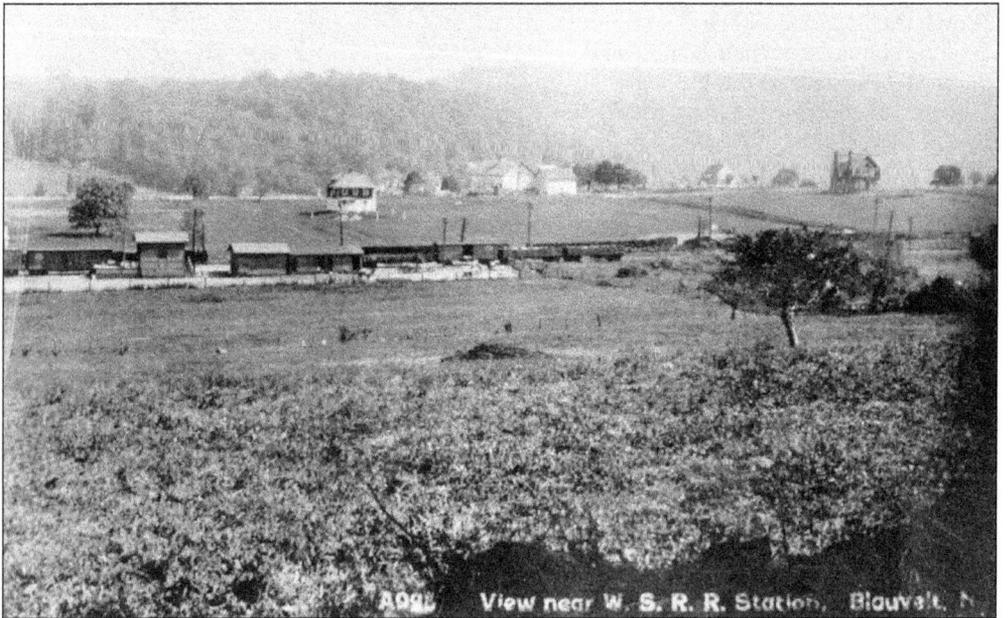

The West Shore station in Blauvelt was built near Erie Street in 1883 in the midst of farmland and connected Blauvelt to New York-bound ferries in Weehawken, New Jersey. Although it carried both passengers and freight, passenger service was discontinued in 1959. The station, pictured in the 1930s, was designed by the same architect that designed stations in Orangeburg and Tappan. Today, the tracks are used only by freight trains. (Courtesy Nyack Library.)

Centuries before the steady flow of the Hackensack River was dammed and nearby land cleared and flooded to create a system of reservoirs in the 1960s, "the creek," as it was commonly called, was used over the years for waterpower, fishing, swimming, exploring, and childhood adventure. Two boys, pictured here c. 1880, are perched in fallen trees above the creek bank not far from Nauraushaun. (Courtesy HSRC.)

Judge Cornelius Blauvelt—farmer, merchant, builder, and state legislator—was instrumental in establishing the Erie Railroad that linked Greenbush to Piermont, New York City, and beyond. Around 1800, he started a general store that in 1836 became the first post office, which remained in use until 1955. To honor Judge Blauvelt, residents of Greenbush renamed the hamlet Blauveltville in 1836. By the early 1900s, it was more commonly called Blauvelt. (Courtesy OHMA.)

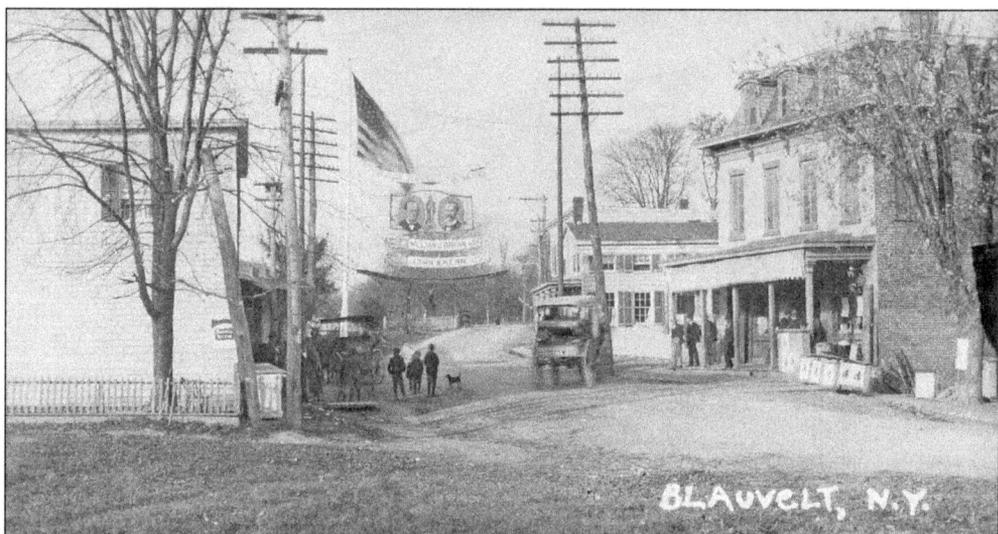

Built in 1867 on Western Highway, Lediger's was a general and hardware store, a three-story structure that still stands today. George Lediger, a German immigrant, established it with Henry Edebohl, both of whom served as postmasters. The store, then operated by George and John Klee, is pictured looking north in 1908, the year that William Jennings Bryan ran—and lost—as the Democratic presidential nominee for the third time. (Courtesy OHMA.)

Even though it was no longer owned by George Lediger in 1909, most people still referred to George and John Klees' store as Lediger's. Even the old horse-drawn delivery wagon that Lediger used to pick up orders and deliver groceries, supplies, and other merchandise to homes in Blauvelt still carried his name. In 1911, the only telephone in all of Blauvelt was located in this store. (Courtesy Nyack Library.)

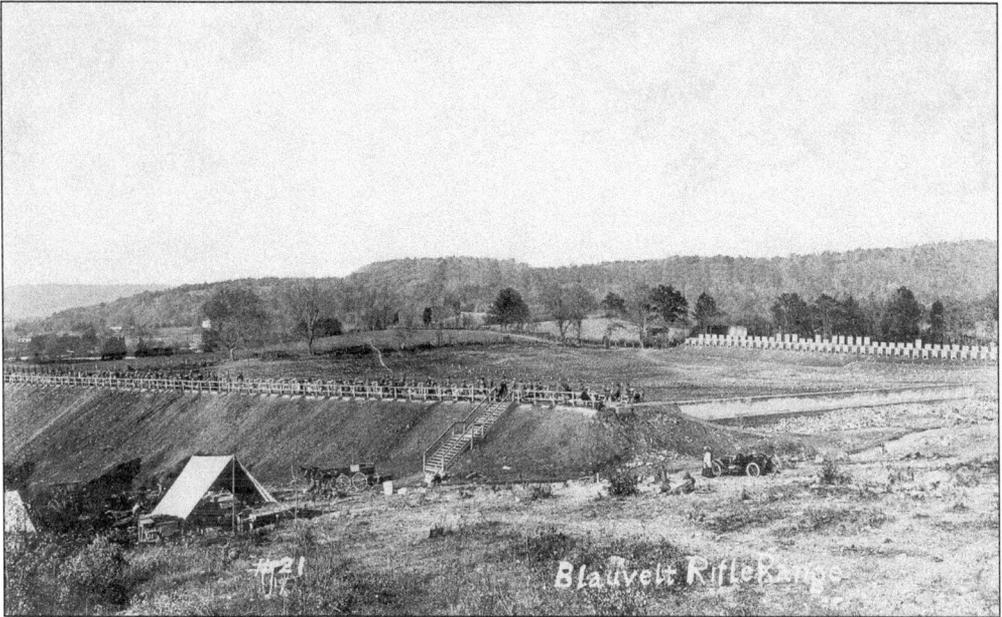

In 1910, the New York National Guard bought land near Clausland Mountain from the Blauvelts to build a rifle training range called Bluefields, the English translation of Blauvelt. But after months of public furor over live stray bullets flying into homes in South Nyack, Camp Bluefields was closed in 1913. During World War I, it was reopened for training and again in World War II for soldiers from Camp Shanks. (Courtesy OMHA.)

Between its closure in 1913 and reopening in 1918, Camp Bluefields was a popular YWCA summer camp for young working girls from New York City. Charging $3.50 for a week's vacation of sleeping in tents and engaging in a variety of activities, the camp adhered to a regimented program. The girls were required to wear uniforms of bloomers and middy blouses, and the start of activities was signaled by bugles. (Courtesy OMHA.)

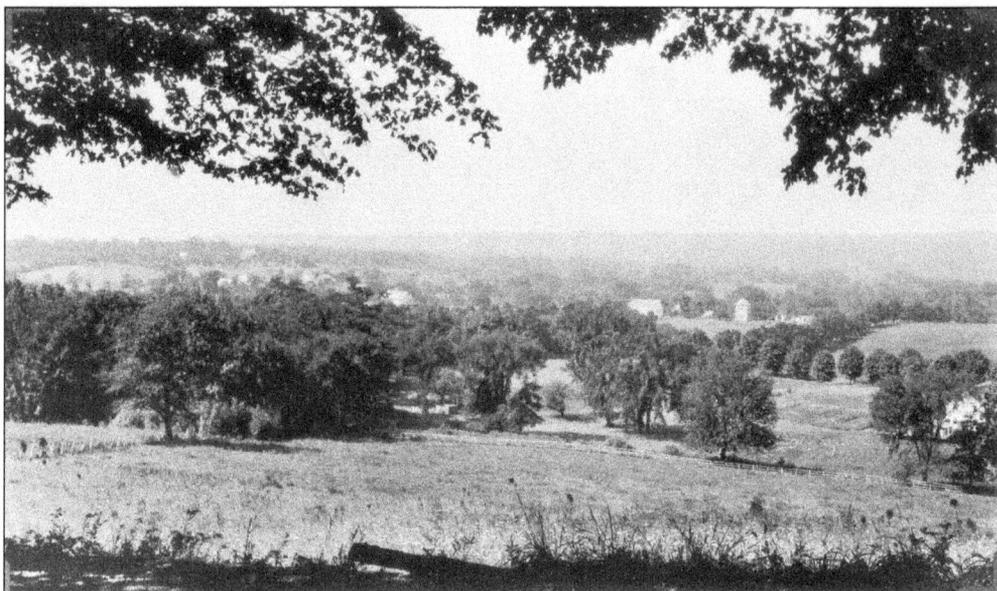

Looking out from Bradley Hill c. 1900, Blauvelt's rural setting is clearly shown. The hill was named for Stephen Bradley, a Blauvelt resident and founder of the Fiber Conduit Company in Orangeburg in 1893. Made from pressed layers of wood pulp sealed with pitch, these pipes made it possible to safely run electric wiring under streets, through buildings, and along railroads. Bradley Hill Road in Blauvelt is also named after him. (Courtesy HSRC.)

For most of its history, Blauvelt was a small, productive dairy and farming community, with few stores and houses. The buildings of downtown Blauvelt were simple structures located near the Erie rail station. Pictured here in 1890, the man on the right stands along the bridge that carried Western Highway over the Erie railroad tracks. The station was closed in 1936. On the left stands the Blauvelt Hotel. (Courtesy Nyack Library.)

When Judge Blauvelt moved to Piermont in the 1840s, he sold his house and the attached post office to his son-in-law, who sold it 10 years later to John Raab. A prominent family in Blauvelt, the Raabs were the sole station agents for the Erie Railroad from 1854 to 1936. The family lived in this well-cared-for house, shown c. 1890, for over 100 years. (Courtesy HSRC.)

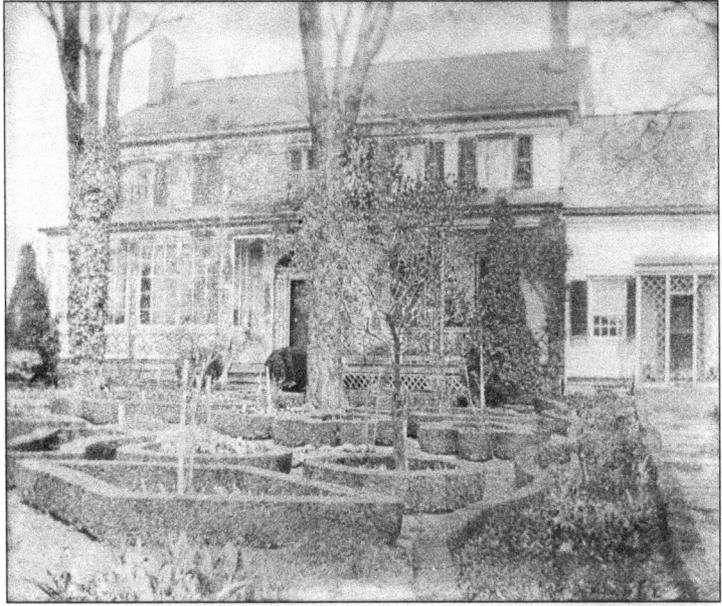

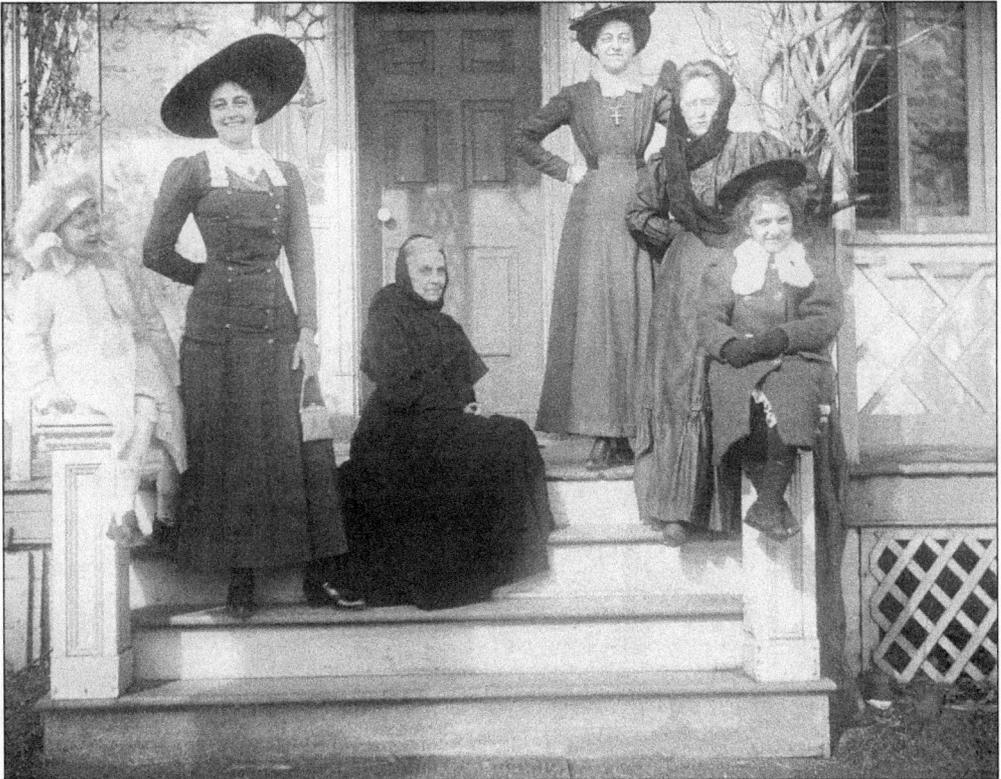

The Blauvelt/Raab House remained in the family until the late 1950s when Catharine Raab sold it to Joan Cobb, who donated it for use as the Blauvelt Library. Standing on the front porch of the house, c. 1900, are multigenerations of Raabs. They are, from left to right, Anne; Catherine's sister Marie; her grandmother; Rosemarie; Catherine's mother; and a young Catherine. (Courtesy OHMA.)

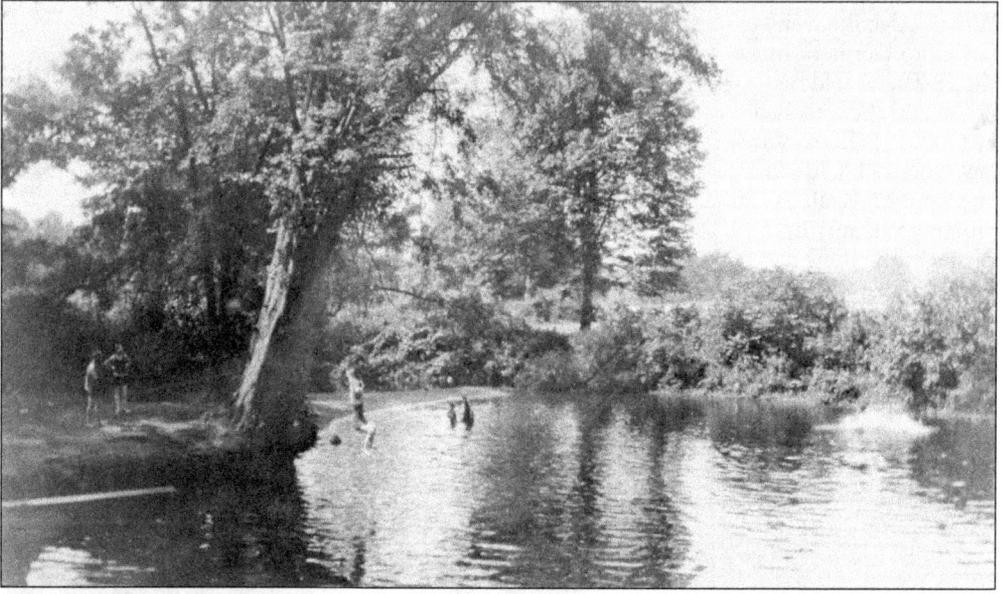

Forty-Foot Hole, pictured c. 1930 near the Fifth Avenue Bridge, was a popular spot to swim, canoe, and play. Its name derived from efforts to determine water's exact depth. A weight tied to a 40-foot rope was lowered to its full length and, it is said, did not touch bottom. This favorite spot was destroyed when Lake Tappan, a series of reservoirs on the Hackensack River, was expanded in the 1960s. (Courtesy Nyack Library.)

Running behind the vast banks of walls that held rifle practice targets for soldiers training at Camp Bluefields was a labyrinth of concrete tunnels—the longest stretched a quarter-mile—that enabled troops, instructors and others to move about the camp without being exposed to live fire. The ruins of these tunnels and other structures remain today in Blauvelt State Park and are popular sites to see and explore. (Courtesy HSRC.)

Nine

GRAND VIEW

Inspired by a railroad official who, in 1870, declared this scenic spot a "grand view," the Village of Grand View is as well known for the beauty and bounty of its past, as it is for the charm and tranquility of its present.

Referred to for much of its history as the "North End of Tappan," this was part of the 1671 Van Purmerant patents that led to the settling of Nyack. Van Purmerant's, son Cornelius Clausen Cooper, inherited and deeded a parcel of this forested riverfront to his brother John, who built a small house above a distinctive curve of coastline and fishing ground called "the Bight" in the 1730s.

During the American Revolution, the first full-scale engagement between the American and British navies took place just offshore here on August 3, 1776. Well before the war, Garret and Abraham Onderdonck discovered rich deposits of sandstone. When peace returned, they returned to quarrying in earnest.

Between 1820 and 1840, a total of 16 quarries were in full swing and building stone was being shipped to New York. By the mid-1820s, steam-powered ships arrived and soon provided faster service between Nyack and New York. In 1859, the Northern Railroad of New Jersey extended its line to Sparkill, and in 1870, New York was now just an hour away when the Nyack and Northern Railroad connected Grand View to Jersey City, a connection that continued for nearly 100 years. In the late 1800s and early 1900s, these trains also brought tourists, and elegant hotels and inns were built overlooking the Hudson to accommodate them.

Grand View was incorporated in 1900. But by 1917, a dispute over taxes for maintaining River Road erupted and the village was disincorporated. In 1918, the village was reincorporated as Grand View-on-the-Hudson, while those "up the hill" reverted to hamlet status as Upper Grand View.

The Tappan Zee Bridge was begun in 1952, and several homes were demolished or relocated during construction, which was completed in 1955. Today, this remains a picturesque community of distinctive homes, hills and waterfront, and, irrefutably, some of the grandest views in Orangetown.

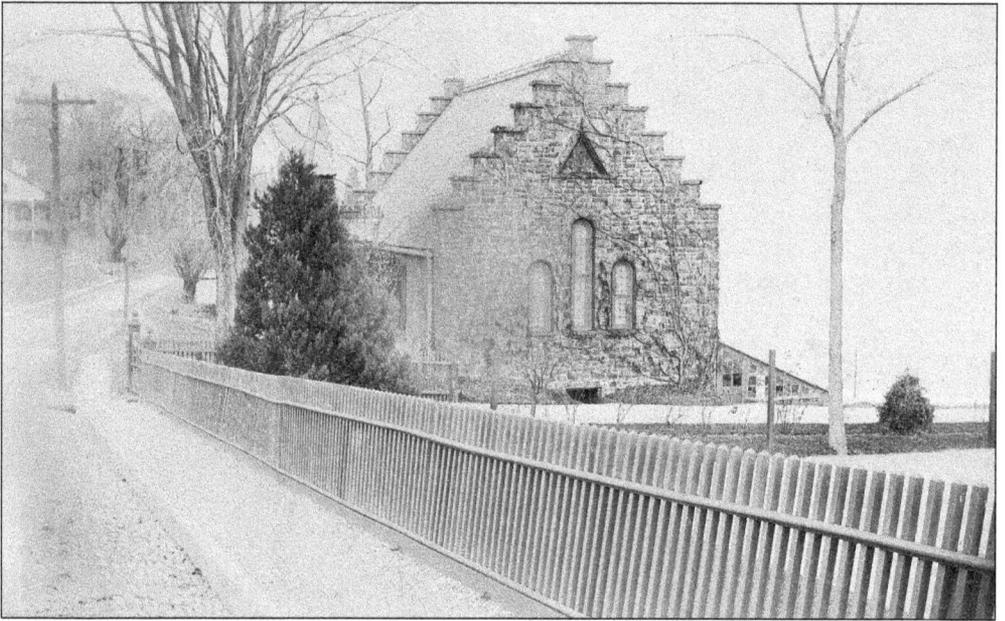

The Wayside Chapel, with its distinctive step-gable roof, was built in 1867 with nearby stone for use by the Sabbath Sunday school. Originally built with a belfry and bell over the entry, services were held weekly until 1930. It was converted into a private home in 1938. The chapel's prized rose window was donated to Christ Episcopal Church in Sparkill, where it remains, and the bell now stands outside village hall. (Courtesy HSRC.)

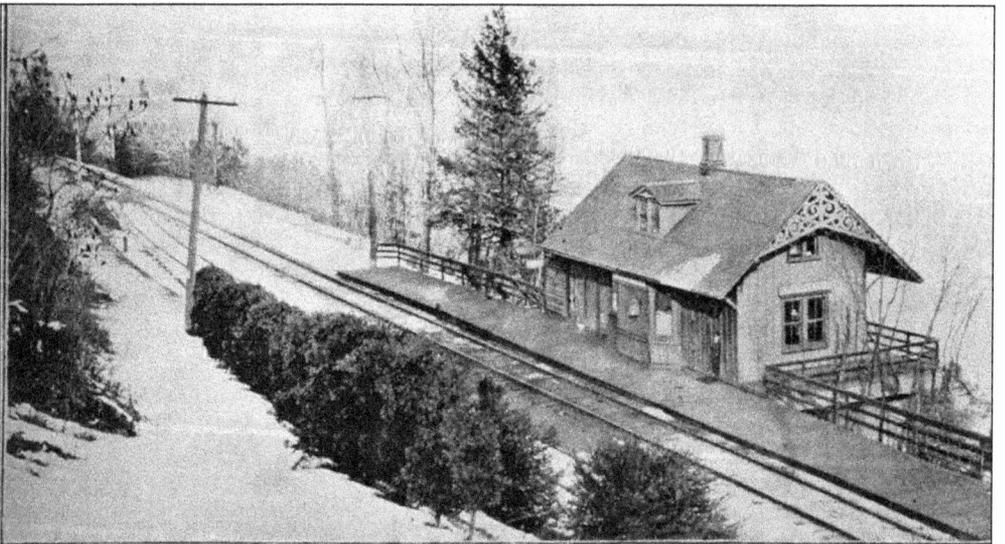

Photo by Van Wagner, Englewood. GRAND VIEW STATION.
27 miles from New York City, on N. R. R, N. J.

In need of a suitable name to call the rail station on this spot in the 1870s, a railroad official looked out over the Hudson and declared, "What a grand view!" His observation caught on, and the Grand View Station was built. The station master lived in a house nearby and handled 25 trains daily. Passenger service ended in the 1960s. What remained of the station collapsed during a storm in 1970. (Courtesy Nyack Library.)

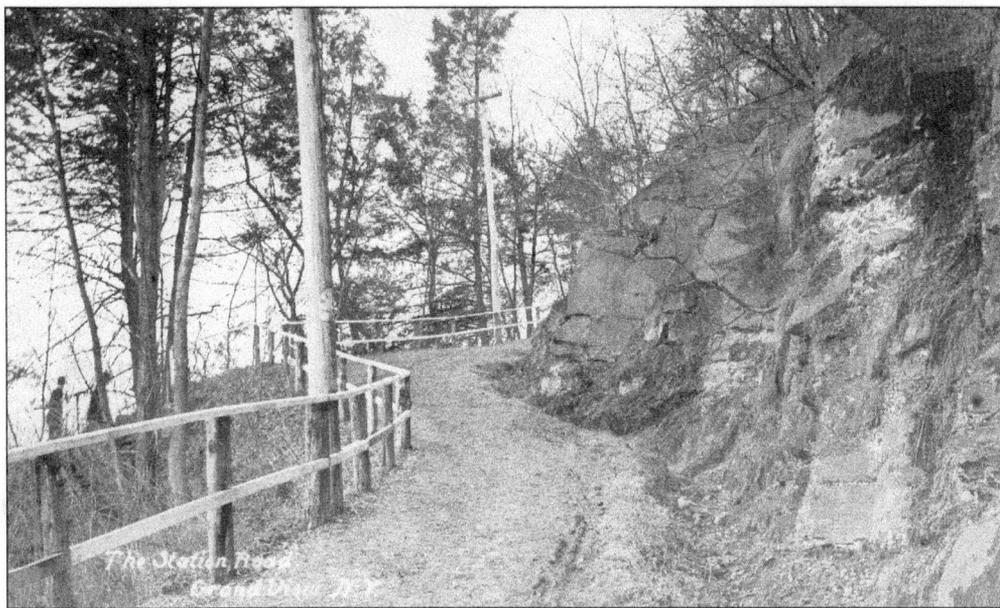

In the late 19th century, this narrow, winding carriage road, known as Station Lane provided access for people, horses, wagons, and utility poles carrying electricity uphill to the Grand View rail station. Often treacherous in winter and susceptible to washouts and mud in spring and summer, it provided the quickest path from River Road. In the 1930s, it was extended further to connect the station with Route 9W. (Courtesy Robert Knight.)

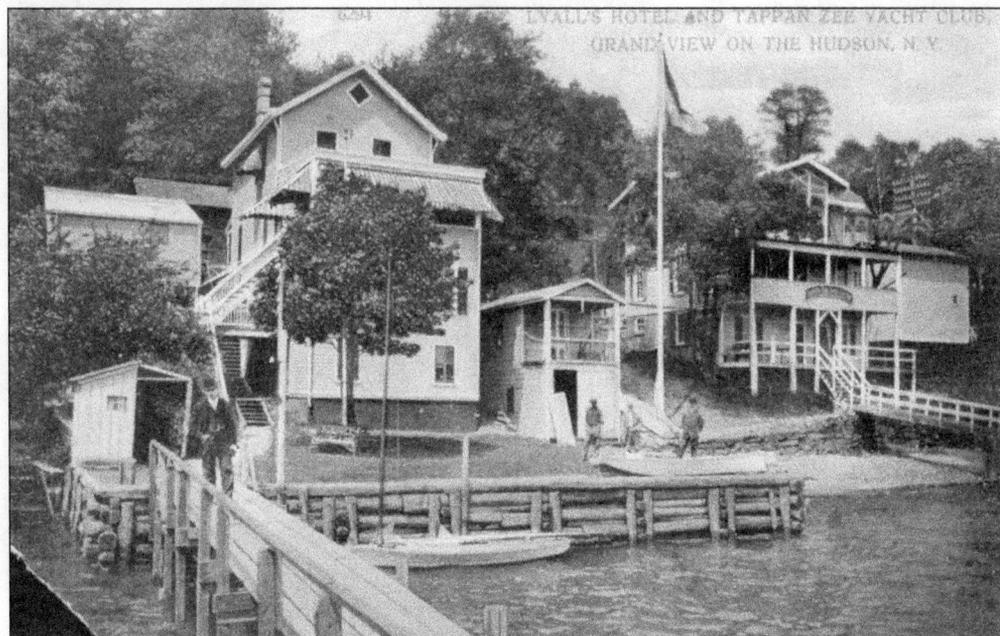

The Lyall Hotel, built by David C. Lyall in the 1870s, became a fashionable riverfront place for yachters, especially after the establishment of the Tappan Zee Yacht Club next door in 1883. Lyall ran the hotel for several years, but it was abandoned after his death. The club enjoyed tremendous popularity and success, and it moved to larger facilities down River Road in 1914. Both buildings are now private residences. (Courtesy Nyack Library.)

THE BIGHT.

The Bight, pictured looking north at low tide c. 1910, was a distinctive curve of coastline and popular fishing area stretching along River Road. Beyond the bend was a popular fishing spot. The Salisbury House can be seen off Cornelison Point to the left. Beneath the long formation of rocks were pipes. These pipes emptied periodic overflow from septic tanks into the river until 1973, when a better storm and sewer system was built. (Courtesy Nyack Library.)

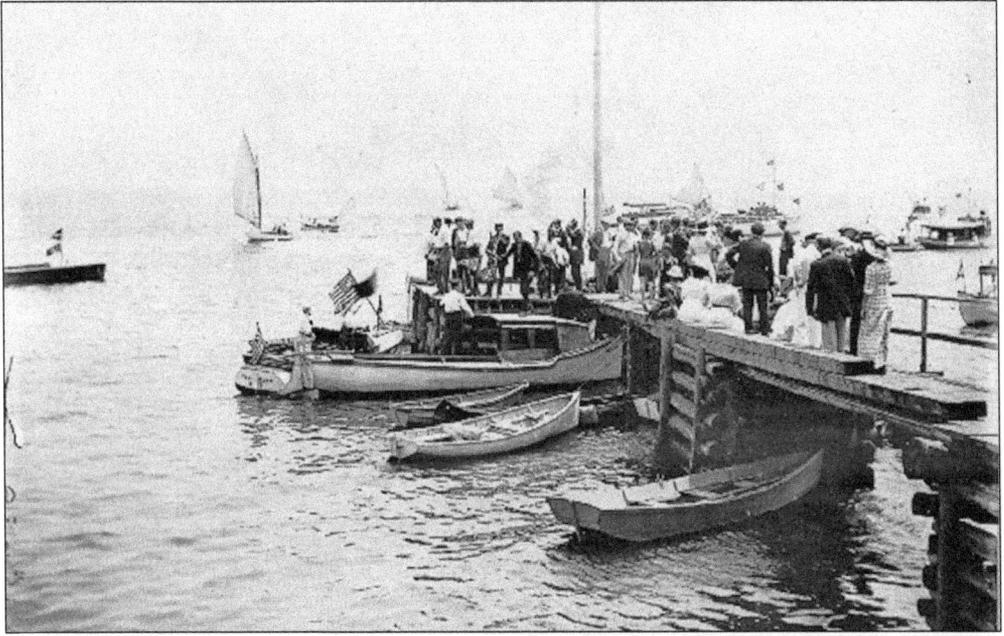

After moving from its original building just north on River Road, the new Tappan Zee Yacht Club became the area's most popular and luxurious location for yachtsmen. When it opened in 1914, there were 52 yachts from nearby sailing clubs anchored offshore in celebration and more than 500 people gathered for a lavish party. During World War I, it was the headquarters of the Coast Guard flotilla. The club closed after the war. (Courtesy Nyack Library.)

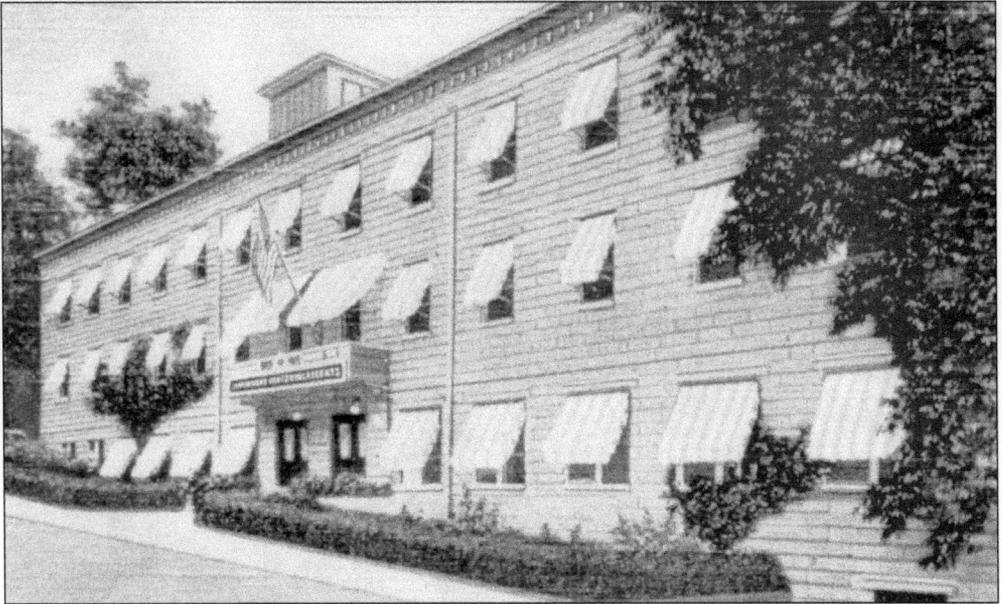

Originally built as the Grand View Hotel, this impressive three-story structure was bought by a Jewish charitable group in 1916. Renamed the Jewish Home for Convalescents, it was a nonsectarian facility for up to 125 patients from New York hospitals, sent here to recover from surgeries and other conditions. It closed in 1973 and was demolished in the early 1980s. A new residence was built in its place. (Courtesy Nyack Library.)

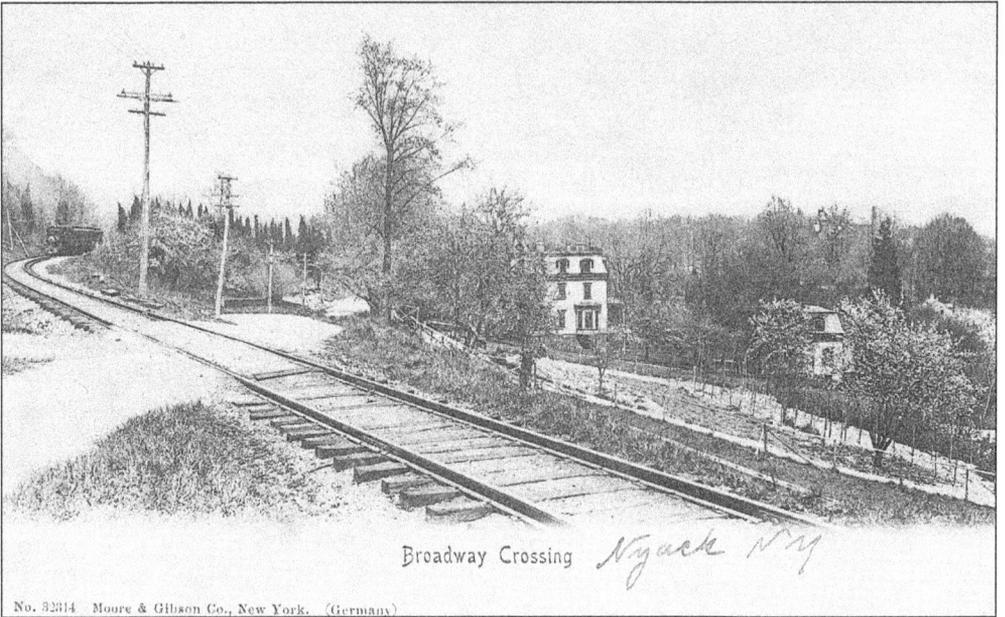

Broadway Crossing *Nyack N Y*

No. 82814 Moore & Gibson Co., New York. (Germany)

Although the tracks that once carried trains across Broadway at Route 9W have long-since disappeared, the distinctive 1875 Victorian house, pictured center c. 1900, still stands today. From 1922 to 1955, it was the Rockland Academy, a private school for young children run by Rev. F.A. Sisco, a rector from Piermont, and his wife. In 1955, the academy was sold, and it has remained a private residence ever since. (Courtesy Robert Knight.)

After the Tappan Zee Yacht Club relocated down the River Road in 1911, this building, braced by huge stone supports in the Hudson, opened in 1914. The club experienced hard times after World War I and closed. It was purchased for use as village hall in 1928. The large dock once used by the yacht club and others remained in use until it was destroyed by 24-inch-thick ice in 1948. (Courtesy OHMA.)

110

Once a prominent fixture of the Wayside Chapel, this 515-pound bell, cast in Holland in 1873 and inscribed with the word "Come," was donated and placed in front of village hall in the late 1930s. During World War II, the bell was used to signal blackouts in the event of enemy attack. The building was placed in the National Register of Historic Buildings in 1980, and the bell remains there today. (Courtesy OHMA.)

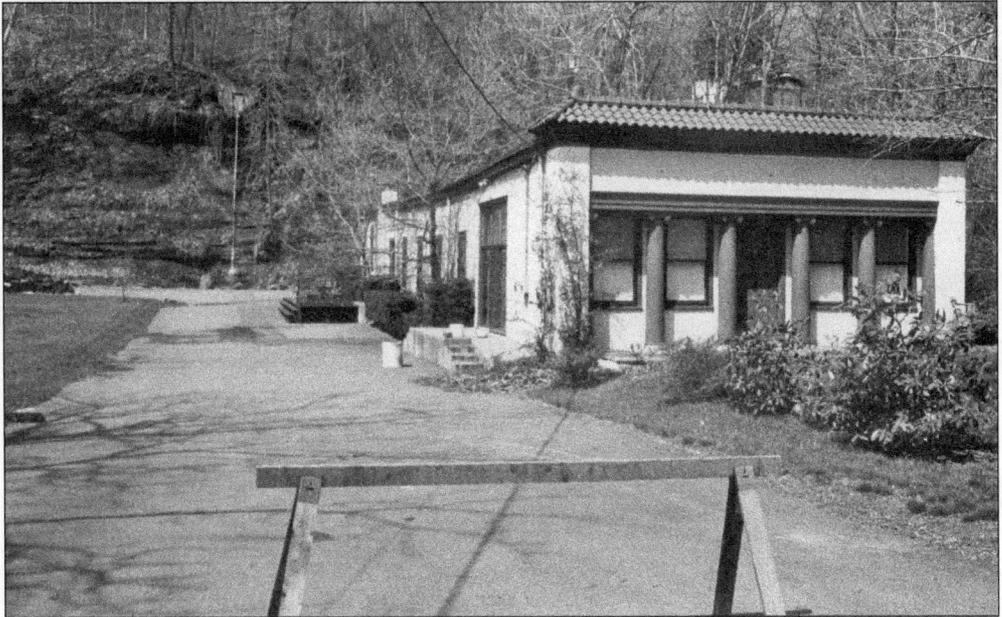

Built near an old quarry and spring-fed waterfall, this early 1900s house became the Cascadian Bottle Works. From 1930 to 1967, it operated as a carbonated water facility, bottling Cliquot Club Soda. In the 1970s, the spring water was shipped for office water coolers in New York. Operations ceased after a truck spilled chemicals on Route 9W and polluted the springs. This building has been a private residence ever since. (Courtesy OHMA.)

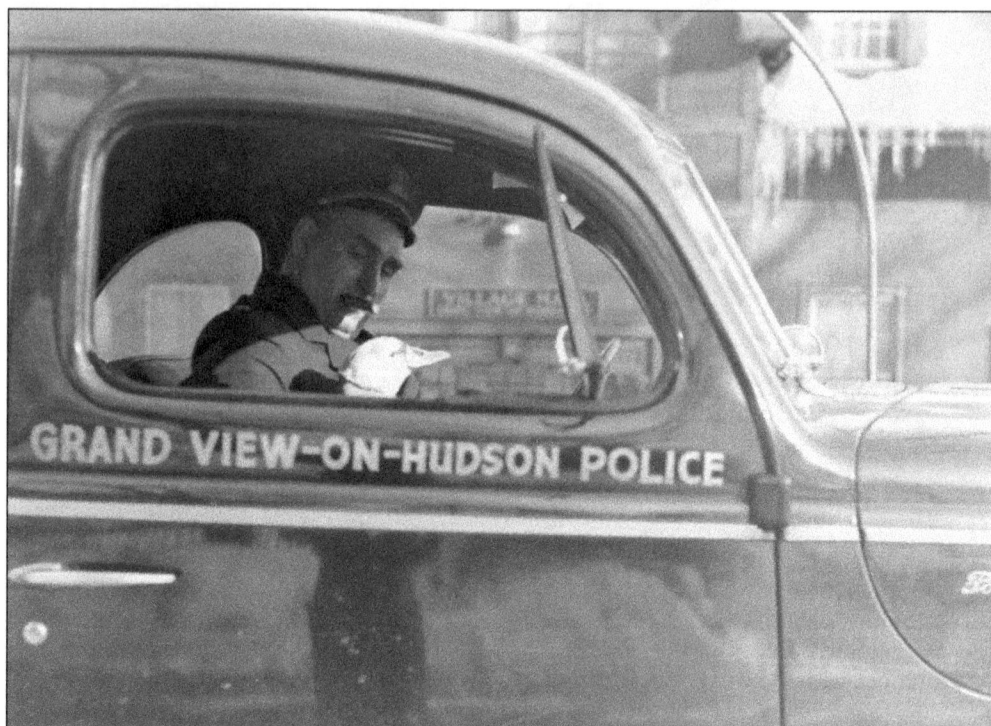

On a cold winter morning in 1950, police chief George Cline found a lost and stranded white goose near village hall. He rescued the goose and brought it inside his police car to warm up. Chief Cline was known throughout Grand View for his dedication and willingness to help anyone, anytime, for any reason, including directing traffic and clearing clogged household drains. He was known just as distinctly for his ubiquitous cigar. (Courtesy OHMA.)

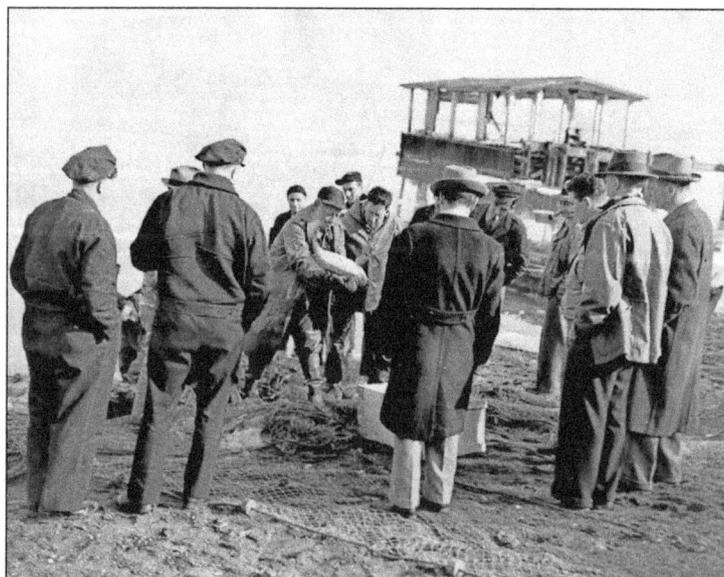

Fishing along the Bight was always a favorite pastime in Grand View, and a successful catch could always attract a crowd. Here, in February 1946, a group of spectators that included police chief George Cline encouraged busy fishermen as they used nets and bare hands to haul in and show off a particularly large striped bass from the Hudson. (Courtesy Nyack Library.)

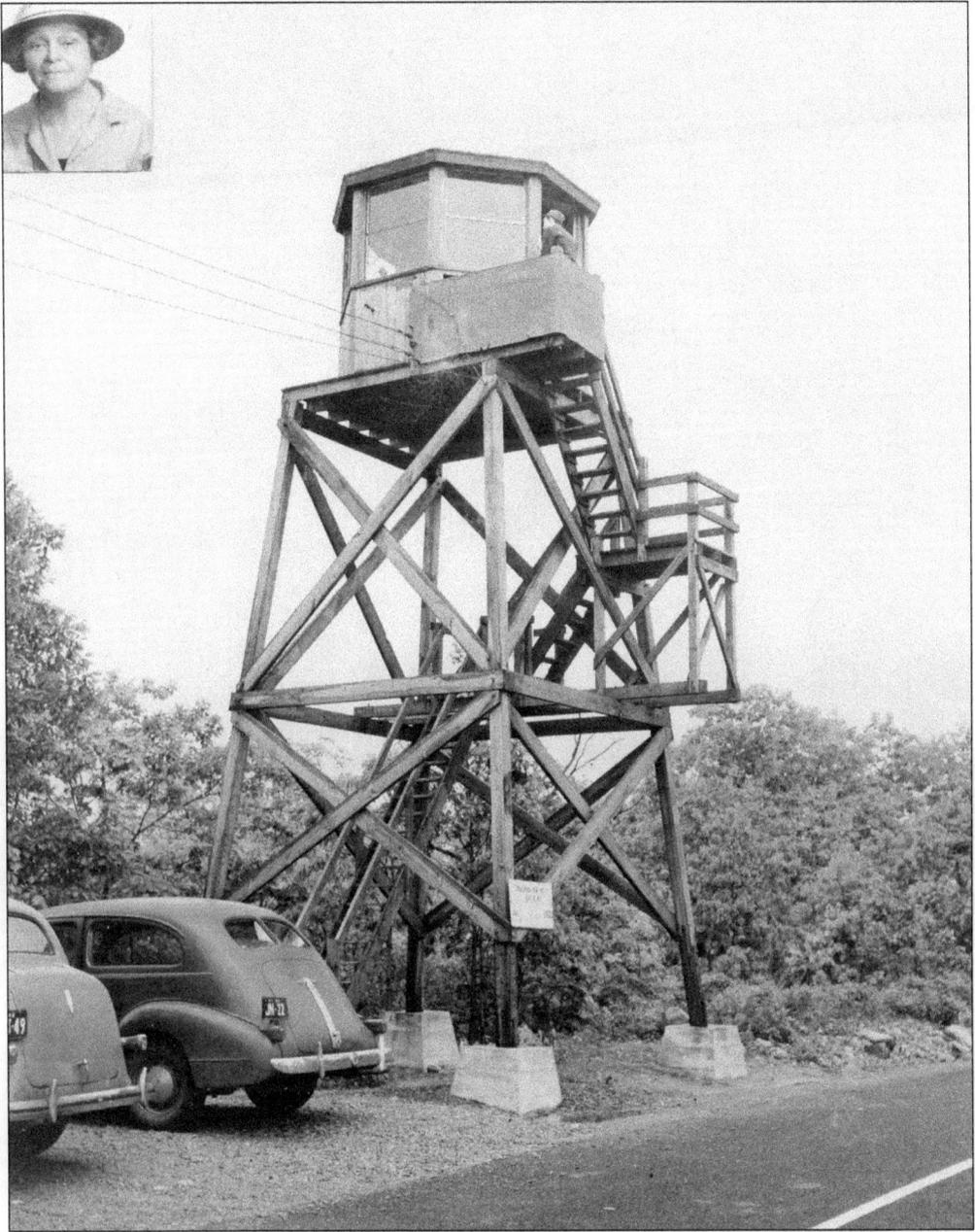

On Tweed Boulevard in Upper Grand View, this observation post was built in 1942 as part of the Civil Defense Program during World War II. Throughout the war, civil defense volunteers would occupy this tower day and night, scanning the skies for German aircraft. After the war, the tower was used to spot brush and forest fires. In the upper corner is Ida Schaff-Regelman, who served as a volunteer observer. (Courtesy Nyack Library.)

As the building of the Tappan Zee Bridge began in 1952, this spot on the Bight was where the bridge would come ashore. The storm wall built years before would disappear, as would Munson's boathouse and the walkway that led to it. Doctor Munson, a dentist who lived across the road and just up the hill, built and used it to keep his vintage Chris-Craft speedboat. (Courtesy Nyack Library.)

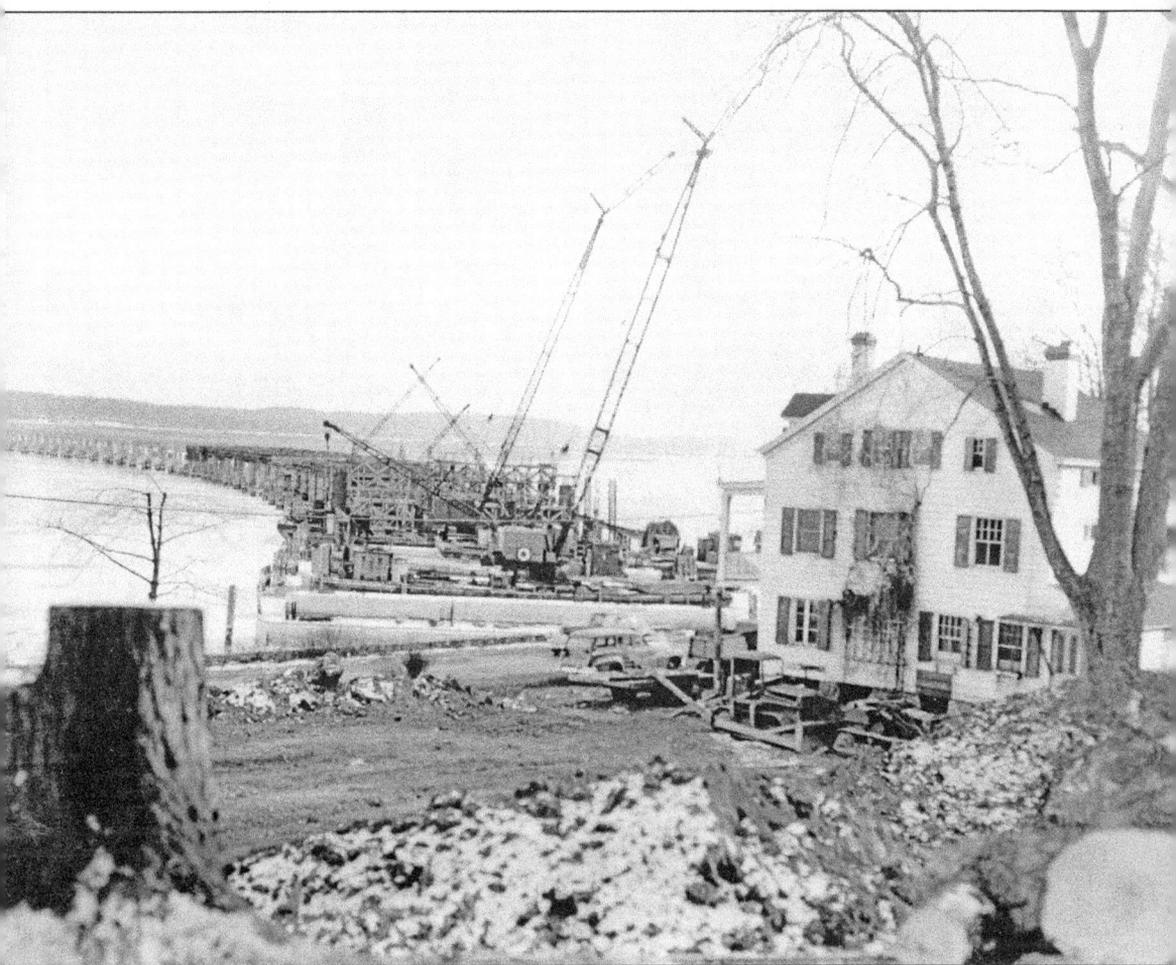

In 1954, the Gaylor House near Bight Lane stood directly in the path of the Tappan Zee Bridge causeway. Built originally before 1800 and operated for a time as a private school, the house was owned by Albro Gaylor, a mayor of Grand View in the 1930s. The house was not destroyed but instead was picked up and moved to a safer location uphill and west in South Nyack. (Courtesy Nyack Library.)

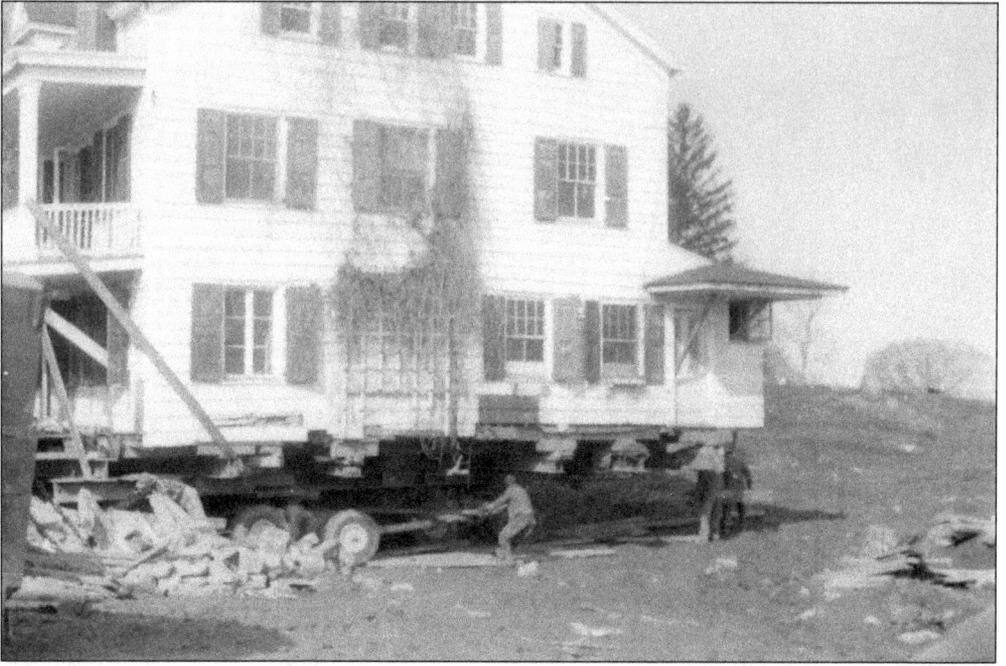

Many homes were lost in Grand View, but not every house in the path of the New York Thruway was demolished. The Gaylor House in Grand View was one of many that was relocated. It was delicate work, and trees were often removed along streets to make way. The Gaylor house was moved, vines and all, in 1954 to South Nyack where it remains today. (Courtesy Nyack Library.)

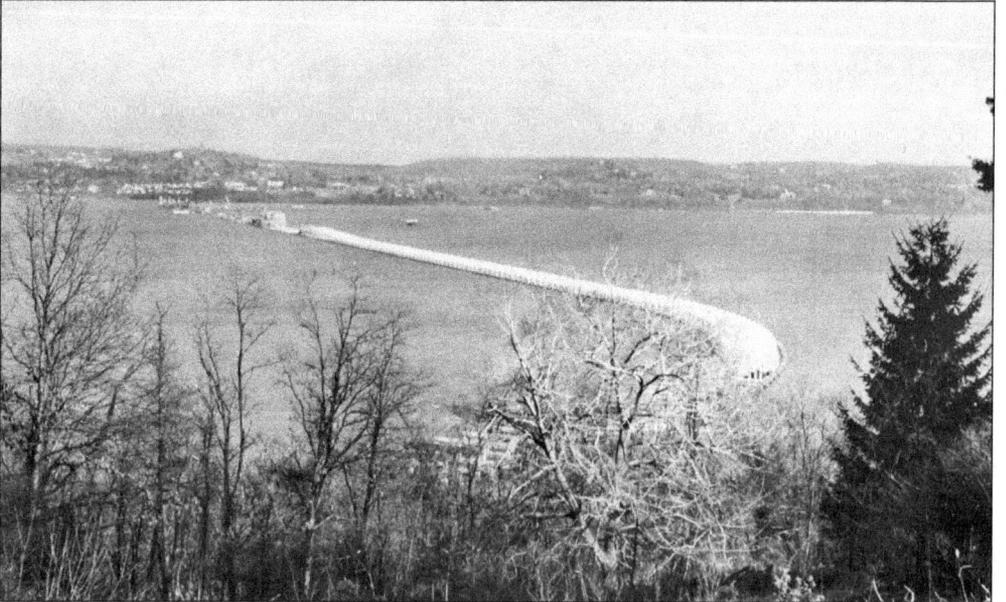

Taken in 1954 from Tweed Boulevard in Upper Grand View, the long, sweeping, work-in-progress S-curve of the Tappan Zee Bridge could be seen approaching the Rockland shore. Larger sections of the bridge, especially the higher sections under which ships, barges, and other river traffic would pass, had not yet been added, and other sections of the eastern structures had not yet come ashore in Westchester. (Courtesy Nyack Library.)

Ten

SOUTH NYACK

Until it broke away from Nyack in 1878, South Nyack was considered more a Nyack suburb than an entity of its own. Included in the incorporation in 1872, South Nyack later contended that its taxes were used more to Nyack's benefit than theirs, and brought about disincorporation on February 7, 1878. Four months later, the Village of South Nyack was officially incorporated.

The land here was part of the rich forest and shore deeded by Cornelius Clausen Cooper to his brother John; land that included present-day Grand View. Like the Lenape, a Native American tribe before them, settlers here took advantage of the plentiful fishing along the distinctive shoreline of the Bight. In 1770, Michael Cornelison, who owned farmland on this shore, built the main section of the Cornelison-Salisbury House, a landmark that stood here until it was demolished for apartment buildings in 1958. In the early 19th century, a nearby shipyard constructed river sloops and, as steam power took prominence in the 1820s, the steamship *Orange* was built there as well.

Orangetown Fire Company No. 1, Rockland's first volunteer fire company, was established in 1834. As the Northern Railroad of New Jersey extended into South Nyack in 1870, the dominance of river shipping and shipbuilding diminished, and freight and passengers bound for New York switched to trains. Commuter train service continued until 1965. In the late 1800s and early 1900s, shoe, pipe organ, and ice businesses prospered. A tourist trade also developed, and hotels and resorts like the Tappan Zee Inn and the Avalon Hotel attracted the rich and prominent from New York City.

But of all the villages and hamlets that both absorbed and reflected the development of Orangetown in the 20th century, South Nyack sacrificed more in the name of progress than any other. In the building of the Tappan Zee Bridge and the New York Thruway in the 1950s, South Nyack lost more than 100 homes, its commercial center, village hall, police and railroad stations, and all or parts of several streets. Yet despite the wrenching change these projects created, South Nyack still retains its gracious, residential nature and historic Hudson riverfront allure.

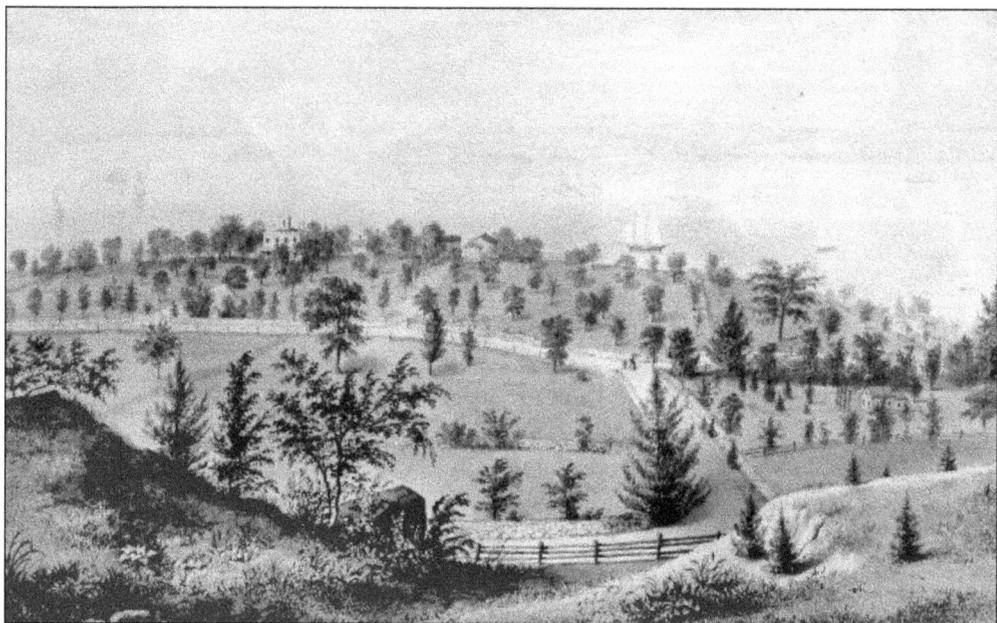

Rendered from a vantage point atop South Mountain in 1845, Robert Knox Sneden's view of South Nyack shows only a few houses along the river and the long-gone farms and pastures that existed then. The Hudson was a busy place and several sailing vessels, as well as a steam-powered boat, are seen plying the water. The Salisbury House and estate are seen on the right. (Courtesy Nyack Library.)

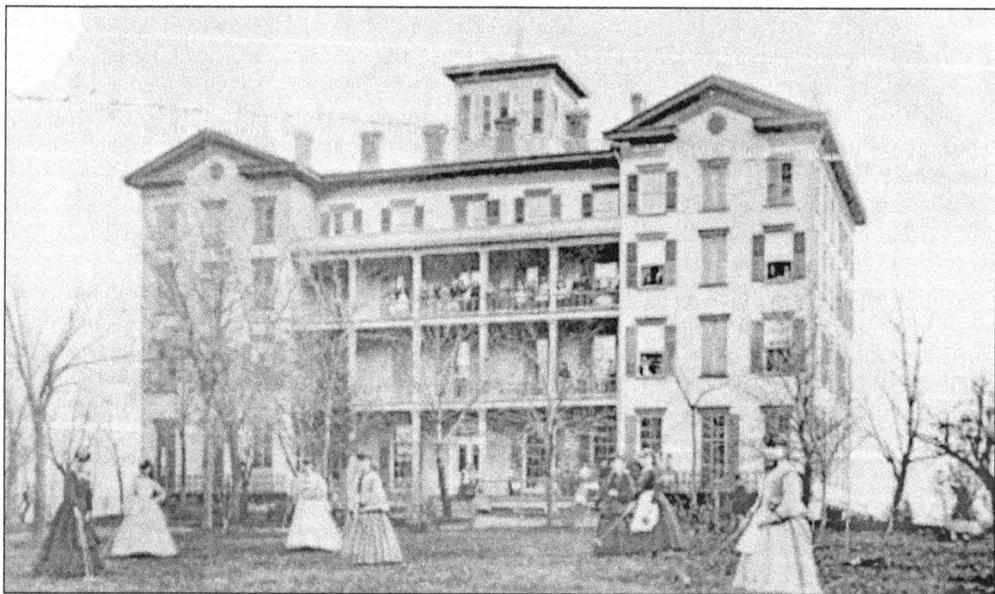

The Rockland Female Institute, modeled after Mount Holyoke in Massachusetts, opened in 1856 as a prestigious school of higher learning for women. The distinctive structure, pictured here with students playing croquet on the front lawn, was also used as the Tappan Zee Inn resort during summer months until the early 1900s. The Institute closed due to finances in 1899, then became home to the Hudson River Military Academy until 1907. The building burned in 1932. (Courtesy Nyack Library.)

Built from local sandstone, this venerated house overlooking the Hudson was built by Michael Cornelison in 1770. Cornelison was a Patriot during the American Revolution, and the house was often attacked. He was held prisoner in New York for a time by the British, who used his house as a headquarters. In 1876, Cornelison's granddaughter married John Lawrence Salisbury, and the house, pictured here c. 1885, became known as the Salisbury House. (Courtesy HSRC.)

Revered for its Gothic style, tower, and the four carillon bells that softly chimed the hours throughout the surrounding neighborhood, Bell Memorial Chapel was built by Louis Bell in 1899, and the adjoining Bell Home was built a year earlier. Both chapel and home were destroyed in the building of the New York Thruway. But the chimes and a clock were dismantled and installed in the Grace Episcopal Church in Nyack. (Courtesy Nyack Library.)

119

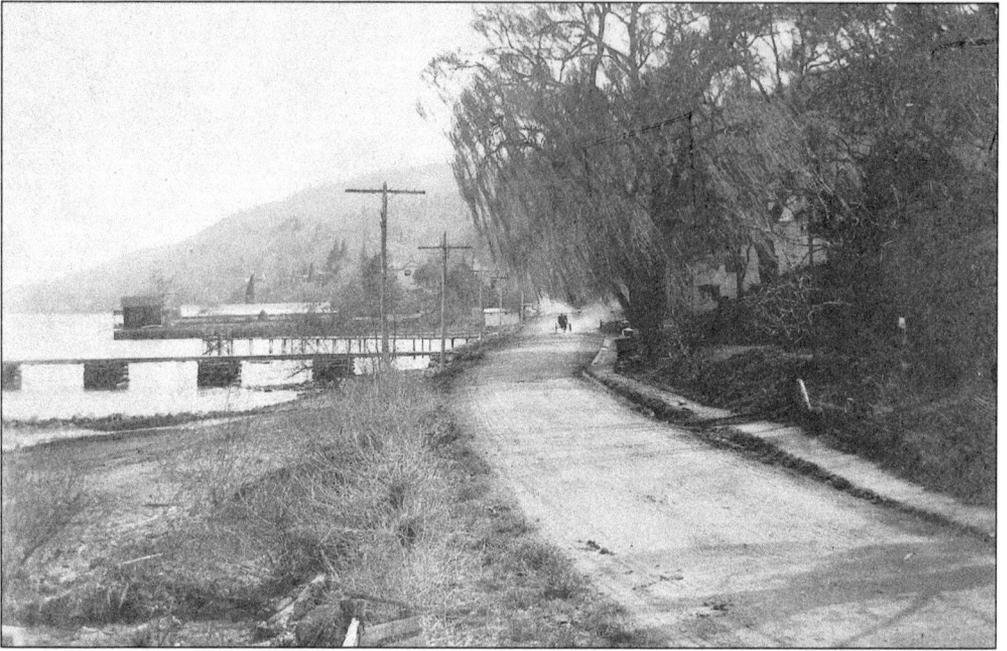

Before the arrival of the automobile, paved streets, and curbs, this scene along the Bight shows a tranquil and wooded stretch of River Road and riverfront, few homes, early utility lines and a single horse and buggy and its driver. Several private docks and boathouses were built out into the Hudson by local landowners in the years before and after this c. 1900 picture. (Courtesy HSRC.)

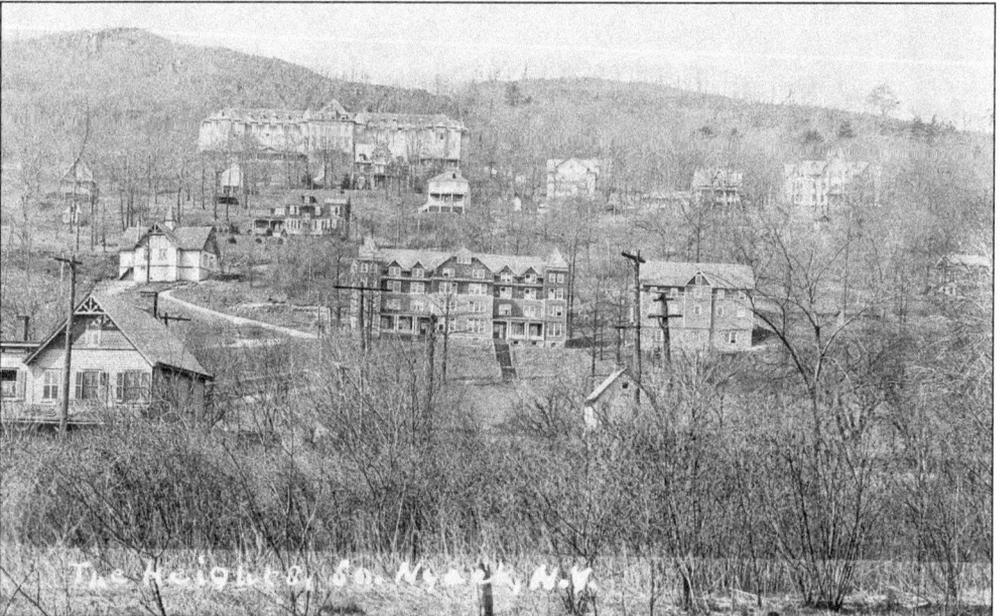

In the area known as the Heights, the Missionary Training Institute, pictured c. 1900, was its most prominent landmark. Relocated from New York City in 1897, the Institute, now Nyack College, was founded by Dr. A.B. Simpson to train Christian missionaries for service locally and internationally. In the early 1900s, residences and classrooms were added, and the curriculum was expanded to include liberal arts in addition to theological studies. (Courtesy Marilyn Schauder.)

120

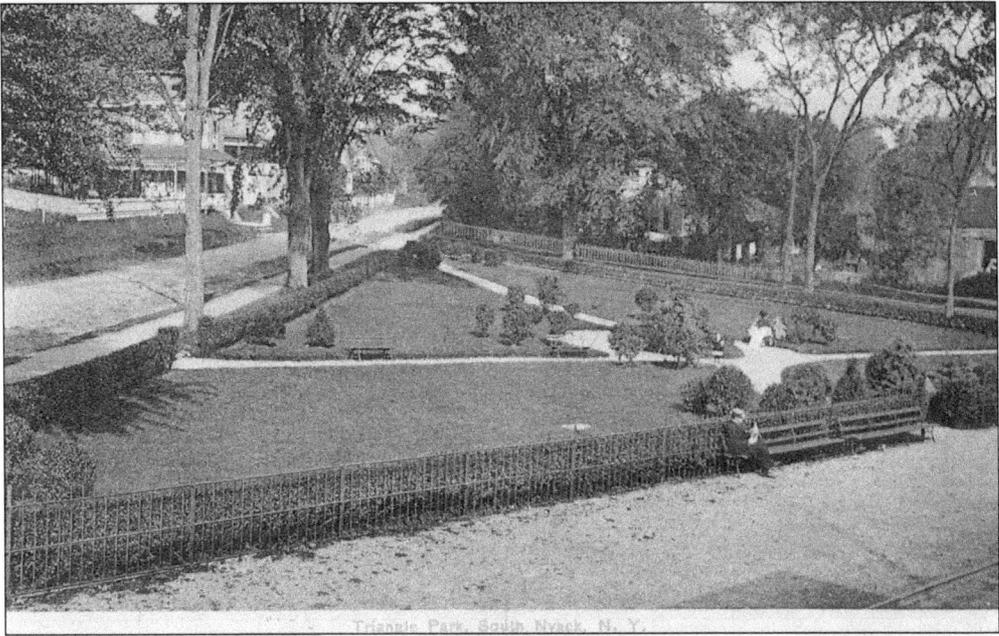

Near the train station in South Nyack's central business district, Triangle Park, pictured in the early 1900s, was a small, pleasant and well-cared-for neighborhood gathering spot. Lined and defined by houses, businesses, and other buildings, it was named and known for its shape and the direction of paths that ran through it. Triangle Park and the surrounding neighborhood were demolished in the construction of the New York Thruway. (Courtesy Robert Knight.)

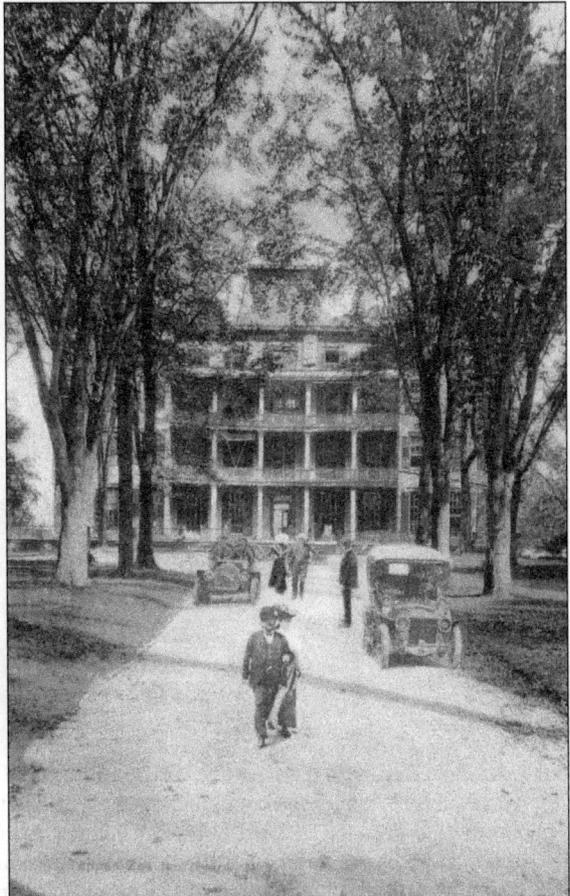

Favored in the summer months by New Yorkers looking for cooler air and quieter surroundings, the elegant Tappan Zee Inn resort, pictured c. 1910, was on land that stretched from Piermont Avenue to a private beach on the Hudson. In the off-season, this distinguished structure was used as the Rockland Female Institute until 1899. In the 1920s, it became the private Nyack Club, then a community club. Fire destroyed the building in 1932. (Courtesy Nyack Library.)

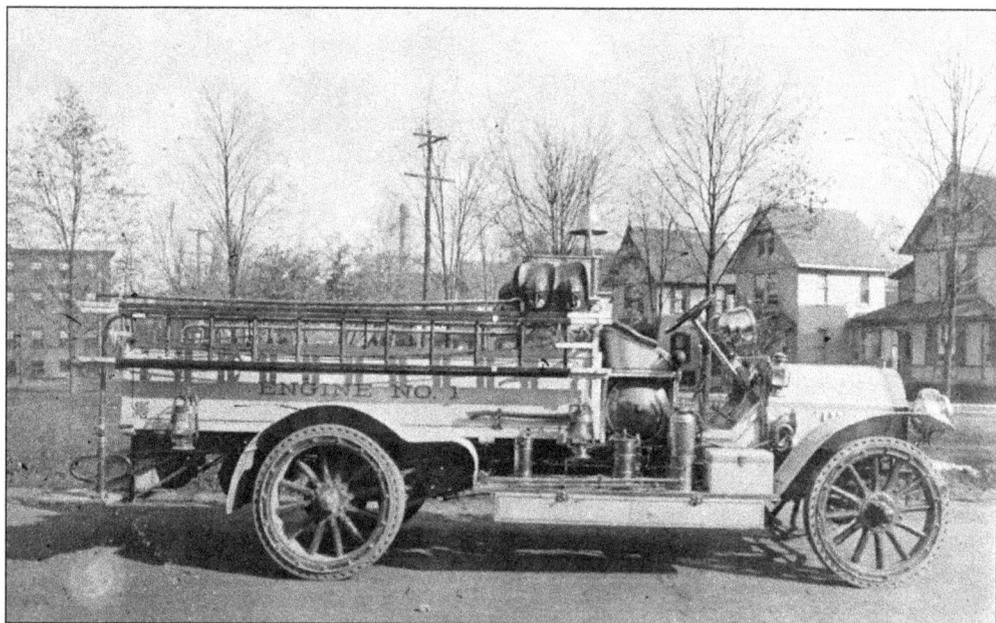

Founded in 1834, Orangetown Fire Company No. 1 is the longest continuing volunteer service in Rockland. In its early years, the company responded to calls in all of Nyack with only one piece of equipment. But as other companies formed nearby, it primarily served South Nyack. In 1915, the company bought its first gas-powered engine, a welcome addition that enabled faster response time. The tires were most likely solid rubber. (Courtesy Nyack Library.)

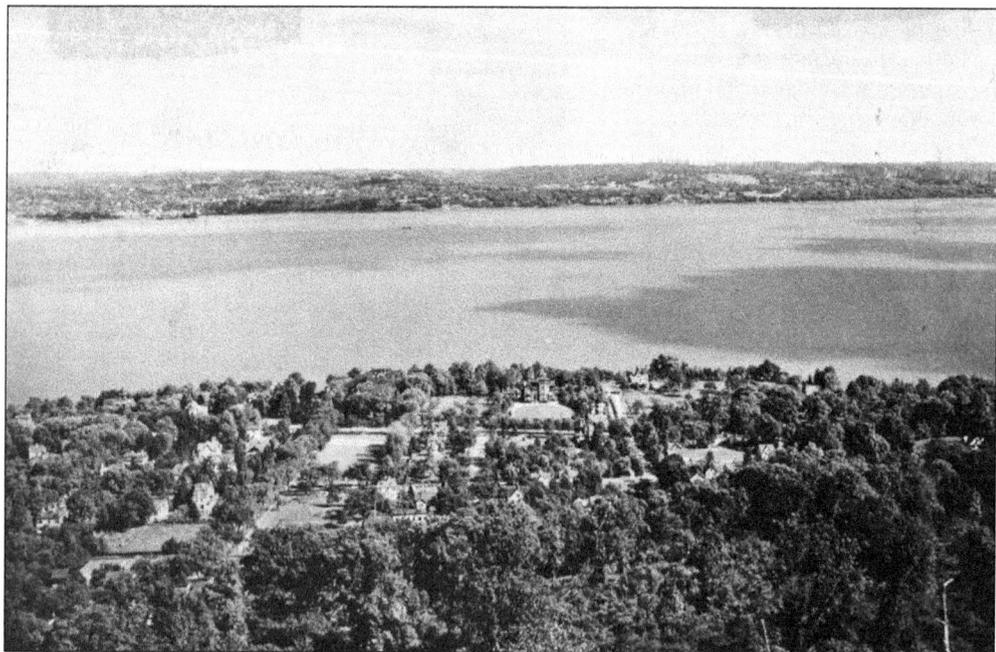

With an equally peaceful-looking Hudson shoreline to the east in Westchester, the western shore at South Nyack is shown in 1950, two years before construction of the Tappan Zee Bridge officially began. Taken from the top of South Mountain, this quiet view shows a section of South Nyack north of Smith Avenue and north of Piermont. (Courtesy Nyack Library.)

Eddie Nolan's, on the corner of Cornelison and Chase Avenues, was a popular spot in South Nyack's business district. It, like Al Tretta's Blue Flame across the street, was purported to be a speakeasy during Prohibition. During World War II, soldiers from Camp Shanks frequented Nolan's, and military police were assigned to the Nyack and South Nyack police stations to keep order. Both restaurants were demolished for the Thruway in 1954. (Courtesy HSRC.)

Near Nolan's and Blue Flame was South Nyack's only deli, the "corner store" was owned by Anna Van Vorst. It was the neighborhood place to pick up a sandwich or a quart of milk, and where commuters headed to the train station could get their morning coffee and paper. For kids, it was a treasure trove of penny candy, ice cream, and soda. It was torn down for the thruway. (Courtesy HSRC.)

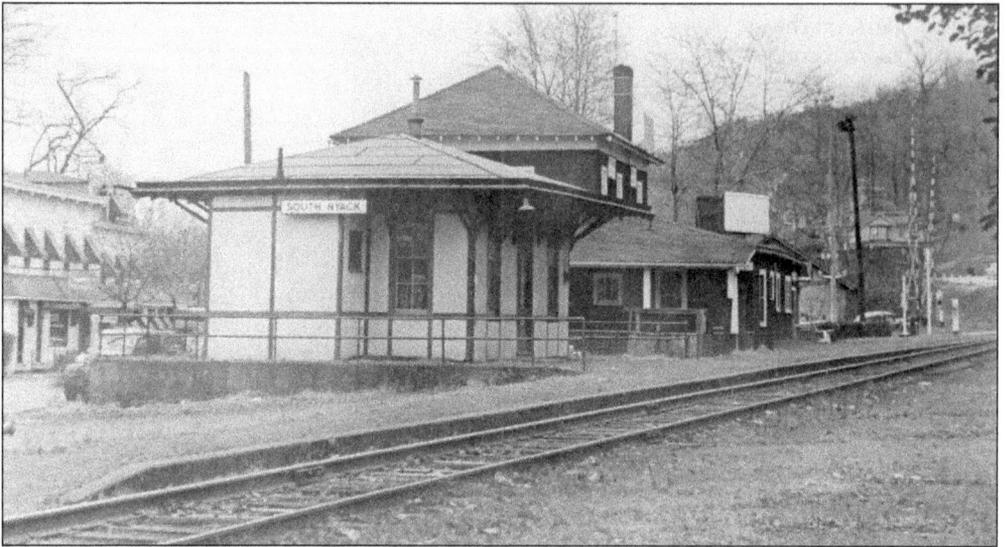

The rail station pictured here in 1953 was the second station built in South Nyack. The first was constructed in 1872 in then-unincorporated South Nyack (now Nyack) at Cedar Hill and Franklin, and it served as the Northern Railroad's terminus. A new South Nyack station was later built at Chase and Franklin, shown here across from Nolan's Restaurant. It was demolished to make way for the New York Thruway. (Courtesy Nyack Library.)

Ed Nolan, owner of Eddie Nolan's restaurant, sponsored a bowling team that was acclaimed throughout Rockland County. Pictured in 1947, the team included, from left to right, Swede Charleston, Emil Schawb, Ed Nolan, team captain Pete Hackett, and Chink Toto. Willie Arietta is in front. Emil Schawb also managed the Nyack Rockies of the North Atlantic League, a 1940s professional baseball team that played on Nyack High School's diamond from 1946 to 1949. (Courtesy Tom Hackett.)

124

On December 15, 1955, just past where traffic to and from the Tappan Zee Bridge would pass over the South Nyack shoreline, the Tappan Zee Bridge and New York Thruway were officially opened. On hand were a list of officials that included Gov. Averell Harriman, the mayor and town board of South Nyack, actress Helen Hayes, members of the press, and hundreds of spectators from around the area. (Courtesy Nyack Library.)

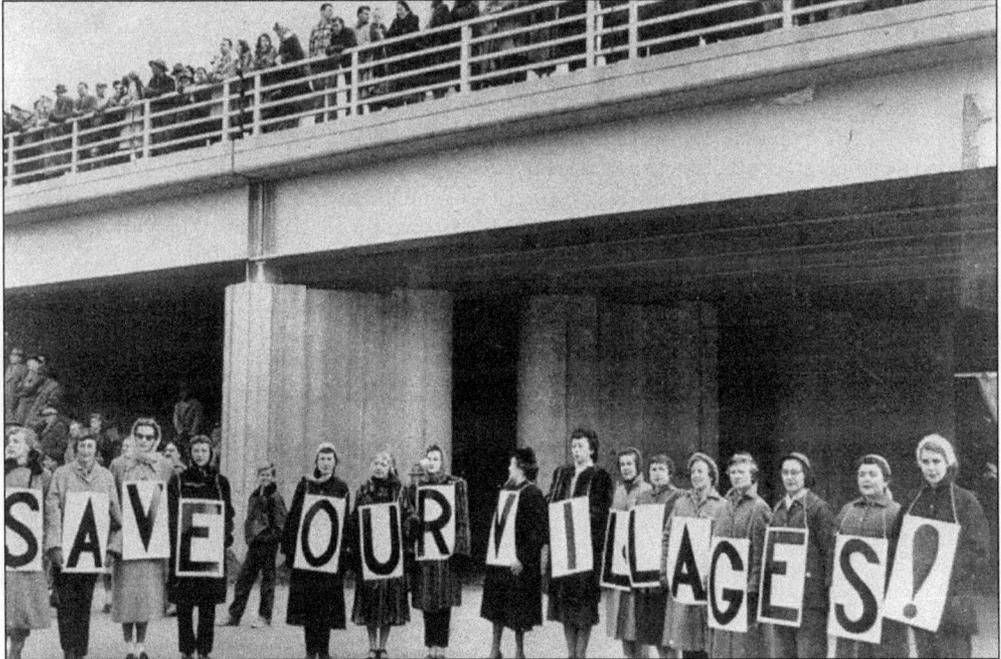

The kind of progress that the new bridge and interchange represented was not without its opponents. At the time, there was also a proposal in play to connect the New Jersey Turnpike to the New York Thruway, a plan that would cut Palisades in two and all but destroy Piermont and Grand View. However, thanks to the efforts of the Committee to Save the Villages and many others, the plan was defeated. (Courtesy Nyack Library.)

125

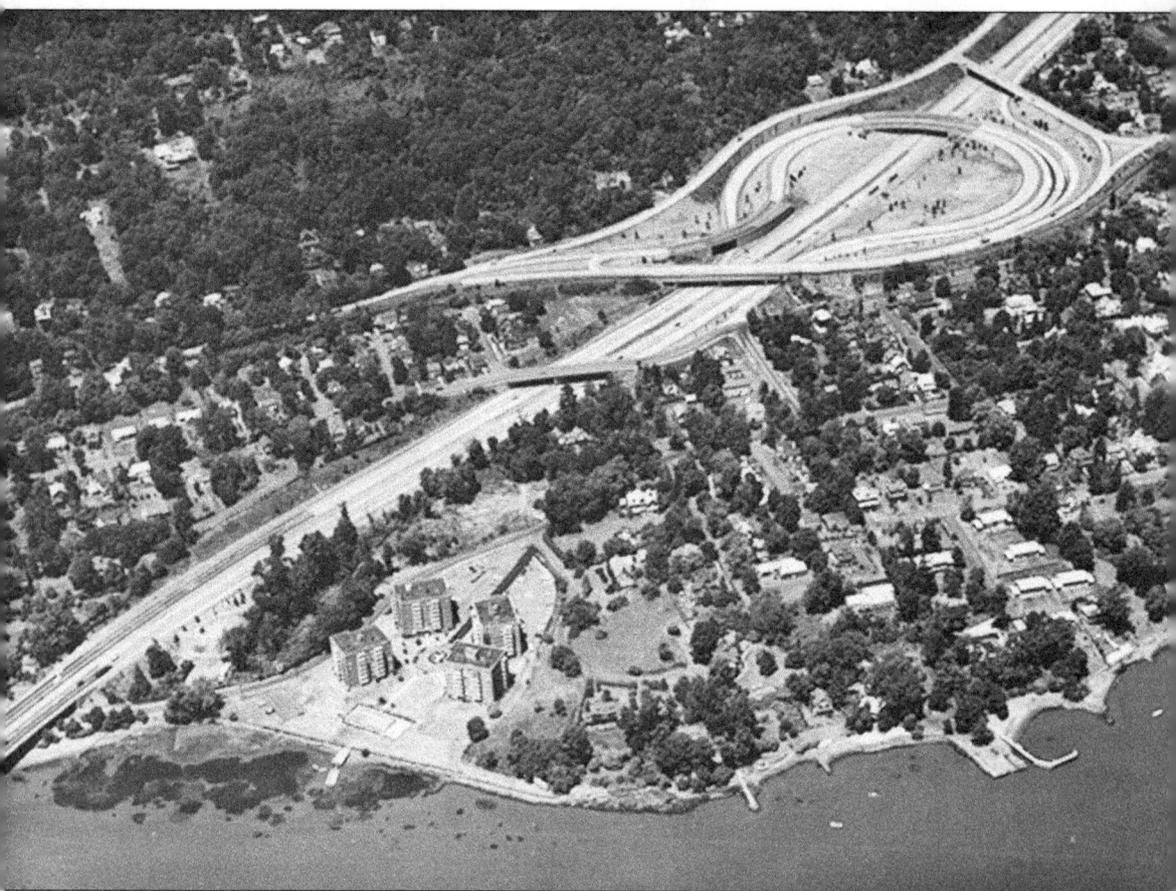

This photograph starkly shows the impact of the Tappan Zee Bridge and New York Thruway interchange on South Nyack. During construction, some likened the removals, relocations, and destruction of neighborhoods, businesses, and streets to scenes they had witnessed in postwar Europe. But despite all of the jarring changes, South Nyack survived and adapted gradually and successfully to a different style of life along the Hudson's scenic riverfront. (Courtesy Nyack Library.)

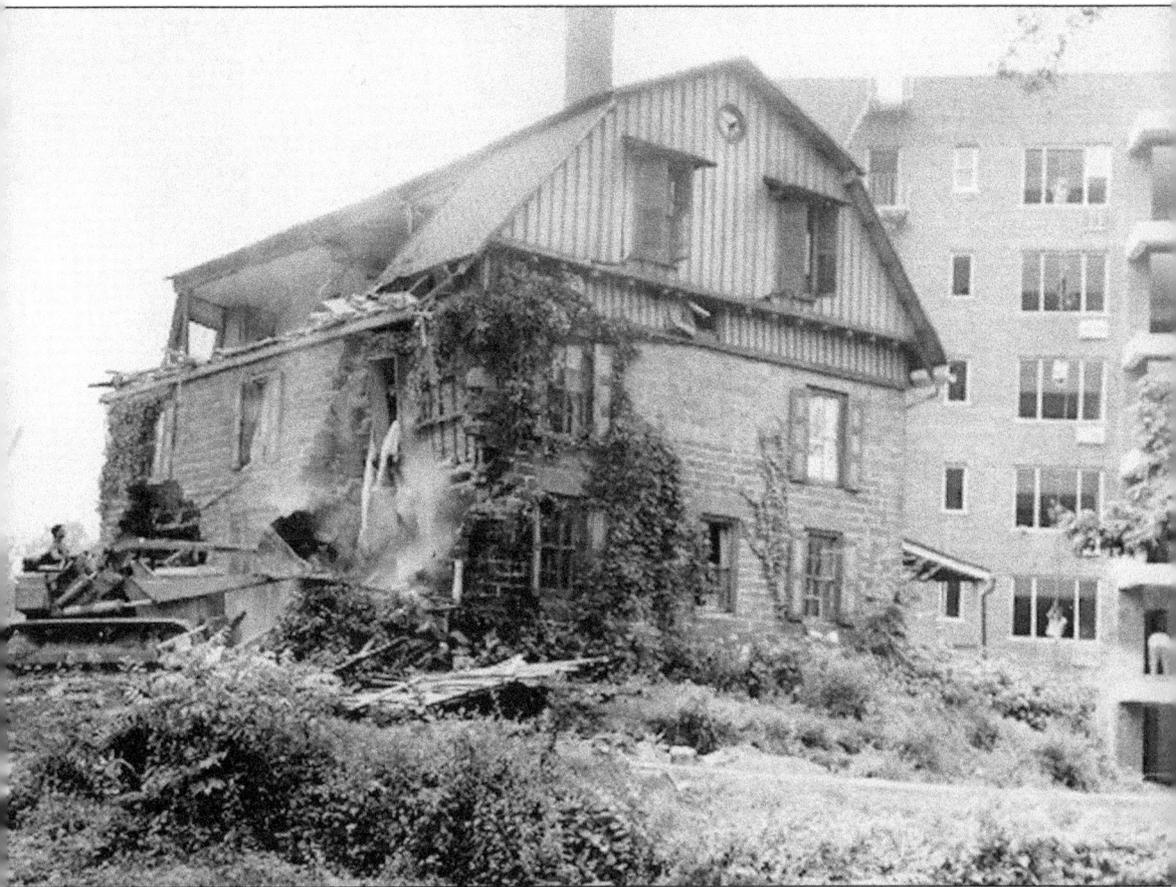

By 1958, the Salisbury House, now in the shadow of the New York Thruway, had fallen on hard times and was in need of repair. Efforts to raise enough money to save it were unsuccessful, and the house was demolished at the same time its replacement, the four-unit Salisbury Manor Apartments, was being built. Two Salisbury descendants, Louise and Jennie Salisbury, were the last family members to live in the house. (Courtesy Nyack Library.)

Visit us at
arcadiapublishing.com

www.ingramcontent.com/pod-product-compliance
Lightning Source LLC
Chambersburg PA
CBHW050711110426
42813CB00007B/2154